Published in conjunction with the Mormon Arts Center Festival,
June 29-July 1, 2017, The Riverside Church, New York, New York

ISBN: 978-1977709714

Mormon Arts Center
P. O. Box 230465
New York, NY 10023-0008

Cover: Levi Petersen, *Esterbend* (2015) (still from the single-channel video)

THE KIMBALL CHALLENGE AT FIFTY
MORMON ARTS CENTER ESSAYS

TERRYL GIVENS, KEYNOTE

PAUL L. ANDERSON
RICHARD BUSHMAN
CAMPBELL GRAY
KRISTINE HAGLUND
JARED HICKMAN
MICHAEL HICKS
KENT S. LARSEN
ADAM S. MILLER
GLEN NELSON
STEVEN L. PECK
JOHN DURHAM PETERS
JANA RIESS
ERIC SAMUELSEN
NATHAN THATCHER

MORMON ARTS CENTER

TABLE OF CONTENTS

RICHARD BUSHMAN

THE KIMBALL CHALLENGE

I was teaching at Brigham Young University when President Spencer W. Kimball delivered the address that provides the underlying theme of the essays in this volume. The talk was titled "Education for Eternity" and was given to the BYU faculty in September 1967 at the beginning of the academic year. The talk provoked us to think of teaching as a spiritual calling and urged us to fill our classrooms with "the Spirit of the Master" as well as with facts.

Although significant then, the talk had an interesting afterlife. Ten years later, one of its subordinate elements was brought to the fore and made the basis of an *Ensign* article. Near the end of his 1967 address, President Kimball had asked about the fruits of a BYU education. Could we produce Wagners, Bachs, and Carusos? Wasn't it possible that BYU students could write a greater oratorio than the Messiah? "Can there never be another Michelangelo?" "Could there be among us embryo poets and novelists like Goethe?" In 1977, while President Kimball was still alive, this portion of the talk, originally an afterthought, became the central point of the article in the *Ensign*.[1]

The *Ensign* essay, titled the article "The Gospel Vision of the Arts,"[2] opened with a new introduction by President Kimball: "In our world, there have risen brilliant stars in drama, music, literature, sculpture, painting, science, and all the graces. For long years I have had a vision of members of the Church greatly increasing their already strong positions of excellence till the eyes of all the world will be upon us." Ten years after the initial address, President Kimball chose the arts as the main theme of a follow on essay.

Artists down to today have responded to the Kimball challenge with great enthusiasm. If you google "Gospel Vision of the Arts", a stream of entries comes up citing the article. For many Mormon artists, it has been a manifesto and a call to arms. They have loved it because it validated their enterprise. Prophetic words assign art a place in the work of the kingdom.

While I was at BYU, I was aware of artists Trevor Southey and Dennis Smith consciously searching for ways to blend their beliefs and their art. (Later I learned there were others on the same quest.) I resonated to their efforts because I was searching for

ways to make history relevant religiously. How could we approach a divine perspective on the course of human events? The results of my deliberations appeared in *Dialogue* in 1969 in an essay called "Faithful History."

The question will remain for people with religious natures: How can faith be integrated with culture? The desire to know God is so powerful that it seeks expression in every realm of life. The arts with their intimate access to our deepest feelings must, we think, inevitably connect with our faith. The speakers in the symposium offer a variety of answers to how this may be accomplished by Mormons. As these essays show, Mormonism may not yet have produced a Michelangelo or a Goethe, but we do believe our religion and our art belong together.

ENDNOTES

[1] Spencer W. Kimball, "Education for Eternity," BYU Annual Faculty Conference, Sept. 12, 1967. https://ucs.byu.edu/sites/default/files/readings/EducationforEternity-Kimball.pdf.

[2] *Ensign*, July 1977.

TERRYL GIVENS

THE FORGING OF MORMON IDENTITY

I applaud this event as a seminal moment in Mormonism's coming of age, artistically. And I applaud those who have spoken of the need to cast a wide net, and make the term "Mormon Art" as inclusive as possible. At the same time, I would point out that though a solar system may have many diverse bodies: planets and comets and nebular debris, it also has a center of gravity, that gives the system its coherence and its identity. It is that core identity, or assorted core elements of that identity, that I wish to explore this evening. Not by way of definition or exclusion, but by way of interrogation and suggestion. So I intend my remarks as one entirely subjective starting point only for giving substance to the expression, "Mormon Art."

In part 1 of these remarks, I will begin with the general topic of ethical responsibility and art, and I will say something about how Mormon theology gives the topic very particular contours.

In part 2, I want to move to the consideration of culture, and how what I am calling Mormon art (art that is informed by a uniquely Mormon consciousness), takes shape as an engagement with particular tensions that typify Mormon culture.

PART 1. FOREST

Fiona and I have a home in the countryside of rural Virginia. We have a few acres. Not many, just a few. Fiona has long said I need a hobby and that writing doesn't count. So I have taken up gardening. But I don't grow fruits or vegetables. I am turning our woods into parkland. We have lots of beautiful hardwood: white oak, red oak, and maple, and hickory. We also have giant yellow poplar, which the bees exploit for pollen and nectar. A few flowering dogwood. And then there are the scrubby pine and prickly holly and cedar and a thousand species of weeds and bushes and undergrowth. I work with an axe and a mattock. I am clearing out the understory, one weed and fern and hardwood sapling and softwood tree at a time. Fiona wants it to look like Darcy's estate in *Pride and Prejudice*. I work a few hours most mornings, cutting and stumping and hauling everything to the fenceline. I love this work. It is one of the deepest and most consis-

tent joys in my life. It's a humble enough project, that wouldn't impress a real farmer or woodsman. Joseph Smith and his peers could do a month's worth of my labors in a lazy weekend. But it's becoming my own sacred grove, so to speak. Invested with my sweat and labor and deep affection for the land and its beauty.

Most mornings, I sit and pause at work's conclusion, to admire my progress, as the forest floor, swept clean of debris and any young growth besides substantial hardwoods, extends just a little further than it did yesterday. And many mornings, I have been taken in thought to Parley Pratt's enthusiastic vision of God's grand design, which I can so readily identify with, because it is strikingly visual, and analogous to my own happy struggles against nature's entropy. "Men are the offspring or children of the Gods," he wrote, "and destined to advance by degrees, and to make their way by a progressive series of *changes*, till they become like their father in heaven, and like Jesus Christ their elder brother. Thus perfected, the whole family will …continue to *organize*, people, redeem, and perfect other systems which are now in the womb of *Chaos*."[1] In my mind's eye, I see the work of Genesis I continuing through aeons of time, as God and his co-creators sweep outward and onward through endless space, organizing, arranging, ordering, improving, and redeeming. The Great Gardner, cultivating and nurturing and unfolding a beauteous cosmic garden.

Friedrich Nietzsche was, unexpectedly, in accord. Entropy, disorder, chaos, are the natural way of things. The most fundamental human compulsion, for Nietzsche, is the will to power. Although horribly abused, misunderstood, and misappropriated as a concept, Nietzsche's idea is nonetheless powerful and, I think, profound. The "true nature and function of life," as he puts it, is the compulsion to impose form on inert matter. I think he would not be averse to formulating it thus: we are ferociously driven to define ourselves as agents. We want there to be no basis for any cosmic observer to mistake the case: we are acting, not being acted upon. Of course, it is not hard to see, that the activity which more than any other values the reordering of the contingent into the intentional, expresses the sheer delight of a directed will, aspires to give new form to what is ready to hand, cradles and caresses and savors and shapes—is art.

From Pratt's perspective, of course, and I believe from most of ours, this is the essence of the Divine. God moves through the void, giving form and definition to cosmic dust, separating earth from sky and land from sea, animal from animal, plant from plant, and man from woman. And everywhere, he leaves his imprint.

Thus, Nicolai Berdyaev is able to say: 'God created the world by imagination.'" What is the nature of God's artistry? In the sublime language of Isaiah, the Messiah will come as the great Healer, Transformer, Alchemizer. "He will give unto those who mourn, beauty where there were ashes, the oil of joy for mourning, the garment of praise for the spirit of heaviness." How can the artist operate in solemn imitation of that kind of creative activity?

ART AS SACRED RESPONSIBILITY

In this sense, there is a sacred dimension to all art—and I mean art here in the broadest sense of creators, improvisers, and chroniclers—that takes as its province the human condition, human suffering, and human destinies. Because its materials are human, and because of its undeniable affective power, the moral weight of the artist's vocation is profound if sometimes oblique.

Artists have long agonized over the possibility, for example, that art can allow us to make the suffering of another into an object of merely aesthetic pleasure. Dylan Thomas, in a brilliant but disturbing poem, swore he would never do such a thing, even as he did just that. Writing about a child who had burned to death in a London fire, he vowed to "Never ... let pray the shadow of a sound/Or sow my salt seed/ In the least valley of sackcloth to mourn/The majesty and burning of the child's death/I shall not murder/ The mankind of her going with a grave truth/Nor blaspheme down the stations of the breath/With any further/Elegy of innocence and youth." So much for good intentions. Not only did he turn the tragedy into exquisite poetry, he even punned about graves and grave truths along the way.

A century earlier, William Wordsworth expressed the same worry. In an early masterpiece, "The Ruined Cottage," he chronicled one of the age's most painfully detailed accounts of prolonged human misery. The poor woman, Margaret, suffers with her husband and children two years of famine. Then he abandons her. The eldest child sickens and dies. Margaret seeks heavenly help and consolation, but God never responds. Her heart and health waste away. Her cottage falls into disrepair. Her wits fail her, and the infant dies of neglect. Still praying for rescue, she dies in unremitting grief. Midway through this account, the poem's narrator stops his tale in worried self-recognition, saying "It were a wantonness, and would demand/ Severe reproof, if we were men whose hearts/Could hold vain dalliance with the misery/Even of the dead; contented thence to draw a momentary pleasure, never marked/By reason, barren of all future good."

For some artists, however, a different imperative guides their work: Let illustrate with a strongly worded critique of the art of Francis Bacon by the great art critic Arthur Danto. Bacon specialized in bleak and grotesque depictions of post-war despair. (One of his painting sold for 142 million, the highest price ever paid for a painting at that time).

(See Francis Bacon, *Three Studies of George Dyer*, 1953, Louisiana Museum of Modern Art, Humlebaek, Denmark)

https://www.bing.com/images/search?view=detailV2&ccid=uF-TR5iR6&id=A041E6650AE9CF69F1496880F3DF6FC5DC-85BA55&thid=OIP.uFTR5iR6qzfOLQHAs53evwEsBc&q=francis+bacon+-study+for+portrait+1953&simid=608042988620809945&selectedindex=91&mode=overlay&first=1

Danto writes of one series in particular:

"These depicted screams seem to entitle us to some attitude that they at least express an attitude of despair or outrage or condemnation, and that in the medium of extreme gesture the artist is registering a moral view toward the conditions that account for scream upon scream upon scream. How profoundly disillusioning it is then to read the artist saying, in a famous interview, ... 'I've always hoped in a sense to be able to paint the mouth like Monet painted the sunset.' As if, standing before one of these canvases, Bacon were to say, 'Well, there, I think, I very nearly got a screaming mouth as it should be painted. Damned hard to do.' ... To paint a scream because it is a difficult thing to paint, where the difficulty is not at all emotional but technical, like doing a figure in extreme foreshortening or capturing the evanescent pinks of sunrise over misting water, is really a form of perversion. ... As humans, however, we cannot be indifferent to screams. We are accordingly victims ourselves, manipulated in our moral being by an art that has no such being, though it looks as if it must. It is for this reason that I hate Bacon's art."[2]

If I can suggest what I think is at stake here, one might say it is different conceptions of knowledge, of the kind of truth the artist designs to depict. And here is where Mormon theology makes an implicit argument for privileging—in fact, for recognizing—one specific kind of knowledge. Mormons seldom allude to God's omniscience—in fact there is dispute as to whether or in what sense our God is possessor of all knowledge. I want to suggest that we are right to be suspicious of the connotations, if not actual denotation of the term. By the connotations, I mean imagining an objective posture, transcending all subjectivity, devoid of any bias or point of view.

The great theologian Dietrich von Hildebrand explains how what he calls the hypertrophy of intellect poses a similar problem on the human scale. When knowledge *about* an object eclipses knowledge *of* an object, knowledge that is predicated on an appropriate *response* to another. "Those people do not really live who can neither love nor experience real joy, who have no tears for things that call for tears, and who do not know what genuine longing is, whose knowledge, even, is deprived of all depth and real contact with the object." Such objectivety, he continues, "fails to conform to the real features and meaning of the cosmos."[3]

Philosopher Thomas Nagel makes the same point, that subjective knowledge is the only knowledge there can ever be of an experienced reality, in his famous essay on "What it is Like to Be a Bat." "Whatever may be the status of facts about what it is like to be a human being, or a bat, or a Martian, these appear to be facts that embody a particular point of view. ...It is difficult to understand what could be meant by the *objective* character of an experience, apart from the particular point of view from which its subject apprehends it. After all, what would be left of what it was like to be a bat if one removed the viewpoint of the bat? ...Certainly it *appears* unlikely that we will get closer to the real nature of human experience by leaving behind the particularity of

our human point of view… If the subjective character of experience is fully comprehensible only from one point of view, then any shift to greater objectivity—that is, less attachment to a specific viewpoint—does not take us nearer to the real nature of the phenomenon: it takes us farther away from it."

In a similar vein, Teppo Fellin et al. make the argument that it is perspective that actually constitutes, rather than delimits, knowledge. All *"organisms operate in their own "Umwelt" and surrounding…. Perception and vision are species-specific, directed, and expressive,"* not *"singular, linear, representative, and objective." There is no "unique, all-seeing vantage point for perception; … Perception necessarily originates from a perspective, or point of view."* All perception, in other words, is "directed perception."[4]

I give these examples to suggest the sense in which an imagined non-perspectival omniscience would encompass no meaningful knowledge at all. For instance, consider this unsettling speculation from the realm of conventional theism that follows logically from a conventional view of omniscience: One scholar argues that, from the perspective of God, the "laws of physics governing our universe are extremely mathematically elegant and beautiful." And "while humans would prefer that the world contain less evil that elegance, . . . God might have a much greater appreciation of the laws of physics." God, from his omniscient perspective, would thus see human suffering as an "inevitable trade-off" for mathematical beauty.[5]

By contrast, I want to argue that what conventional theism sees as limitation in the Mormon case, is in actuality the only fullness of knowledge that is either possible or desirable. An eternal (Mormon) God, who is located in time and space, with particular values, ideals, and projects, and who would always see something "particular" in a given circumstance, who would always be on the inside—not as a kind of ineffable Immanent, but as a being thoroughly imbricated in relationship. And that is the kind of experiential knowledge we are called to emulate. In Restoration scripture, when Enoch approximated God's eternal perspective, his ascension was not experienced as an objectified omniscience. He experienced what Solomon experienced—an *enlarged heart*. His relational situatedness in the vortex of human lived reality was amplified, not distanced. "His heart swelled wide as eternity." This may be the sense in which, as Dorothy Sayers writes, a work of creation is always a work of love.[6] So I offer that discussion as one instance of how I imagine Mormon theological commitments should inform our approach to artistic culture.

PART 2. OF MORMON ART AND CULTURE

Nothing is more indeterminate," wrote the great German philosopher Johann Gottfried Herder, "than this word [culture]." Frederick Barnard points to Herder's observation that a people "may have the most sublime virtues in some respect and blemishes in others . . . and reveal the most astonishing contradictions and incongruities." Therefore, Barnard writes, "a cultural whole is not necessarily a way of referring to a

state of blissful harmony; it may just as conceivably refer to a field of tension."[7]

A field of tension seems a particularly apt way to characterize Mormon culture. It may be that all systems of belief rooted in the notion of a God who dies have, as Chesterton suggests, "a collision and a contradiction" at their heart.[8] Yet Mormonism, a system in which Joseph Smith collapsed sacred distance to bring a whole series of opposites into radical juxtaposition, seems especially rife with paradox—or tensions that only appear to be logical contradictions. I see these paradoxes as destabilizing in the best of ways, as providing the catalyst, the energy, for perpetual self-examination and healthy discontent. Mormonism is profoundly agonistic—this is its single most important adaptation from the Romantic culture of its inception; the turn from medieval and neo-Classical stasis to Romantic dynamism was most economically captured by William Blake, who said simply, "without contraries, is no progression." So one premise that I would assert as integral to any conceptualizing of Mormon culture, or a Mormon aesthetic—is that it is at its heart an immersion in irresolvable contraries. And like Wordsworth in his magnificent "Intimations Ode," which we quote for all the wrong reasons, Mormonism at its best celebrates precisely those points of indeterminacy and friction, what the poet called "obstinate questionings Of sense and outward things, Fallings from us, vanishings; Blank misgivings," and "shadowy recollections." Mormonism does not take refuge in facile resolutions. This is as it should be. Emerson wrote of art that "Our music, our poetry, our language itself are not satisfactions, but suggestions..... Unluckily, ... the main attention has been diverted to this object; the old aims have been lost sight of, and *to remove friction has come to be the end.*" (again, I would note parenthetically, it is this discomfort with cognitive dissonance that is at the heart of secularism's faith crisis).

Mormonism is rich in paradoxes: I have identified some of the more prominent as *searching vs certainty*, authority vs individualism, innovation vs syncretism,—but I will illustrate their relevance for cultural production with two in particular; *the sacred and the banal* and *Eden and Exile.*

Regarding the first: Mormonism's key heresy is not, I am convinced—as a matter of both theory and historical fact—in any particular articles of faith. Mormonism's heresy is in the concrete particularity of the content of that faith. Let me illustrate with a personal experience. I had a colleague at the University who was extremely hostile toward Mormonism. Upon my pressing him to explain his reasons, he posed the following question: "Do you Mormons really believe that a million years from now you will be creating worlds and peopling them with your posterity?" I said I would answer him if he answered my question first: "What will *you* be doing one million years from now?" "Growing in the grace of Christ!" he responded. "No," I persisted. "One millions years from today, on the evening of June 30, if I knock on your heavenly door, what will I find you doing?" After a moment, all the air went out of his sails. "I see your point," he conceded. "Anything I say would sound absurd." That was for me a moment of privotal

insight. It is not the content of Mormon belief that is the source of provocation and allegations of blasphemy. It is the specificity, the concreteness, of our truth claims.

Protestantism, as Charles Taylor notes, thoroughly disenchanted the world. Mormonism moved in the opposite direction. It collapsed sacred distance not by eliminating the transcendent, but by infinitely expanding the imminent. It is important, I think, for us to recognize that this is what is at work in the story I told about my colleague. This re-enchantment of the quotidian represents the most fundamental conceptual divide between Mormonism and the modern world—of secularism but also of the Protestant West. This is why LDS art, at least, LDS religiously themed art, cannot entirely adopt the world view of Catholic or Protestant. Let me illustrate with two suggestive pieces that I think reflect what is at stake here.

(See Gianlorenzo Bernini, *The Ecstasy of Saint Teresa*, 1647-1652, Cornaro Chapel, Santa Maria della Vittoria, Rome)

https://www.bing.com/images/search?view=detailV2&ccid=utUu7H-bR&id=BEBAEEBB57D204AC7D77643704C607C67184BC22&thid=OIP.utUu7HbRHYMRTVB2XEgXzgEsDh&q=Ecstasy+of+Saint+Teresa&sim-id=608010175049237589&selectedIndex=11&ajaxhist=0

The immediate challenge of rendering the sacred in Mormonism is this: we can revert neither to winged angels or rapture in the face of the ineffable. Mormonism resists the interiorizing or psychologizing of religious experience as a cop-out, insiting on the tactile reality of gold plates and heavenly messengers. The grounding of our sacred history in gritty materiality was to early commentators, as to my colleague Gardner, an affront and an outrage. Remarked one sarcastic author of an Illinois gazetteer in 1834:

> Those who are particularly desirous of information concerning the millions of warriors, and the bloody battles in which more were slain than ever fell in all the wars of Alexander, Caesar, or Napoleon, with a particular description of their military works, would do well to read the "*Book of Mormon*," made out of the "golden plates" of that distinguished antiquarian Joe Smith! It is far superior to some modern productions on western antiquities, because it furnishes us with the names and biography of the principle men who were concerned in these enterprises, with many of the particulars of their wars for several centuries. But seriously ...

"Names," "biographies," "particulars"—in such words of reproach Mormonism's critics vividly highlight the religious taboos Smith violated.

Or as another editor jibed, "[these saints] are busy all the time establishing factories to make saints and crockery ware, also prophets and white paint."

So the problem is, how do you collapse sacred distance without going from the sublime to the bathetic; if you strip angels of their wings and God of his immateriality.

Here is one strategy:

(See Tom Holdman, *The First Vision*, 2000, Palmyra, New York Temple of The Church of Jesus Christ of Latter-day Saints)

http://thetrumpetstone.blogspot.com/2011/02/temple-stained-glass-scriptural-scenes.html

This is a striking amalgam, that borrows from stained glass and its resonant, ancient, reverential associations, the aura of sanctity and otherworldliness inherent in the pre-modern age, in order to dampen the presumption of the modern miraculous. Mormonism lacks the mists of history, distance, and ineffability that are markers of the sacred—and so we have brazenly appropriated a medium that is employed to supply them.

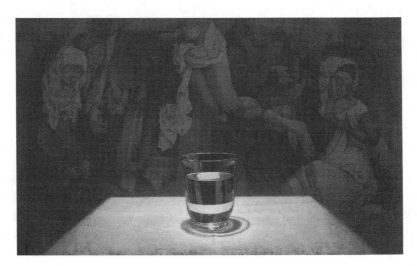

Ron Richmon, *water with descent, 2016*
oil on canvas, 47 x 76 in.
Church History Museum, Salt Lake City, Utah

Another strategy, evident in Ron Richmond's *water with descent*, employs the powerful, suggestive imagery of Mormon sacramentalism, poised against a background of historic Christian crucifixion imagery, to achieve the same effect: the incorporation of Mormonism's modern eruption on the scene into a longstanding Christian narrative.

(See sculpture of Joseph Smith and Oliver Cowdrey receiving the priesthood from Peter, James, and John, Fayette Visitor's Center, Fayette, New York)

http://www.ldshistorysites.com/united-states/new-york/fayette/

Or in this brilliant representation, we have a number of strategies at work. Any do-

mesticating attempt to mythologize, allegorize, or interiorize this account of heavenly visitations is emphatically precluded by the medium. In cast bronze we find a defiant solidity that conspicuously incarnates the farm boy and his colleague in the identical way as the resurrected beings. And yet, there is the slightest hint of celestial mobility and fluidity, and the capture not of an emblematic, static event, but of the moment, in real, moving time with real psychological and emotional valence, that continues unfolding seconds later, locating the historic event in an ongoing continuum that connects directly with—and incorporates—the viewer in its temporal domain. This is no monument to a frozen myth, that forever lingers outside of human time. It allows us rather to see the celestial as it bleeds into and suffuses our own world, and then casually slips out again. Rather like that startling moment in the Book of Mormon, when Nephi says with guileless matter-of-factness, "I returned from speaking with the Lord to the tent of my father" (1 Ne. 3:1).

Let me turn to the second pair of paradoxes—perhaps the most fertile in Mormon art history: Eden and Exile.

A radical theology, emphasizing chosenness and exclusive stewardship over divine truth and authority, a history of persecution and alienation from the American mainstream, together with enormous institutional demands of religious commitment, personal sacrifice, and distinctive religious practices, have welded the adherents of Mormonism into a people who so powerfully identify with one another that one writer did not hesitate to call them the only instance in American history of a people who became almost an ethnic community.[9] Casting all others as "gentiles," and fellow Christians as inheritors of a Great Apostasy, this rhetoric of difference, together with a history of persecution and geographical remoteness, compounded their isolation into a virtue and sign of blessedness.

The quest for Zion was for the Saints a search for Eden—but it was always an Eden in exile. The cost of chosen status appears recurrently in the Mormon psyche as both nostalgia and alienation; and the opposing movement toward integration into the larger world they had fled was fueled by both a longing for inclusion and an imperative to redeem the world. From its earliest days, Mormon converts embraced a sense of themselves as people of covenant, peculiar, chosen. But their art and literature reveal a recurrent unease with such difference. Isolation is often felt as a burden of exclusion and is frequently transformed into a quest for connections and universals.

In her novelistic treatment of this paradox, Virginia Sorensen makes such alienation a general, rather than individual consequence of LDS history and theology. The irony is that a gospel of universal brotherhood, rooted in a commission to proselytize the world, is so marked on every hand by borders, boundaries, and radical difference. In Sorenson's novel, the character Mercy, a pioneer arrived in Utah, notes this existential isolation, and reacts with a powerful nostalgia for connectedness, in an early passage of remarkable poignancy:

as it rose higher, it paled, and presently was the moon she knew. There, that was better. After all, the moon had no right to be different anywhere. Even if a woman came west with her family, looking for home, and everything else changed, the land and the people and the talk even, and living grew to be an intense and difficult thing, she should still be able to look up and see the moon the same.[10]

Like the heroine whose life she chronicles, Sorensen's work maintains a fragile dialectic, trying to skirt the perils of complacency toward one's own culture on the one hand and repudiation of a larger social and cultural identity on the other, fully at home in neither realm. Though acclaimed by critics like Clifton Fadiman and Bernard DeVoto, and praised in the *New York Times*, *The Nation*, and elsewhere, *A Little Lower than the Angels* was condemned by LDS leaders for precisely the same attributes the press lauded. "Poignantly human," opined *Newsweek*'s critic; Joseph and the other characters were portrayed as too "ordinary," complained LDS apostle John A. Widtsoe in a church editorial.[11]

(See William Warner Major, *Brigham Young and His Family*, ca. 1845-1851, Church History Museum, Salt Lake City, Utah)

https://fineartamerica.com/featured/brigham-young-and-his-family-william-major.html

Mormons insist on the need for a gospel restoration, but then feel the sting of being excluded from the fold of Christendom they have just dismissed as irredeemably apostate. (This double-minded self-identifying is blatantly manifest, it seems to me, in this portrait of Brigham Young's family—started in Nauvoo and finished while he was living at Winter Quarters and not in the drawing room of a manor house.) Or in a parallel way, Mormons have long identified their faith with America's providential role in history. Mormon origins, the Book of Mormon as artifact and as history, Church headquarters, the Garden of Eden, and the New Jerusalem—all are identified with a specifically American locale. But in an age of internationalization and global growth, Mormons are necessarily rethinking the limitations and obstacles created by a presentation of the Church as an American institution, and raising the possibility of a church surreptitiously engrafted with at least some expendable and merely accidental local baggage. In their thoughtful and provocative exploration of these distinctions, Mormon artists and intellectuals may be an effective prod in facilitating the transition of Mormonism into a truly international faith.

Let me here illustrate how powerfully conflicted these feelings of exclusion and of chosen status can manifest—not in the production of Mormon art—but in Mormon response to art. Consider this painting, a particularly good work by the artist Danquart Weggeland.

(See Danquart Weggeland, *Gypsy Camp* (*Campsite Along the Mormon Trail*), 1874-1875, Utah Museum of Fine Arts, Salt Lake City, Utah)

http://www.huffingtonpost.com/terryl-l-givens/eden-and-the-ambiguities-of-exile-the-mormon-case_b_2577002.html

This painting was long exhibited as *Campsite Along the Mormon Trail.* But a close look makes very clear these are not Mormons, but Gypsies. And *Gypsy Camp,* is in fact, the painting's original title. The question, is how did viewers make the curious mistake of misidentifying the subject, reading themselves into the canvass? Clearly they saw their own story there, of happy exile, making merry in the wilderness, even as they yearned for connection to civilization and longing for life on the other side of the fences cutting them off from familiar comforts and culture.

This next example is a splendid version that embodies both of the paradoxes I have described, the sacred and the banal, and Eden and Exile.

(See C. C. A. Christensen, *Handcart Pioneers' First View of the Salt Lake Valley*, 1890, Springville Museum of Art, Springville, Utah)

http://www.smofa.org/uploads/files/248/SMA-Fourth-Grade-Lesson-Plans.pdf

C.C.A. Christensen's work has been published in *Art in America* (May-June 1970), exhibited in the Whitney Museum of American Art (1970), and is omnipresent in Mormon chapels, office buildings, and homes. His canvasses' hard edged primitivism accentuates with a kind of earnest pathos the rugged theme of pioneer triumph over adversity in its many forms. His *Handcart Pioneers' First View of Salt Lake Valley* (1890) is entirely typical in its perfect figuring of Mormon religiosity as gritty physical work. Family groupings surround two heavily laden handcarts, both pulled jointly. Proximate working hands are echoed by the entwined hands of children. Community—of family, pioneer companies, and the New Zion, is the dominant theme—accentuated by the emptiness of the world they are about to enter. Attaining the steep mountain summit, a triumphant couple raise hands in a jubilant gesture—but the blue sky at the apogee is no heavenly realm crowning their climb up Mount Purgatory. Zion and repose both wait upon their descent back down into earthy life and labor. It would be hard to more pointedly depict the collapse of yearning for transcendence and the heavenly city into the holiness of the prosaic.

(See Brian Kershisnik, *She Will Find What Is Lost*, 2012, Cris and Janae Baird, Arlington, Texas)

http://www.kershisnikprints.com/index.php?route=product/product&product_id=84

I am particular fond of these works by Brian Kershishnik because they move us in a rendering of community that is a uniquely Mormon version of the invisible church.

The first grouping of boisterous wingless heavenly throngs could be relegated to outlier status in the genre of angelic depictions, but the second version is harder to explain as emanating from anything other than a particularly Mormon obliviousness to the veil, as a delimiter of communion and familial interaction.

Let me explain what I mean by pointing to a historical development that makes my case for me. In England, the first—and still Catholic—version of the Book of Common Prayer included this lovely petition over one who had died:

"Graunte ... that at the daye of judgement his soule and all the soules of thy electe, departed out of this lyfe, may with us and we with them, fully receive thy promises." But wishing to shun every vestige of Catholic reaching beyond the grave, Thomas Cranmer decided such prayers "smacked of the old religion in which the living could perform religious acts on behalf of the dead," in one scholar's words.[12] Calvin agreed that even "commending [the dead] to his grace" was unscriptural and inappropriate.[13] Three hundred years later, Protestants were still hostile to any gestures that suggested living Christians could influence the disposition of the departed. And all Protestants had been united in rejecting purgatory. As Calvin's biographer notes, "There is, for Protestants, only heaven and hell," and the disposition to one or the other was final.[14] But if, as apostle James Talmage pointed out crucially, the LDS faith envisions "the possibility of a universal salvation,"[15] then that universalism must find a way to include the vast billions of the uncatechized within its orbit, and in Joseph's language, "*save our dead together with us.*" And so Mormonism developed a theology of the period between mortality and final judgment where evangelizing continues, in a process that encompasses the living and the dead with little regard for boundaries between the two. And the permeability of that membrane radically reshapes the nature of human Interdependence. And for Mormons, it utterly defines the nature of a celestial sociality, of which we are already a part.

"The need for communality [in our] worship is the chief torment of man," Dostoevsky wrote. He was never more wrong. Mormon art tells us at least that much.

ENDNOTES

[1] Parley P. Pratt, "Materiality," *The Prophet* 1, no. 52 (24 May 1845), reprinted in Millennial Star 6.2 (1 July 1845): 19-22.

[2] Arthur Danto, "Francis Bacon," *Embodied Meanings: Critical Essays and Aesthetic Meditations* (New York: Farrar, Straus & Giroux, 1994), 100-01.

[3] Dietrich von Hildebrand, *The Heart* (South Bend, IN: St. Augustine's Press, 2007), 56, 48.

[4] Teppo Fellin, Jan Koenderink, Joachim I. Krueger, "Rationality, Perception and the All-Seeing Eye," *Psychonomic Bulletin & Review* (11 October 2016), 23.

[5] Don N. Page, "The Everett Multiverse and God," cited in Kirk Lougheed, book review of *God and the Multiverse: Scientific, Philosophical, and Theological Perspectives, Faith and Philosophy* 32:4 (October 2015): 481-82.

[6] Dorothy Sayers, *The Mind of the Maker*, London: Methuen, 1941), 104.

[7] Barnard, "Culture," in *Dictionary of the History of Ideas*, ed. Philip P. Wiener (New York: Scribner's, 1973), 1:618..

[8] Gilbert K. Chesterton, *Orthodoxy* (New York: John Lane, 1908), 50.

[9] Thomas O'Dea's claim is paraphrased in Dean L. May, "Mormons," *Harvard Encyclopedia of American Ethnic Groups*, ed. Stephan Thernstrom (Cambridge, Mass.: Harvard University Press, 1980), 720. As early as 1954, O'Dea refers to the Mormons as a "near nation," an "incipient nationality," a "subculture with its own peculiar conceptions and values," and "a people." See "Mormonism and the Avoidance of Sectarian Stagnation: A Study of Church, Sect, and Incipient Nationality," *American Journal of Sociology* 60.3 (November 1954): 285-93. Later, he would say "the Mormon group came closer to evolving an ethnic identity on this continent than did any other comparable group" [my emphasis]. *The Mormons* (Chicago: University of Chicago Press, 1957), 116.

[10] Virginia Sorensen, *A Little Lower Than the Angels* (New York: Knopf, 1942 [repr. Salt Lake City: Signature, 1997]), 4.

[11] Mary Lythgoe Bradford, "Preface" to Sorensen, *A Little Lower* (1997), x-xi.

[12] The Book of Common Prayer, 1549 edition, http:// justus.anglican.org/ resources/ BCp/ 1549/ Burial_ 1549.htm; Mark Chapman, *Anglicanism: A Very Short Introduction* (New York: Oxford, 2006), 26.

[13] Bruce Gordon, *Calvin* (New Haven, CT: Yale University Press, 2009), 255.

[14] Gordon, Calvin, 336.

[15] James E. Talmage, *The House of the Lord* (Salt Lake City, UT: Deseret, 1971), 54.

PAUL L. ANDERSON

SACRED ARCHITECTURE AND THE WIDOW'S MITE: AESTHETICS, ECONOMICS, AND CULTURAL ADAPTATION IN LDS TEMPLES, 1967-2017

In 1973, the year after the Ogden Utah Temple had been completed, I was in Utah after finishing my architecture degree on the east coast. I had seen pictures of the unusual Ogden building in Church publications, and had decided that it was a new low point in Mormon architecture. I made plans to go see it in person, expecting to have my negative preconceptions reinforced. Arriving at the temple, I saw pretty much what I expected, but inside, in spite of myself, I had a surprisingly good experience. The temple workers were friendly and welcoming—one complimented me on my beard, which a few other Utahns had seen as a sign that I had become a dangerous hippie. I even liked the incongruous escalators carrying people dressed in white like angels floating up and down between levels of heaven. I left the building with an unusually good feeling, convinced that whatever I thought of the architecture, the Lord had accepted it and His spirit was there. Driving south on the highway I looked up at the Wasatch Mountains and thought that the creator of that vast landscape must think that my ideas of good and bad architecture were like two-year-olds arguing about who had made the best castle in a sand box.

However, this fleeting experience of insight and humility did not stop me from embarking on a career of making judgments about the merits of works of art and architecture. Even while trying to avoid unnecessarily harsh criticism, I realized that any praise of outstanding works in these fields naturally implied that the general run of other works, created with the best of intentions, lacked some of their artistic power and sophistication. In this paper about temples, I hope that I can call attention to things that are "lovely, or of good report, or praiseworthy" while respectfully analyzing things that appeal to me less.

When Elder Spencer W. Kimball delivered his 1967 BYU talk on the arts in the Church, there were thirteen operating temples. The Ogden and Provo Temples were completed in 1972, and when Elder Kimball became President of the Church in 1974, one of the first major events of his presidency was the dedication of the Washington

DC Temple, the sixteenth in the Church. When the *Ensign* published the edited version of his BYU talk in 1977, the temple count remained at 16, although several new temples were nearing completion. Neither his 1967 talk nor the 1977 published version, which called for great new achievements in art, literature, and music, specifically mentioned architecture—there were no calls for a Latter-day Saint Christopher Wren or Frank Lloyd Wright—although they did quote an inspirational paragraph by American architect Daniel H. Burnham. Perhaps it is not reading too much into the talk to suggest that great architecture might be one of the arts to be cultivated in our culture.

Since the number of temples in the Church grew more than ten-fold in the subsequent fifty years, from 13 to almost 160, the design and construction of beautiful temples would seem to have been one of the greatest opportunities to realize President Kimball's vision.

Of course, building temples around the world is a complicated process, involving economics and cultural adaptation as well as aesthetics. Church leaders and managers have sought to control expenditures in order to stretch the Church's finances—our widow's mite—to serve as many people in as many places as possible. Looking back on the last five decades, it is not difficult to see the tension between building temples that meet the members' expectations of splendid surroundings for the most important spiritual events of their lives, and the Church's need to avoid unnecessary extravagance.

The fundamental questions of what a Mormon temple ought to look like and how it should function had been mostly resolved in the years before Spencer W. Kimball's presidency. In their exterior appearance, three basic prototypes had been developed.

The first of these prototypes was the simple rectangular box with a tower in front. I will call this the Front Tower Type. Church Architect Edward O. Anderson and President David O. McKay developed this architectural form as they worked on plans for the Swiss Temple in the early 1950s. This was the first of several attempts to make a modest sized and inexpensive temple for an area with relatively small membership. According to the architect, this simple design was based partly on the precedent of the one-towered St. George Temple, although single-towered churches are common in many Christian denominations.[1] A variation on this prototype added wide low wings to the sides of the main façade, like the São Paulo Temple. A more recent example is the Oquirrh Mountain Utah Temple, completed in 2009 (ill. 1).

The second prototype was a stack of large and smaller boxes with a tower in the center. The Idaho Falls and Oakland Temples were examples of this type. This was a particularly appropriate shape for a building that would be seen equally from all sides, with less emphasis on a front façade. I'll call this the Center Tower Type. Another example is the Madrid Spain Temple, completed in 1999 (ill. 2).

The third general prototype was a long box with towers at both ends. This building shape could evoke the many-spired Salt Lake Temple—as the Washington DC Temple

ill. 1 Oquirrh Mountain Utah Temple
photograph by Paul L. Anderson

ill. 2 Madrid Spain Temple
photograph by Paul L. Anderson

quite consciously did. Or it could resemble the Logan or Manti Temples with a single tower at each end, like the newer temple in Brigham City, completed in 2012 (ill. 3). I'll call this the Multiple Tower Type.

The exterior design of LDS temples over the last fifty years can be seen as nearly 150 attempts to create well-proportioned and somewhat distinctive versions of one of these three prototypes. Although this limited menu of temple designs gives limited scope to the creativity of temple architects, it does guarantee that Church members will recognize them as temples and Church leaders will find them acceptable and consistent symbols of our faith.

The idea that newer temples should all be crowned with a gilded statue of the Angel Moroni became firmly established early in President Kimball's administration with the approval of an angel-topped design for the Jordan River Temple in 1978.

The basic interior arrangement of modern temples had also been mostly established under President McKay. The use of a filmed presentation of the endowment, a dramatic break from the live theatrical presentations of the past, began with the 1955 Swiss Temple where accommodating multiple languages was a major consideration. A single sacred cinema room replaced the series of palatial muraled ordinance rooms of the past. The 1964 Oakland Temple had two theaters flanking the celestial room to allow two endowment presentations at the same time, while the 1972 Ogden and Provo Temples grouped six ordinance rooms around a central celestial room. A later development of this plan added another room—a veil room—between each ordinance room and the celestial room, making a three-room path through the temple instead of just two. Architecturally, this allowed the projection screen to be the focus of the first room, and the veil to be the focus of the second.

One of the design challenges of the multi-media temples was how to make the windowless ordinance rooms, where temple worshippers would spend most of their time, interesting and beautiful. In contrast to the grandeur of ordinance rooms in historic temples, these theaters could seem dull and even claustrophobic.

The reintroduction of murals to ordinance rooms beginning with plans for the Nauvoo Temple in 1999 (although first completed in the Columbia River Temple in 2001) seems to me to be one of the most significant improvements in the aesthetic and spiritual quality of modern temple interiors. For Nauvoo, BYU art professor Frank Magleby led a team with five well established Utah Valley artists on the Nauvoo project. The reappearance of temple murals has provided opportunities for many artists to participate again in the enrichment of these sacred places, generally evoking the beauties of the temples' unique geographical settings, much like the Terrestrial Rooms of earlier temples. In recent years, temples have also been ornamented with increasing numbers of framed original paintings by contemporary artists, mostly scenes from the scriptures and church history or local landscapes. At least one artist, Frank Magleby, was called on a mission to produce paintings for temples, and distinguished Utah painter Valoy Eaton

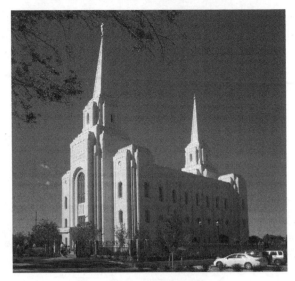

ill. 3. Brigham City Utah Temple
photograph by Paul L. Anderson

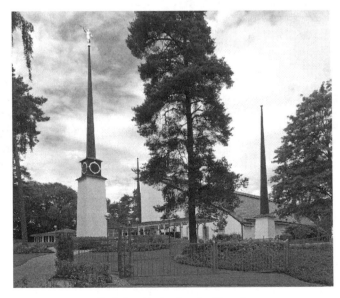

ill. 4. Stockholm Sweden Temple
courtesy of Creative Commons Attribution-Share Alike 4.0 International

volunteered to donate twenty-four original paintings over a period of six years.[2] I am glad to see more original art in our temples, and hope that a wider range of inspirational art may be acceptable in the future. Decorative glass in geometric designs or scriptural scenes have also become common features in temple interiors.

Tracing the development of temple architecture over the past five decades, it is possible to see a pendulum swing between impressive, rather opulent buildings intended to be landmarks in their communities, and more modest, almost minimal buildings, intended to provide temple blessings in many places on a much smaller budget. One swing of the pendulum to the side of economy took place under President Kimball. In 1980, austere standard plans for temples in three different sizes were published by the Church for use in ten places, including Atlanta, Sydney, and Santiago.[3] These designs had no towers and not much religious character. As evidence that the pendulum might have swung too far, two years later, before any of these temples were completed, it was announced that all would have towers after all, making them examples of my first prototype—the Front Tower Type.[4]

The same year, a new temple design team including architect Leland A. Gray began working on a new standard plan in two sizes. These were to be one-story structures, and the larger version was to cost no more than 1-1/2 times the budget for a stake center.[5] The surprisingly original new plans tried to give the small modern temples some of the character of the Salt Lake Temple with three freestanding spires at each end of the steep-roofed structures. These could be seen as a version of the third prototype—the Multiple Tower Type. While the larger version in Boise, Chicago, and Dallas were considered to be too small in their support facilities, requiring additions with larger laundries, dressing rooms, and cafeterias soon after completion, some of the smaller temples were considered more satisfactory, partly because of the modest demands placed on them in areas with fewer members. The prominent roofs provided an opportunity to adapt to local building traditions—the roof could be red tile in Latin America, blue tile in Taiwan (the traditional Chinese color for temple roofs), and gray slate in South Africa. Perhaps the most successful variations on this plan were made by a distinguished non-LDS architect in Sweden, John Sjostrom, who transformed the six spires to resemble the free-standing bell towers of rural Swedish churches, and gave the facade elegant proportions, a traditional Swedish stucco surface, and round "rose" windows (ill. 4). Inside there were fine Scandinavian furnishings and accessories, as well as some traditional stenciled decorations. Built using Swedish materials and construction methods, although it was probably the most beautiful of these standard plans, it was also the least expensive to build.[6]

To improve the support spaces in the larger six-spired temples, a modified multi-story plan more than four times as big was developed to be used in Oregon, Nevada, and California. The first of this group to be completed, the Portland Oregon Temple, was a gleaming white building set among evergreen trees. Its six spires were integrated into the

ends of the building, and various symbolic elements drawn from nineteenth-century temple-building traditions were part of its design.

The most monumental building in this group was built in San Diego and designed by a distinguished local LDS architect, William Lewis. Its two towers were large enough to enclose a grand staircase on one end and a celestial room on the other. Expansive walls of ornamental translucent glass filled the temple with natural light—a relief from the mostly windowless temples of recent years. They also gave a transparency to the exterior that seemed open and friendly. Ironically, this impressive, monumental, expensive building had grown out of the standard plans that were developed just a few years earlier to save money. Sitting on the edge of a freeway and surrounded by commercial development, the San Diego Temple was a prominent landmark. With tongue in cheek, a local newspaper critic wrote that its location proved that Mormons did not believe in "separation of Church and Interstate." Although its somewhat fantastical towers were controversial in the Church and the community, the temple's powerful image appealed to some. Former San Diego City Architect Mike Stepner said that the temple provided just what the city needed—a "signature building on its northern border" to "let you know this is San Diego and not San Clemente or Mission Viejo."[7]

The 1990s saw the construction of several more large temples, including the central-towered Bountiful, Mount Timpanogos, and Madrid Temples, examples of the second prototype. The Preston England Temple and Boston Temple, with a single front tower, were examples of the first prototype.

The pendulum swung again in the direction of economy in the late 1990s when President Hinckley announced a program of building even smaller temples. Designed in two sizes of 7000 or 11,000 square feet, they were either half or two-thirds the size of the very small Stockholm Temple. More than thirty of these mini-temples were built in some haste leading up to President Hinckley's deadline for 100 total temples by the end of the year 2000. The buildings were quite similar to each other architecturally, with vaguely classical cornices and a tower on a not-quite symmetrical roof. A few of these buildings had special decorative features, like the ornamental windows in the Palmyra Temple that recreated the nearby Sacred Grove. One exception to this general uniformity was The Hague Netherlands Temple designed by notable non-Mormon Dutch architect Albert van Eerden. It is a crisply modern version of the plan with horizontal lines all around the exterior stonework. These very small plans are no longer being built, and several of them have been scheduled for remodeling and expansion.

Since 2000, the Church has built a variety of larger temples throughout the world. The three prototypes developed more than fifty years earlier still seem to provide the current menu of possibilities, although creative variations have been seen in many places. For example, the impressive temples in Rexburg, Idaho and Manaus, Brazil have a single front tower; buildings in Panama City, and Kyiv, Ukraine have a center tower; and

temples in Brigham City and Kansas City have two towers each.

One of the most interesting developments in recent temple design has been a shift toward inclusion of architectural elements of various historical styles. New Yorkers are familiar with this design direction from the Manhattan Temple interiors in a late Victorian mode, carefully imitating even some of the quirkier details of the Salt Lake Temple. During a 2011 devotional at Brigham Young University-Idaho, Thomas E. Coburn, Managing Director of the LDS Church Temple Department, explained that church president Thomas S. Monson and the church's temple department were beginning to construct temples according to the "timeless" and "classical" designs of the cultures and people they will serve, citing the recently published architectural rendering of the Philadelphia Pennsylvania Temple as the first of many examples.[8]

This shift towards historicism is not unique to the Church. American public buildings in updated versions of historical styles have become more common in the last two decades, and even some major architecture schools, once the implacable fortresses of modernism, have begun to tolerate and even encourage such design directions.

In early 2009, the Church retained Perkins and Will, a very large and prestigious architectural firm with a distinguished history going back to 1935, to begin planning a temple on a site in downtown Philadelphia. This firm produced a handsome modern design with a single tower. When Church leaders reviewed this design for approval, they sent it back, asking for something more attuned to the historical architecture of the city. Roger Jackson of the Salt Lake firm FFKR, who had worked on several previous temples including Nauvoo, was invited to provide a different exterior design with two towers and many Georgian and Federal style elements drawn from notable Philadelphia buildings (ill.5). The Church leaders gave it their approval. Moreover, the city landmarks committee loved it and asked the architects to pass on their thanks to the Church for creating "a noble building" in their community. Perkins and Will and FFKR continued working together on many aspects of the building, particularly the elaborate and beautiful interior details.[9] The building was completed and dedicated in 2016.

Another interesting recent temple with historicist leanings is in Tijuana, Mexico, with Salt Lake architect Allen Roberts of CRSA Architects as principal designer of the exterior (ill. 6). While the project started as a slight modification of an existing plan, some practical problems, including building code requirements, obliged the architects to make substantial changes and opened the way for an original design.[10] Although the basic plan is of the central-tower type, the architects gave a distinctly Hispanic appearance to the building, drawing on historic Mexican and Spanish colonial architecture, particularly the spectacularly beautiful nineteenth-century mission church of San Xavier del Bac near Tucson, Arizona. The interior architectural details, such as railings, doors, and other woodwork, and the furnishings evoke Mexican or Southwestern styles. The murals seem to recall the Baja landscape, including the lovely sea coast. Because security

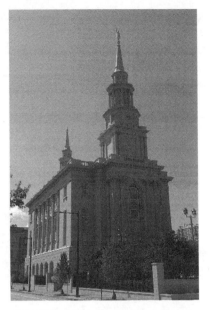

ill. 5. Philadelphia Pennsylvania Temple
courtesy of Creative Commons Attribution-Share Alike 4.0 International

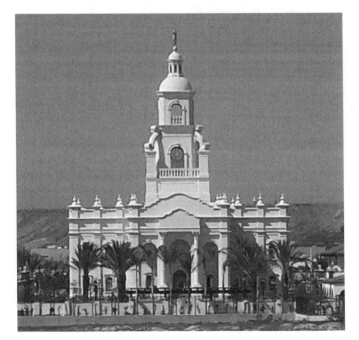

ill. 6. Tijuana Mexico Temple
courtesy of Creative Commons Attribution-Share Alike 4.0 International

is an important issue in Tijuana, the architects incorporated additional missionary and temple worker facilities next to the temple in a traditional hacienda plan, with the buildings opening inward toward a peaceful plaza with a fountain, and the backs of the buildings helping to provide an attractive but sturdy wall against the outside world. The whole compound, including parking, is seriously fenced and entrance is controlled from a guardhouse. The result is a harmonious collection of buildings in a secure retreat.

A half-century after President Kimball's visionary address on the arts in the Church, we might ask how far we have come in temple design. While it seems unlikely that we have yet produced a temple that will find a place in future histories of American or world architecture, some will no doubt merit mention in local or regional architectural histories, if only for their size and prominence. However, it seems to me that the best of our temples today are far more interesting and varied in their exterior design, more sophisticated in their response to local traditions, and more richly adorned with inspiring art and appropriate furnishings than the temples of the 1970s. Perhaps President Kimball would take some satisfaction in that.

ENDNOTES

[1] Edward O. Anderson Oral History, interviewed by Paul L. Anderson, December 1973, Salt Lake City, Utah, The James Henry Moyle Oral History Project, LDS Church Archives.

[2] Telephone conversation with Valoy Eaton, September 19, 2017.

[3] "Church Launches Worldwide Temple-Building Emphasis with Announcement of Seven New Temples," *Ensign*, May 1980.

[4] "New Temples Combine Beauty, Efficiency," *Ensign*, March 1982.

[5] Interview with Leland A. Gray, February 28, 2017.

[6] Interview with Leland A. Gray, February 28, 2017.

[7] Tony Perry, "Mormon Temple Rises Above Ordinary," *Los Angeles Times*, January 4, 1993.

[8] Thomas E. Coburn, "President Thomas S. Monson: Taking Temples to All the World," Brigham Young University-Idaho Devotional, September 20, 2011, cited in Wikipedia, "Temple architecture (LDS Church)," retrieved 2012. This quotation does not appear in the BYU-Idaho website in 2017.

[9] David Brussat, "Credit for temple in Philly" in *Architecture Here and There*, August 12, 2016, includes an extensive account of Philadelphia Temple design process submitted by Roger Jackson, architecturehereandthere.com

[10] Interview with Allen Roberts, June 2017.

CAMPBELL GRAY

Is It Possible?

Throughout President Kimball's two essays[1] there are two principal ideas: First, that a noble, spiritual teacher (or artist, or scientist, or inventor, or doctor, etc.) who lives by faith, dependent upon the Spirit and whose professional practice is authentically consistent with spiritual practice, will have a substantial advantage in achieving success in their field when compared with those whose lives are otherwise. The second idea is somewhat related: that a point will be reached, perhaps in the artist's aptitude and in the process of time, when the expressions of such people will be influential among audiences that are much wider than the Church community—perhaps the global community of peers, receivers and critics. In speaking to educators in the first essay and artists and the general Church membership in the second, the bold declaration is that it is not a matter of waiting for the context to change so that our work will be appropriately received. It is a matter of focusing our artistic efforts in such a way that the context as it is will both receive them and respect them. In President Kimball's rhetoric, each of the arts effectively practiced by Mormons, has the potential to stand at the forefront of its disciplinary field, and at the same time inspire to higher levels audiences well beyond the Church community.

Generally speaking, this condition has not been achieved by Mormon visual artists. It is true that artists such as Minerva Teichert and C.C.A. Christensen have received a degree of American art historical recognition[2], however it could be argued that the nature of this recognition is somewhat peripheral to mainstream American art historical discourses. Their work has not been broadly influential and I suggest that neither have fulfilled President Kimball's vision. Perhaps the Mormon artist who has come closest to the vision is Joseph Paul Vorst (1897-1947), whose presence and work Glen Nelson introduced to this generation in the recent Mormon Arts Center Festival symposium (June 29, 2017) (see pp. 80-89 in this volume). Clearly Vorst occupied a notable place in regional, if not national American art history as a social realist who explored the difficult conditions of American life in the years leading up to and through the Great Depression, and on to the Second World War. His work was collected and exhibited by significant national institutions, however unlike two or three of his peers, Vorst's work fell out of the published discourses soon after his death and it has been relatively unknown since.

With BYU Provo graduating substantial numbers of Mormon artists each year and others with aspirations of making significant social contributions attending art schools elsewhere, yet none have come to light for their work in anything other than a relatively insular "Mormon" context, one must ask if it's possible to fulfill President Kimball's vision to any substantial degree. Perhaps the two domains of "Mormon art" and secular art by Mormons are dislocated from each other to the extent that we are not aware of great things happening by Mormon artists in a secular context. Regardless, we are left with two principal problems: can faithful Mormon visual artists compete at the most influential levels of contemporary visual art practice without compromise to values and beliefs? and, can faithful Mormon visual artists in this context center their work upon content and ideas that lead viewers toward deity?

It is my contention that Western social conditions currently exist in which a Mormon artist with these kinds of commitments and motivations can fulfill President Kimball's vision. Indeed, it is my contention that this can be achieved without a requirement to conform to any particular external expectation other than applying deep thought, analysis and creativity in constructing intelligent visual theses. In order to understand these current social conditions and recognize the opportunities that exists, it is valuable to track the principal changes that have occurred in society that lead us to this point in time with the opportunities that exist for Mormon artists.

I will briefly explore two significant sea-changes that have occurred within the past 200 years, the effects of which have produced surprisingly fertile opportunities for artists who aspire to make a difference in society now. Society's forward progress is naturally dynamic and is steadily changing as it goes. But there are times when this natural dynamic accelerates and deepens dramatically for a time, and it seems at this moment that society's apparently stable axis shifts substantially and social conventions change irreversibly.

To clarify the kinds of changes taking place in each of these sea-changes, I will refer to a few examples of works of art that demonstrate the fundamental conditions underlying the changes. I will focus almost wholly on what the work tells us about the role of the artist in society and the social conditions that give context to that performance. I will speak in gross generalities with the subsequent exaggerations that accompany this method of discussion. Nonetheless, this cursory overview will provide an argument that describes these fertile conditions for Mormon artists.

We will begin with this image of *The Lock* by John Constable painted in 1824.

(See John Constable, *The Lock*, 1824, Private Collection)

https://www.bing.com/images/search?view=detailV2&ccid=KH-2lQyr9&id=D62C3A8AA12FF9CF4D95A1C3167D090CC7B6AC-D6&thid=OIP.KH2lQyr9guExbvgFpN4hhwDoEM&q=john+consta-ble%2c+the+lock&simid=608004282316098806&selectedIndex=2&ajax-hist=0

Our eyes naturally go to the man in the painting's centre who is operating the lock. The painting revolves around him—the tree in the background leans in the same direction that he leans, the rope tying the boat in front of the tree points to him, the clouds on the far left swirl back around to the tree on the right framing the locksman, and, against the probability that someone of his social station, engaged in this kind of lowly activity in the early nineteenth century would perhaps wash clothes infrequently, he is wearing clothes of the brightest hue—in order to attract our attention. An axiom occurs here: everything that is seen is intended to be seen, hence it is clear that we are supposed to focus on the locksman. The power of the work's discourse rests primarily with this person.

This is a common person involved in common activities in the highly class-conscious British society of the 19th century. Moreover the painting's tone is one of vitality, contentment and peace. The work speaks of the nobility of the activities of common people. It seems to suggest that this locksman and his place in the broader social structure is as valued as any landed gentry, nobleman or prince. To understand the significance of this message we should observe the fundamental changes that were occurring in society and in art practice at the time.

The western world's kingdoms and principalities had progressed to such an extent that a monarch, or a prince or an aristocratic landowner, could not hold government of their domain alone. Representation from the lower classes was essential to establish the conditions that would enable the monarch's self-sustaining mechanism to continue to advance in a manner that would satisfy her or his ambitions and keep society stable and balanced. The feudal system was fading away quickly. Levels of representation and decision-making by the lower classes steadily increased to the point where the balance of power flipped over and the monarch's previously preeminent powers weakened against the capacity of the lower classes to determine its community's destiny.

In these conditions the concept of nation was born and with it, the idea of a public. A condition that accompanied these births was that discipline of the masses was no longer at the whim and fancy of the monarch and his advisors. The responsibility for discipline and its systems also shifted to the public. Hence a fundamental objective of this new society was the production of the moral, self-governing citizen. Indeed, the production of this condition occupied minds and governments at the highest level and the newly invented, purpose-built art museum was a primary tool in the system of its production.

Along with government being transferred to the populace the role of artist shifted dramatically. The artist heretofore had been regarded as a craftsman. The artist was commissioned by the monarch, the church or the aristocracy to create works the discourses of which were to elevate the commissioner in the social power-structures of the time. The portraits and family groupings demonstrated wealth and social bearing. The grand exotic landscapes and battle scenes demonstrated the commissioner's capacity

to traverse and control the world and to subject adversaries, the portraits of other important people demonstrated important social alliances or social control. Artists, while applying style and perhaps some forms of subversive imagery, were at the mercy of the commissioner.

But with the shift of government to the populace, artists were freed from these shackles and chose subject matter of their own liking and in response to a new emerging market. With the artist's status being that of a commoner, the artist's subject matter naturally focused on their peers and the integrity and value of commoner's lives.

This condition was shortly preceded by a shift in the definition of art and its new relationship with aesthetics. As a craftsperson, the artist's work was valued by its capacity to meet the purposes of the commissioner, not unlike today's kitchen cabinet maker. But increasingly, as the concept of the moral self-governing citizen emerged and interest was given to those human conditions that might generate elevated feelings and behavior among the masses, exposure to and appreciation of beauty was thought to have significant influence on one's comportment – one's inner grace and bearing. Aesthetic theory and principles had been evolving over centuries and at this moment, since artworks were newly seen to have the capacity to convey beauty which in turn increased a person's comportment, aesthetics began to be linked to visual art for the first time. Art emerged within the aesthetic discourse and artists became agents of moral improvement.

Returning to Constable's painting of *The Lock*, this is a radical contemporary work of its moment possessing a highly influential discourse, provocative and relevant to the time. Its purpose (among others) was to enshrine the nobility of labour among the masses, and the value of the lower classes to the entire social scheme. It is no wonder that when it last sold two years ago, it went to auction with an estimate of GBP 2million, and sold for GBP 9.1million.

In summary then:

- The artist, recently freed to select subject matter at will, focused on the nobility and well-being of common labour and activity
- Beauty (aesthetics) is regarded as being an independent quality possessing the capacity to generate increased comportment in the viewer
- Aesthetics is now tied to the work of visual art
- All of the above have a relationship to the development of the moral, self-governing citizen and the stability of publics and nations

These are only some of the evidences of a sweeping sea-change that occurred in western society at the end of the eighteenth and beginning of the nineteenth centuries. Some regard these changes as evidences of the beginning of Modernism. Others point to earlier signs to find its beginning. It is important to remember that all of these condi-

tions occurred within a continuously evolving context—and they weren't going to stand still at that point either.

Once the common classes had obtained the balance of social power, the right of representation was quickly given to the bourgeois sectors of society—the intellectuals and businessmen—those with the most influence. Indeed, it was the bourgeoisie that had affected the change in power in the first place. But the utopian ideal upon which representative government functioned was that the people governed—Abraham Lincoln's "government of the people, by the people for the people."

The longer the bourgeoisie represented the people in government, the more secure they became and the fewer the voices they truly represented. The number of disenfranchised sectors of society steadily grew. This is no better represented than in American real estate or automobile advertisements in 1950's magazines—the white family with two children and a dog, in the front yard of a white painted suburban home with a shiny white vehicle in the driveway, all surrounded by a white fence. One of the distinguishing features of this kind of Modernity throughout its 130 year history is an increasingly reductive approach to theories, practices, people and things. Scientific reductive methods became the model of research and progress. On the one hand this intellectual method gave rise to larger numbers of specializations enabling great discoveries in various disciplines with the consequence that major problems were solved; on the other hand it created mainstreams, dominant theories and practices, which in turn produced disenfranchised sectors in the increasingly widening space outside the mainstreams.

Similar situations had developed in many social practices including the visual arts. Painting dominated, the visual arts were broken apart and competition developed between the art forms with many being disenfranchised. In accordance with scientific practice, each art form increasingly focused on itself and its area of competence. A painter's superiority in society was claimed by knowledge of and adeptness with paint (or the chosen materials) and its capacities. Hence the work steadily withdrew from being concerned with representation of the world and focused more upon the properties and opportunities—the internal relations—that painting possessed. Painting subsequently became increasingly abstract.

(See Morris Louis, *Alpha Phi*, 1960, Tate Gallery, London)

https://www.bing.com/images/search?view=detailV2&ccid=mH-jrQdU8&id=5BA8E6DBDDE84BF7C6CA9FDB828C48287AD-B0835&thid=OIP.mHjrQdU8F_dTzQYLhH6PBQEsCw&q=morris+lou-is%2c+alpha+phi&simid=607989898456990451&selectedIndex=3&ajax-hist=0

It is important to note that abstraction was a consequence, not an objective. The quest was to seek the irreducible essence in painting—its most pure state, because in its purity one would find its power and significance.[3] This was a utopian reductive proj-

ect—the rhetoric suggested that if painting (and anything else for that matter) were to find its most pure form, perfection had been achieved and the painter would hereafter reside in this condition. One prominent theorist eventually declared that flatness was the characteristic that painting shared with no other art form and was painting's irreducible essence.

But if painting was to make no reference to anything beyond itself, it could not ask anything of the viewer who stood outside the work. In other words, if it was entirely internally related and hence wasn't about something, then in principle there was nothing to be learned from it. Indeed, the expectation was that the viewer's eyes were disconnected from the brain and one would simply revel in the work's visuality – it was a purely optical experience without meaning. At the same time, if the work made no reference to anything beyond itself, if it carried no meaning, and thus it could not be compared with any other painting, how would one determine quality which to a large degree, is a comparative process?

The answer is in the nature of the aesthetic experience that one receives from the work. But clearly the aesthetic response to these works was different to the kind of aesthetic response one would obtain from Constable's *The Lock*. No longer is the viewer learning about the dignity and value of everyday work and productivity. No longer is the viewer asked to absorb those kinds of socially noble ideals and hence increase in comportment. The kind of aesthetic response that was to be obtained from these abstract works had also been reduced to an inexpressible quality located somewhere in the work's formal relationships, revealed by the elated cry: "hey man, it works!"

So the late Modernist work is abstract, esoteric, superficial, psychological and ineffable.

Against the backdrop of hegemonic systems of social control being imposed upon the rising number of disenfranchised sectors, firstly the blacks in the southern United States developed unique and powerful strategies of civil disobedience and they began to resist bourgeois expectations of social behaviour placed upon them. Thereafter, students from some key universities who travelled to the southern states to learn these methods, mobilized their peers, and also resisted expectations placed upon them. Further, waves of resistance developed feminists, gays and lesbians, prisoners, and so on, came to the table to declare that governmental representation did not include them, and against the utopian ideology of nationhood – government of the people, by the people for the people—the dominant white bourgeois representatives had no ideological legs to stand on and the structures underpinning government practice began to fall apart. The centre could not hold. And so it was with art.

Of course, once a manifesto is declared, once the utopian ideal is seen to be conceived, the movement is closed and the only open space to explore is elsewhere. The mainstream had become so narrow that the space beyond was vast. The ideological purity of the Modernist project was polluted by the egos and wealth of its primary

protagonists and almost everything about Modernist painting—the works, the artists, their styles, their wealth, and institutional acceptance—was seen to be enclosed within that confined, self-focused, Modernist space.

So the new work reacted to every one of these factors and did not look like anything that preceded it.

(See Robert Morris, *Mirrored Cubes*, 1965, Tate Gallery, London)

https://www.bing.com/images/search?view=detailV2&ccid=tm-CiEXhE&id=37C4CDACE9FAA51E3E5372E6C8381E3D1EB-B87E9&thid=OIP.tmCiEXhEVK35MVmmHxMQ1wEs-Dt&q=robert+morris%2c+mirrored+cubes&sim-id=607990830474791389&selectedIndex=1&ajaxhist=0

Instead of the work carrying the mark of the artist—that sign of status and wealth —it was industrially produced. Instead of it being filled with complex internal relations, it was simple and relied heavily upon its context. Instead of it possessing an ineffable transcendental aesthetic, it rejected aesthetics completely—in fact some called it anti-aesthetic.[4] As Robert Morris declared: "the better new work takes relationships out of the work and makes them a function of space, light, and the viewer's field of vision."[5] Minimalism's primary project was to dismantle the Modernist theory.

(See Art & Language, *Map to not indicate*, 1967, Tate Gallery, London).

https://www.bing.com/images/search?view=detailV2&c-cid=LJsXVPh4&id=020E40DB80C6B3B886F8D121EB36C-F65EE745639&thid=OIP.LJsXVPh4VpgZ7DY2wBjkvQEs-D1&q=Art+%26+Language%2c+Map+to+not+indicate&sim-id=608005759788647539&selectedIndex=0&ajaxhist=0

Hot on the heels of Minimalist theory, another quick attack on Modernist art occurred and in theoretical terms Conceptual Art completed the task that Minimalism began. It has been said that the Modernist path was a continual, reductive procession. Minimalism and Conceptual Art continued that reductive process into physical oblivion: Minimalism eliminated the aesthetic and the hand of the artist and Conceptual Art negated the necessity of the object.

In this work by Art & Language, the image that we see is an incomplete map. It contains the American states of Iowa and Kentucky. One state's scale is true to the other's and the relationship to each other on the page is accurate according to that scale and their relative positions. With these givens, the rectangular line surrounding the two states can be read as an actual line on the earth's surface with coordinates able to be identified accurately for each corner and every point along the lines. The title of the work is *Map to not indicate*, and at the bottom of the diagram a number of geographic and geopolitical features that are not indicated within the rectangle are listed. Our minds quickly act to

fill in the spaces—our imagination "sees" the map forming and completing at least to the extent of locating the features contained in the list. The thing in front of our eyes, then, is a catalyst, a trigger for the creation of the actual work in our minds. Hence the work of art no longer exists in physical space but is a construction of the mind.

In reacting to the Modernist project with such power and economy, the Minimalists gave permission for the mind and the eye to be reconnected and in doing so, they also admitted that everything within the viewer's field of vision influences the viewer's response to the work and the work's meaning. In other words, the eye, the mind and the context in which one is placed are all fundamentally interconnected and inter-influential. And Conceptual Art enshrined those principles in a deeply intellectual and potentially meaningful way. The axiom that emerges from this framework is that the work's concept—its discourse—is paramount. All other strategies function to effectuate the discourse.

In summary:

- The work of art is based in idea / concept / discourse

- It is externally related—the art object is a catalyst for inquiry about a subject

- It is equally interdependent with context—physical, social, political, economic, etc.

- The artist is a researcher, speculator and proposer

- The viewer's eyes and mind are inextricably interdependent

- Everything within the viewer's field of vision influences the work's meaning

- The viewer is a receiver of the discourses hence the art work is a tool of communication

These principles newly located within visual arts theory and practice demonstrated that a fundamental change had occurred. However that change was a symptom of a much broader field of discontent whose momentum was growing across almost all dimensions of western social practice. Many remember and sympathize with the impacts of the Civil Rights movement and all that it taught us about diversity and cultural awareness. We remember the Vietnam moratorium marches and the autocratic way that young people were conscripted to fight in a complicated battle that had little bearing on their lives and the nation, and that in the end, was not won. We remember the contentious legislative discussions surrounding the Equal Rights Amendment proposed to the US Constitution. We remember the broad-scale resistance that was applied to any hegemonic institutional force and in the visual arts, institutions such as the Museum of Modern Art and the Whitney Museum of American Art both in New York City were the target of strikes and picketing against insensitive authoritarian decision-making that ignored the artist's intentions.

While society continues to press for changes that emerge from the legacy of this moment in the late 1960's and early 1970's, it is generally accepted that the fundamental principles underlying social relations have evolved. So too the principles of art theory and practice continue to evolve but only within the principles established at that moment. If concept / discourse is paramount and if the work's intention is to convey meaning, to provoke inquiry and to challenge assumptions about a particular important issue, then every tool and material is open to being applied to that end. Thus every medium, method, arrangement, aesthetic, strategy, etc. is utilized in the exploration of the discourse. The artist is researcher, communicator, provocateur and politician. The artist, via the work asks important questions, challenges conventions and assumptions, speculates on alternative models and behaviours, proposes principles and scenarios, and otherwise rethinks and reimagines circumstances and contexts.

So where does this leave the faithful Mormon artist? In *most* situations images of the Saviour recognizable by beard and drapery, or ones representing historical religious scenes will not be received with respect in secular contemporary art contexts. Works that articulate discourses for which knowledge of religious histories or tenets is essential are likewise unlikely to be received respectfully. Additionally works of art in which the discourse is dogmatic or received as proselytizing are also in the same category. It is important to stress that these are generalized statements. There are circumstances when these forms might be received critically in a secular context, but this depends upon both the situation into which the work is placed and the manner in which the subject is explored.

On the other hand the conditions that heighten a viewer's empathy, that cause one to evaluate moral principles and explore the complexities of human existence and purpose are not uniquely religious in character. Questions that interrogate these issues often challenge conventional thought and open minds to the possibility of other forces at work in society and in individual lives. Intelligent questions posed carefully in the context of broader human paradoxes, that address current issues and important conundrums unsettle viewers and create vulnerability, into which alternative propositions can be placed. Indeed, these terms describe the conditions and aspirations of many contemporary artists. At the same time, these conditions are available to Mormon visual artists to exploit and when considered together they outline a vast universe of subjects, methods and receptions any of which could manifest President Kimball's vision. Moreover, when considering sources of inspiration and knowledge of eternal significance (scriptures, temple ceremonies and covenants, General Conference addresses, the questions we ask in prayer, our deep reflection on gospel principles, etc.), most of it directly addresses the mortal human condition and our journey through life and beyond, our stewardship of the earthly realm, our responsibility to learn and act wisely and our love for our fellow beings, all of which provide profound concepts and paradoxes that are valuable for all humans when considered from the basis of principles. Then, at times, when carefully articulated, directly religious concepts can be explored. Indeed, religiosity itself is a site worthy of interrogation.

There is a fundamental tension in the forces operating upon an artist who is attempting to make a living through one's artistic practice and hence find a "style" and a market that one can rely upon for steady income, and the desire to throw off that responsibility as one's principal motivating force in order to focus on exploring issues and artistic methods of personal importance which may not be immediately marketable. Indeed, art history and contemporary practice contains countless examples of artists who sacrifice the first for the second and struggle to survive through time. Under these forces, and while not being a necessary outcome, the demand for the kind of notoriety that accompanies worldly acceptance can place pressure upon moral values and testimony and we witness artists leaving the Church.

However, there are also many examples of artists who make profound contributions to the field and to society, who have primary sources of income outside their artistic practice and who thus find ways to fund both life and practice. In addition, there is a good number of examples of artists who make equally profound contributions to thought, who are after a time, well received and obtain substantial remuneration for their work. It is my observation that we are not seeing Mormon artists who have successfully negotiated these intellectual and professional spaces. Additionally, I am not convinced that Church sponsored art education programs in particular address these conditions and provide the kind of mentoring and encouragement that would inspire artists to negotiate the territory.

By far the majority of contemporary artists that I know are motivated by their desire for a better world. They are people who are not prepared to merely observe, but who are acting within their capacities to provoke change. Their works have quite significant influence within the field as well as within broader sectors of society. The questions they are raising are important and many of the sources from which these questions arise are inspiring. Apart from the normal challenges, I see no impediment to Mormon artists participating in this context and bringing to it challenging and critical questions that are rooted in Gospel principles and personal faith. The causes that we represent are the most profound and earth-changing that exist. They go to the centre of existence for every human being. Theoretically speaking, I know of no other people than faithful Mormons that could know the human condition and its possibilities better. I know of no other people who might have a more complete perspective of the bitter and the sweet, the conundrums, the paradoxes, and the doubts as well as the stable and grounded nature of faith and the evidences of a bright future. I know of no other people who should understand allegory, metaphor and principle more completely and creatively and hence has the potential to interrogate, provoke and challenge more profoundly. And I believe that a noble, spiritual teacher (or artist, or scientist, or inventor, or doctor, etc.) who lives by faith, dependent upon the Spirit and whose professional practice is authentically consistent with spiritual practice, will have a substantial advantage in achieving success in their field when compared with those whose lives are

otherwise, if they apply their thoughts, research and practice prayerfully, intelligently and openly enough.

ENDNOTES

[1] Spencer W. Kimball, "Education for Eternity," address at the BYU Centennial Convocation, (Provo, 10 October, 1975). Published in *Educating Zion*, (*BYU Studies*, Provo, 1996), pp. 43-63. The last part of this address was republished as "The Gospel Vision of the Arts," in *Ensign*, (The Church of Jesus Christ of Latter-day Saints, July, 1977).

[2] Minerva Teichert was included in *Independent Spirits: Women Painters of the American West 1890-1945*, curated by the Autry Museum of Western Heritage, California, and shown there in 1995-6. Thereafter it travelled to a number of art museums including BYU Museum of Art, Provo, Utah. C.C.A. Christensen's *Mormon Panorama* was shown at the Whitney Museum of American Art, New York, in 1970 after which it travelled to a number of Art Museums in the USA. See also, "A Panorama of Mormon Life," in *Art in America*, (May-June 1970), pp. 52-65.

[3] The principal text that outlines this position is Greenberg, C., "Modernist Painting," *Arts Yearbook*, No.1, N.Y., 1961; reprinted with slight revisions in Art & Literature, No.4 (Spring 1965), pp. 193-201. However, Greenberg's earlier writings explore a number of these conditions as do the subsequent writings of Michael Fried.

[4] See Foster, H., (ed.), *The Anti-Aesthetic: Essays on Postmodern Culture*, (Bay Press, Seattle WA, 1983).

[5] Robert Morris, "Notes on Sculpture: part 2," *Artforum*, (October 1966), pp. 20-23; reprinted in Battcock, G., (ed.), *Minimal Art: a Critical Anthology*, (E.P. Dutton and Co., N.Y., 1968), pp. 228-235, (see p. 232).

KRISTINE HAGLUND

BEYOND "THE PRINCIPLE OF NON-DISTRACTION": A PLACE FOR ART IN MORMON WORSHIP

My title comes from a talk Elder Oaks gave to Aaronic priesthood holders about their comportment while preparing and passing the sacrament.[1] He meant that they should dress and behave in ways that will not draw attention to them, but allow people to focus completely on the ordinance. This seems like wise counsel (although I do wish he had focused more on the priesthood duty to clean and trim fingernails—with my boys, that always required a lot more nagging than white shirts!). But his phrase "the principle of non-distraction" was striking to me, because it reminds me of what seems to be the primary governing idea behind most of our discussions of art, and specifically music, in Mormon worship life.

The text of the guidelines for music in sacrament meeting betrays a peculiar anxiety about the possibility that music may distract from worship and "call attention to itself."

(See *Handbook 2: Administering the Church*, 14.4.1-14.4.4)

https://www.lds.org/handbook/handbook-2-administering-the-church/music?lang=eng#14.4.1

The frequent use of the words "appropriate" and "suitable" suggest that there is a clearly (though never explicitly) defined category of music that belongs in LDS meetings. The repeated instruction that "priesthood leaders," "the bishopric," "the bishop and his counselors" should make decisions about what is appropriate, suggests that they will intuitively recognize what music fits into the category. Implicitly, these instructions enshrine the priesthood leader's judgments as authoritative, rather than suggesting shared aesthetic criteria by which performers and church leaders might evaluate music.

While there are a few positive mentions of the power of music to enhance worship and unify the members of the congregation, the overwhelming sentiment I read here is of anxiety—as if musicians are primarily concerned with wresting authority from the bishopric, or, perhaps, as if music itself is dangerously powerful.

The reasons for this anxiety are deep in both Mormon and Christian history. Like a lot of troublesome bits of Mormonism, our difficulty around art in worship has its

roots in history and its potential solution in theology.

Early Mormons brought practices and ideas about music from many (mostly Protestant) traditions with them into their new faith. Methodists brought positive notions about hymn-singing (and some very fine hymns). Baptists were divided—historically opposed to any singing "with conjoined voices," but having allowed public singing in their assemblies beginning in the mid 18th-century. Sidney Rigdon and his fraction of the Campbellites came from a tradition which encouraged hymn-singing, but disallowed any instruments in the church. Given these traditions, and Joseph's early leaning toward Methodism, the singing of psalms and hymns was not particularly controversial in early Mormonism. However, questions about the propriety of choirs and instrumental music did divide the Saints.[2]

Methodists generally frowned on choirs, and the Campbellites strictly forbade them "as a species of profanity. It is a most unholy thing to learn to sing by a constant repetition of our most devotional songs amidst the levity and blunders of a singing school." Nonetheless, "after some altercation" with his formerly Campbellite counselors, Joseph Smith organized a "singing department" in 1836 in preparation for the dedication of the Kirtland temple. The choir for the Kirtland temple dedication was enormous, numbering perhaps 200-250.[3]

Apparently motivated at least in part by rebellion against the strict tradition in which he was raised, in which even listening to a fiddle was prohibited, Brigham Young encouraged the formation of bands and instrumental societies both in Nauvoo and later in Utah Territory. These groups played for civic events, for funerals, and for church services. The general Protestant anxiety about whether music was a help or a hindrance to righteousness seems to have been decisively resolved in favor of a robust, even boisterous musical culture that extended even into worship services. Music was both enjoyed and admired, and musical education became part of the Utah Saints' efforts towards gentility.[4]

But Mormon musical culture may be, to some degree, a victim of exactly that admiration. The Tabernacle Choir became the Church's best known export, and proved absolutely crucial to the Saints' efforts to establish themselves as Americans after statehood. The choir won accolades at the World's Columbian Exposition in Chicago in 1893, even as church leaders were being excluded from an ecumenical council of churches held in conjunction with the Exposition. The power of music to spiritually move crowds became linked in the Mormon mind with music as spectacle. Directors of the choir were something like celebrities in Salt Lake City.[5] I think it is largely some lingering suspicion about the personal influence of musicians and the relationship of art and spectacle that pervades the current Handbook section on music. But there are other dilemmas hinted at by the Handbook, which also have been present since the very beginning. A text used by the Nauvoo choir school, William Porter's Cyclopedia of Music, lays out concerns that will seem, I think, quite familiar.

The causes of desecration of this sacred service are various…

"Too great fondness for display."

"Extreme jealousy of interference. Singers frequently persuade themselves, that the psalmody is entirely their province."

"The character and pretensions of the chorister."

"Bad taste in the choice of tunes and style of performance. In almost every department of art and science, simplicity is the soul of excellence."

"The inattention of the congregation, who, by their listlessness, appear to regard the time of singing as a season for relaxation, or an intermission, to give them an opportunity of attending to their little private concerns."

So here are similar anxieties to those in the current Handbook—worry about whose taste will determine what music is performed, whether musicians might show off or display elements of a too-colorful personality, and whether the music will be sufficiently inspiring to the congregation to contribute to rather than merely interrupt the worship service.

We can abstract from these concerns a tension about the metric by which art in worship is to be judged. On one side, implicit in these complaints about church musicians is an implied standard under which the musicians are operating—one which probably involves technical excellence or complexity. In the Western philosophical tradition, this set of concerns has often been called "aesthetics." On the other side are the concerns of the clergy—that art and music should not distract worshipers, that performances ought not call attention to the music or the performers at the expense of attention to the divine, that congregants should be moved to greater devotion by their experience of art or music. What name can we give to this set of concerns? Do we have a language for thinking about them? They are not ethical or theological or metaphysical questions. I want to suggest that they are, in fact, aesthetic concerns, even though understanding them as such requires a broadening of the category. What might it mean to think about Mormon worship services in aesthetic terms?

Weekly Mormon services are decidedly, frequently, painfully "low church," and shot through with the quotidian exercise of Mormon-ness. While colored shirts and Bach chorales are potentially scandalous and distracting, we apparently don't distract from whatever Mormon worship is with announcements about Cub Scouts, 12-year-olds' tearful stories of Girls Camp, sermons based on readings from Webster's dictionary or Reader's Digest, earnest but atrocious performances of sentimental gospel songs—all of these are somehow "appropriate." This is Mormon worship, for better and worse. I refuse to believe this means we are doomed to relentlessly mediocre music, but I do believe it means we are doomed to make whatever music we have in our worship services *in community*, as part of becoming Christians and Saints. And it means we need to think differently about beauty.

Even the use of "art" in my title is likely to have sent your mind to a museum or concert hall. The force of aesthetic theory for several centuries has been to distinguish art from craft, to establish "art" as something that is understood in relationship to other works of art—rarefied and set off from daily life, not judged by its utility, the economics of its production, or its ethical effects. It's no wonder, really, that people interested in building Zion, and convinced that the physical and spiritual worlds touch at every seam, would be nervous about having this sort of "art" in worship services.

We don't have a lot of latter-day scriptural warrant for an aesthetic theory, but I have been trying for a while to derive one from D&C 42, "the Law of the church". There's a single verse about beauty:

40 And again, thou shalt not be proud in thy heart; let all thy garments be plain, and their beauty the beauty of the work of thine own hands;

The force of Section 42, often called "The Law," is to push theological abstraction into the realm of the practical and the ethical. This law is not an abstraction, not a collection of general principles—it is detailed and specific and concrete method for living in Christian community. Beauty, too, is situated in the material, in useful and necessary physical objects. It is not, notably, described as formal perfection. God's command that beauty be "the work of thine own hands" foregrounds the conditions of production, and the harmonious situation of this work in the life of the community.

It is not especially original to suggest that *l'art pour l'art* fails to entirely account for the kaleidoscopic, multiform cacophony of human creativity and its responses to the creations of others. Critic and provocateur George Steiner insisted in *Real Presences* that all art depends for its transcendence of ordinary experience and the possibility of communicating that transcendence to other humans, on God. On his account, art is a bet on a sacralized universe:

…any coherent understanding of what language is and how language performs, …any coherent account of the capacity of human speech to communicate meaning and feeling is, in the final analysis, underwritten by the assumption of God's presence. …[T]he experience of aesthetic meaning in particular, that of literature, of the arts, of musical form, infers the necessary possibility of this 'real presence.' …The wager on the meaning of meaning, on the potential of insight and response when we encounter the *other* in its condition of freedom, is a wager on transcendence.[6]

Steiner argues that art is always religious, always makes this wager on divine presence as guarantor of meaning and of the transmissibility of meaning. I'm not sure whether I agree with him, but the notion that art must somehow reference God usefully foregrounds the possibility of an aesthetic theory embedded in ethical or religious context over and against the post-Enlightenment sense of aesthetics as somehow walled off from pragmatic concerns.

In this context, Section 42's focus on "the work of hands" re-grounds the notion of beauty in the here and now, in the physical. Steiner reminds us, though, that the physicality of art always points to something else:

> The arts are most wonderfully rooted in substance, in the human body, in stone, in pigment, in the twanging of gut or the weight of wind on reeds. All good art and literature begin in immanence. But they do not stop there. It is the enterprise and privilege of the aesthetic to quicken into lit presence the continuum between temporality and eternity, between matter and spirit, between man and "the other."[7]

Art works as a mechanism for collapsing all kinds of distance and separation—it is a kind of atonement, offering the possibility of communion despite the ephemeral nature of matter and despite human frailty and sinfulness. There are scriptural warrants for this conception of art. Psalm 90, for instance, which reads in part:

> Lord, thou hast been our dwelling place in all generations.

> 2 Before the mountains were brought forth, or ever thou hadst formed the earth and the world, even from everlasting to everlasting, thou *art* God.

> . . .

> 10 The days of our years *are* threescore years and ten; and if by reason of strength *they be* fourscore years, yet is their strength labour and sorrow; for it is soon cut off, and we fly away.

> 16 Let thy work appear unto thy servants, and thy glory unto their children.

> 17 And let the beauty of the Lord our God be upon us: and establish thou the work of our hands upon us; yea, the work of our hands establish thou it.

Here the work of human hands is "established" by reference to God's work—as God's work appears to his servants, their work transcends the limits of mortality. It is notable that the pronouns here are plural—this redemption of human handiwork is part of a covenant made with all of his chosen people. God's beauty is understood not in artistic solitude, but in community.

Perhaps it is because beauty in service to communion is threatened by alienation that Section 42, verse 40 begins with a warning about the dangerous possibilities of differentiation and alienation rooted in aesthetic judgment: "And again, thou shalt not be proud in thy heart; let all thy garments be plain." Whatever "beauty" is in Zion, it is not a source of individual aggrandizement for its creator.

The relationship of beauty and pride suggests another crucial consideration: beautiful objects are always situated within a community and within an economy. Where the force of most modern aesthetic theories has been to *remove* such considerations from the judgment of beauty or artistic merit, this verse seems to insist that we consider the

conditions of production of beauty and that the enjoyment of beauty must not involve distinctions related to wealth or education.

As the French theorist Pierre Bourdieu has usefully elaborated, what we call artistic "taste" is correlated very strongly with access to education and other forms of cultural capital, which mostly comes down to access to just plain old capital. People who "have good taste" are those who have been given a particular set of tools for approaching art—they have been taught to extract "art" from the ordinary materials of life, and to judge it by comparison to a historical body of artifacts which are labeled "art." They have been taught to discuss the formal aspects of these objects, rather than bringing art's content into the realm of ethical judgment. By contrast, Bourdieu generalizes that

> "working-class people expect every image to explicitly perform a function...
> and their judgments make reference, often explicitly, to the norms of morality
> or agreeableness. Whether rejecting or praising, their appreciation always has
> an ethical basis."[8]

The virtues of this "working class" approach seem apparent for a community built around a shared ethical code. Indeed, if the place of beauty is a proper element of "the law," it seems certain that the beautiful must not be judged merely formally, but that ethical judgment would have something to do with aesthetic appraisal.

This inclusion of ethics in aesthetic appraisal is, of course, not original to the twentieth century. I want to turn briefly to older German aesthetics, particularly to Schiller, who insisted that there was a moral component to the beautiful. Where Kant had posited the human *form* as the most truly beautiful object, because it is the most truly free, Schiller argues that the "architectonic beauty of the human form comes directly from nature and is formed by the rule of necessity" ("On Grace and Dignity," NA 255),[9] and thus cannot plausibly be taken as an expression of the "moralische Empfindungszustand"—the moral sensibility—of the person. On Schiller's account, the truest beauty is related to and evokes a sense of duty—grace (Anmut) appears in those moments when the beauty of moral action has become so thoroughly integrated into a person's being that even his unintentional movements reveal it. Grace can be expressed in the human form only to the extent that habitual moral action has left traces in the physical body. This, he asserts, can bestow beauty even on persons who do not have physically beautiful features.

Schiller makes sweeping claims about the potency of beauty not only as the culmination of habitual right action, but as a means of teaching and evoking that action: moral action, he says, requires the kind of careful attention to detail that we learn in aesthetic contemplation—learning to observe beautiful things thus turns our attention outward and prepares us to notice the needs and opinions of others. The balance inherent in the experience of beauty allows us to properly consider competing goods in the application of moral principles.

It is perhaps useful here to consider the verses immediately following the instruction about beautiful garments:

42 Thou shalt not be idle; for he that is idle shall not eat the bread nor wear the garments of the laborer.

43 And whosoever among you are sick, and have not faith to be healed, but believe, shall be nourished with all tenderness, with herbs and mild food, and that not by the hand of an enemy.

That phrase "with all tenderness," suggests precisely the sort of attention that, say, taking neat stitches or carefully trimming a seam might take. It's the same kind of care with which one rehearses a tricky bass line. And the juxtaposition of this "tenderness" with the forceful command not to be idle suggests a broadening of the notion of work that would also encompass the creation of beautiful garments—taking care of the sick counts as work, it is an important task of the community (not "enemies" or outsiders).

In this expansive conception of work, production and appreciation of beautiful objects would seem to be transformed from modes of individual expression or enjoyment to a community project—"the work of thine own hands" will necessarily involve resources that belong to the community. And it will require time—if making beautiful garments counts as "work", in a community where working is a prominent virtue, indeed, a requirement for inclusion in the community, then artistic creation becomes potentially a duty as well as an offering. "Beauty" becomes a unifying feature of Zion. This aspect of creative endeavors was articulated in the early stages of growth of an artistic culture in Utah. An 1877 *Utah Musical Times* editorial asserted that "we believe in homemade music as we believe in homemade cloth. Each, to us, is a source of strength and union."[10] Beauty is *for* something (in this case creating unity)—it becomes means, rather than end.

This is as good a place as any to acknowledge that I feel a little embarrassed about this argument. It feels like making excuses for bad art. And I think that is certainly a possible misuse of a definition of beauty that insists on a moral component. Part of my discomfort with proposing an aesthetic theory that does not insist on things like technical or formal perfection has to do with the long history of bad religious art being justified because it conformed to dogma or elicited religious sentiment. Mostly, though, I think my squeamishness points out how thoroughly conditioned we are by Enlightenment and Romantic period theories about what counts as art.

But thinking of beauty in worship as inhering largely in process, and a messily democratic and communal process at that, doesn't mean, I hope, merely being resigned to mediocrity. It can mean describing artistic efforts in terms of Mormon virtues of diligence or education. It can mean more carefully situating artistic and musical contributions as acts of worship. It can mean being aware of the history of art as spectacle in the Church, and not participating (here I'm actually thinking quite concretely: part of what

musicians can and should be doing is explaining that hymn arrangements created for the 400-voice tabernacle choir should not be attempted by ward choirs!). It can mean becoming educated about the rich musical worship traditions of other churches from which we can borrow, in keeping with long Mormon practice. It can mean helping to articulate a theory of what worship is (instead of merely the thing from which art is not supposed to distract). It can mean recognizing that when I lock horns with the tyrannical bishop who thinks his quirky preferences are God's, that I am frequently operating from the same theological position—the content of our propositions may differ, but the form of the arguments is identical. And it is exactly this discourse that generates the anxiety evident in the Handbook. If we are serious about creating truly beautiful art and music that can have place in Mormon worship, we must take responsibility for finding a new shared framework for conversation.

Maybe the best way to make sense of any of this is with a story about a time I think I understood it for just a minute.

It was a dark and stormy night (really!). We had Stake Conference on an evening when an early, heavy snowstorm had brought a tree down onto a power line near the Stake Center, so we had conference in the dark, with flashlights and cell phones and a single lantern on the pulpit. Our stake presidency wanted to have as much music as spoken word in our conferences, and as stake music chair, I was in charge of orchestrating 7 or 8 musical numbers during the session. It was a wonderful meeting, the darkness making for a kind of hushed intimacy, riveting us to the single source of light at the pulpit. The final musical performance of the evening was by a choir comprised of members from the Spanish- and Portuguese-speaking units in our stake. One could quibble about their technical expertise: there were some notable lapses in intonation, some rhythmic troubles (probably from not being able to see the conductor in the dark!). But they were earnest and well-rehearsed and enthusiastic. In every way that matters, it was glorious. Just when I thought it was nearly perfect, there was a new sound that I couldn't place for a minute. And then I realized the men in the choir were *whistling*! The women were singing words and harmony while the men whistled the tune. The beauty of the moment was overwhelming—I literally shook with joy.

I have had a few similar experiences in my life. In those cases, the performances might have been judged technically excellent, and would likely be called "beautiful" by most hearers. It's quite possible, on the other hand, that someone hearing a recording of the choir at Stake Conference would think it was mediocre, at best. Nonetheless, I want to argue that my judgment that the choir's performance was surpassingly beautiful was an *aesthetic* judgment. I do not mean to rank or compare that choir to another on some scale of aesthetic perfection, only to assert that my response was an aesthetic one, the same *kind* of response I have had to performances that were technically precise, presented in an elegant concert hall, marked by the typical cues for "art." It was an appreciation of sensory beauty, not (or not only) of moral beauty.

I suspect that the darkness had a lot to do with it, the hour spent sitting close to my brothers and sisters straining to see the speakers and performances, forced to rely more on other senses. Indeed, forced to listen so carefully that for the only time I can ever remember in a church meeting, I heard and was deeply aware of the breathing of the people around me. We were all at once more and less aware of our creaturely selves—we could not see bodies or faces, but we could feel each other's presence in all the ways that we never notice—a breath, a sigh, the restless thrumming of a foot or a knee, the occasional gasping snore of a head lolling too far for sleep. There was an unaccustomed tenderness in this bodily nearness.

There was, too, a certain leveling in the darkness. The usual markers of distinc-tion—fancy clothing, jewelry, skin color, attractive features, careful coiffure—all of these were muted as darkness fell on the chapel, just as outside the features of the landscape were effaced by the falling snow. Even the usual confidence and competence of "leaders" was shed. It was the Scoutmaster, not the bishop, who had a lantern in his car; the fabulous organist sounded just like all of the other good pianists when loss of the organ's power supply forced reliance on acoustic instruments; the singers who didn't read music and depended on learning their parts by rote were suddenly at an advantage. If there were poor among us, we couldn't figure out who they were—flashlights haloed every head, showed us the glory we too often fail to see in each other.

There are many words one might reach for to describe such a moment—lovely, reverent, ecstatic, holy. But I want to insist on "beautiful," and, further, to assert that my experience of that beauty had to do with an *aesthetic* judgment—that the moment was not just morally and spiritually, but sensibly and perceptibly beautiful, that my delight was not qualitatively different than my pleasure in other, more technically accomplished performances.

Much to my surprise, and perhaps even to my slight dismay, I seem to end ex-actly where I began: with the word "appropriate." That word need not be merely the vehicle for prissy disapproval or bureaucratic control. At its root, the word is from "propriare"—to make one's own. It is about belonging. "Appropriate" art for Mormon worship, then, is art that reminds us of the deep covenants which bind us to each oth-er and to God in a network of transcendent belonging. It arises from the tender and gracious work in which we lose ourselves and the learned habits of mind that separate the aesthetic from the ethical and metaphysical, for Zion's sake. It is art that is made in the same fractious and messy process as all the rest of Mormon worship—inclusive, improvised, mostly inexpert, and every once in a great while, so deeply beautiful that it offers a glimpse of that beauty which "eye hath not seen nor ear heard."

ENDNOTES

[1] "The principle I suggest to govern those officiating in the sacrament—whether preparing, administering, or passing—is that they should not do anything that would distract any member from his or her worship and renewal of covenants. This principle of non-distraction suggests some companion principles." (Oaks, D. H. (n.d.). The Aaronic Priesthood and the Sacrament. Retrieved August 24, 2017, from https://www.lds.org/general-conference/1998/10/the-aaronic-priesthood-and-the-sacrament?lang=eng)

[2] Hicks, Michael. *Mormonism and Music: A History.* Urbana and Chicago, IL: University of Illinois, 2003, 3.

[3] Hicks., 3-4.

[4] Hicks, 77 ff.

[5] Hicks, Michael. *The Mormon Tabernacle Choir: a biography.* Urbana, Illinois.: University of Illinois Press, 2017.

[6] Steiner, George. *Real presences.* Chicago, IL: Univ. of Chicago Press, 1991, 3-4.

[7] Ibid., 227.

[8] Bourdieu, P. *Distinction: social critique of the judgement of taste.* Translated by R. Nice. Cambridge, MA: Harvard University Press and Routledge & Kegan Paul, 1984, 4-5.

[9] Curran, Jane V., and Christophe Fricker, eds. Schiller's *"On grace and dignity" in its cultural context: essays and a new translation.* Rochester, NY: Camden House, 2005, 127.

[10] Hicks, *Mormoniana*, Mormon Artists Group, New York, 2004, 107.

JARED HICKMAN

MORMONISM; OR, ART ALL THE WAY DOWN

On January 7, 1836, there was a party at Bishop Newell Whitney's home in Kirtland, Ohio. As Joseph Smith described it in his journal:

> Our meeting was opened by singing and prayer offered up by father Smith, after which Bishop, Whitneys father & mother were bless[ed] and a number of others, with a patriarchal blessing, we then recieved a bountiful refreshment, furnished by the liberality of the Bishop the company was large,— before we parted we had some of the Songs of Zion sung, and our hearts were made glad while partaking of an antipast of those Joys that will be poured upon the head of the Saints w[h]en they are gathered together on Mount Zion to enjoy each others society forever more even all the blessings of heaven and earth and where there will be none to molest nor make us afraid.[1]

As Richard Bushman glosses the episode: "Here was a plain man's dream: a feast and genial companionship, safe from enemies."[2] Yet Joseph Smith made a stronger claim for what might otherwise be regarded as an unremarkable scene of domestic happiness. Because of the "liberality" characterizing the occasion (the diversity of the congregation, the generosity of the refreshment, the fullness of good feeling welling up out of good society), Smith pronounced this "sumptuous feast" to be "after the order of the Son of God." Smith's gesture, I want to say, highlights something arguably essential about Mormonism: namely, that Mormonism is a dare, a triple dog dare, the skeptical question behind which might be stated thusly: in "a secular age," as Charles Taylor has dubbed it,[3] in which, increasingly, enchantment cannot be unselfconsciously experienced but must be self-consciously considered, explained, and defended, how can—of all things—a dinner party amongst a ragtag bunch of self-selected oddballs on a January night on the Ohio frontier be *made* sacred in an effectual, meaningful—a motivating, organizing—way? At precisely the moment the sense of the sacred has been subjected to unprecedented levels of scrutiny, to an unparalleled burden of demonstration and justification[4]—a moment when disbelief is becoming a viable and indeed respectable option, where does Joseph Smith get off so confidently crafting a sense of the sacred so entire as to include—I'm sorry, *dubiously*—"sumptuous" spreads and so evidently

compelling to have brought all of us here to this room—181 years later—where we savor this story with knowing smiles?

What Joseph Smith possessed was the audacity and virtuosity to make things sacred, or, to use the Mormon term of art, *consecrate*.[5] All the more so because achieved under unpropitious conditions, when prevailing senses of the sacred were being fundamentally challenged and circumscribed in new ways. Indeed, Mormonism as a whole might be understood as first and foremost what I will call an *art of consecration*—that is, a bravura show of skill at making things sacred by making the unlikeliest things sacred in the least auspicious of contexts. Think no farther than Smith's rhapsodic retrospective on his restoration canonized as *Doctrine and Covenants* section 128: "The voice of Peter, James, and John in the wilderness between Harmony, Susquehanna county, and Colesville, Broome county, on the Susquehanna river declaring themselves as possessing the keys of the kingdom, and of the dispensation of the fulness of times . . . the voice of God in the chamber of old Father Whitmer, in Fayette, Seneca county."[6] Theophany and toponymy—the milestones of dispensational history delineated within the milestones demarcating arbitrary units of territorial administration.[7] As Richard Hughes, Jan Shipps, and others have suggested, Joseph Smith ventured to envelop himself and his followers in an unfolding cosmic drama in a manner that quickly overflowed the established channels of Christian primitivism.[8] As Kathleen Flake has so keenly reminded: "Luther nailed his complaints to the door, and the church fathers countered with decrees of anathema. In such exchanges of creedal statement and dogmatic restatement, most of modern Christianity has formed and reformed itself. Joseph Smith, the founder of Mormonism, wrote stories, however."[9] And, more than that, I'd say, inhabited and enacted stories.

One way of understanding this historical phenomenon would be to highlight what Harold Bloom called "the religion-making imagination" of Joseph Smith.[10] Certainly, some of the most interesting moments in the early Mormon corpus are when we are shown how the sausage is made even as it's being made. For instance, in *The Lectures on Faith* that originally furnished the "doctrine" in the *Doctrine and Covenants* and in which Smith had some substantive authorial, editorial, and pedagogical role: "Let us here observe, that a religion that does not require the sacrifice of all things, never has power sufficient to produce the faith necessary unto life and salvation."[11] Here, in the context of outlining the doctrine of what might be called a new "religion," we get a second-order reflection on how this thing called "religion" itself works, and, thus, a subordination of this new religion's immanent articulation of its doctrine to a larger philosophy of religion. In other words, a sincere faith statement is to some extent being mediated through a dispassionate theoretical understanding of how something called "religion" functions. The cool analytical question the passage is asking might be phrased as "what makes a religion succeed?" But what is intriguing is that this passage is at the same time answering that question in the obviously interested and impassioned form of announcing and enunciating Mormonism, with its properly calibrated dose of "sacrifice." One

might break down the rhetorical thrust thusly: "How does a religion succeed?" "Watch and learn, you sons of bi . . . shops."

In this reading, the operative words in Bloom's phrase—"religion-making imagination"—are "making" and "imagination" rather than "religion." What stands out is not so much the "religion" Smith makes as the frankness and flair with which he is making. To this point, one might further register that the very concept of "religion," as Talal Asad and others have shown us, emerges in a secular age in large part as a tool whereby imperial states discipline the experience and expression of belief into forms compatible with their own authority.[12] That which is called "religion" is to some extent dignified, yes, but only insofar as it is specified as a largely private affair unfolding in disestablished churches and disembodied minds. Which is to say that, given the political trouble the early Mormon movement consistently found itself in, it's not at all clear to me that what Smith and early Mormons created is best described as a "religion." Indeed, the measure of a proper Mormon cultural nationalist, if you will, might be precisely an unwillingness to be content with Mormonism's classification as a mere "religion." My contention in all this is that, apart from the question of what exactly it was that he made, Joseph Smith above all was, to use contemporary parlance, a maestro "maker" and, as this passage suggests, "religion" a distinct object subject to the vagaries of his making.

Following this line, we might play at defining Joseph Smith and Mormonism under the rubric of another term, like "religion," that achieved a new singularity and independence in a secular age: "art." In fact, the emergence of "religion" and "art" as discrete categories can be narrated as a single story. Not coincidentally, in the Romantic era in which Joseph Smith and early Mormonism emerged,[13] a range of thinkers generated modern aesthetic theory and practice as we still know it primarily as a tactic for retaining or rehabilitating some sense of the "spiritual," we'll say, in the face of certain currents of Enlightenment materialism. A leading edge of this Enlightenment materialism was the so-called higher criticism of the Bible, which drew on newly available and ever accumulating textual and extratextual evidence to expose the Bible as a human document. Johann Gottfried Herder, Friedrich Schleiermacher, the Schlegel brothers, and many other properly Teutonic-sounding folks, most of whom identified as Christian and some of whom were clergy, increasingly pointed to the literary richness of the Bible and other sacred texts and performances as the sure sign of the divine moving through human history.[14] To put it far too reductively, the destabilization of the prophetic provoked an elevation of the poetic in order to shore up the authority and felt sense of value deposited in certain traditions. There were massive concessions involved in this move—not insignificantly, a surrender of orthodoxy, by which I here mean a self-serious and -mobilizing commitment to the rightness of a particular doctrinal content. A story can be and has been told in which such a liberalization of Christianity is ultimately indistinguishable from a secularization that leaves the church pews empty.

But this swerve to the aesthetic, at the outermost limits of its ripple effect, also of-

separation of "art" from religion

47

fered breathtaking inducements to sacralize as never before. If, as Herder had modeled, one could, through an empathetic exercise of historical imagination, show how Hebrew poetry represented the transit of Absolute Spirit through the spirit of a particular people in a particular age, could one reverse engineer the process?[15] Was this process exclusively retrospective or could it be prospective: Could one cultivate requisite sensitivities to the spirit of one's own people in this age right now in order to create something some might call "art" that attested to or even summoned the divine presence? If past evidence of the divine inhered in human aesthetic achievement, to what extent could human aesthetic achievement conjure the divine in the present? If seemingly self-evident truths had been demystified as exquisite human constructions—objects made by particular people in particular times and places mystified over time, then to what extent could one knowingly construct meaningful truths in the here and now? Could poets replace priests? How would one do that? What would it look like? William Blake, Friedrich Hölderlin, Walt Whitman, and many others in this period seem to have been incited by such questions.[16] What I mean to underscore is that the aspiration embedded in the aesthetic, even as it shakes loose from "religion" or "spirituality" into its nominal autonomy, is *consecration*—the modern aesthetic is born not merely to reconstitute some sanctity for particular longstanding objects of reverence but by it is borne the possibility of generating, in and with the juddering flows of history, new sacred objects.

Now this possibility is admittedly a fragile and fraught one but no less persistent and vital. In light of the historical particulars I've just sketched, the modern aesthetic suffers from a kind of replacement anxiety. As the distinction between something being called "art" and something being called "religion" is made increasingly plausible through various forms of institutional realization and ideological recrimination, a set of creative expressions that might be provisionally distinguished as "art" loses its nerve, so to speak. Hence, in the work of a preeminent post-Romantic aesthetician like Matthew Arnold, one notes both a bold nomination of "culture"—which he intends in its non-anthropological sense as a certain measure of aesthetic achievement ("the best which has been thought and said")—as a spiritual salve for alienated moderns and a terrified misgiving that the withdrawal of what he in his most famous lines called "the sea of faith" has left us, irredeemable, in a nightmare-world.[17] One perhaps detects a subtler schizophrenia in Amy Hungerford's discussion of modernist and postmodernist literature of the twentieth- and twenty-first centuries: on the one hand, she recognizes how these texts often seem compelled by questions of belief that run athwart familiar secularization narratives that describe or prescribe the world's inevitable disenchantment; on the other, she somewhat blunts the force of this claim by characterizing these texts as primarily fascinated by "belief without content," that is belief as a passing phenomenon, an intriguing subjective state.[18]

The replacement anxiety of the modern aesthetic can also express itself in a formidable repression of the spiritual animus that, we have seen, initially propelled the

modern aesthetic. In this scheme, the emergence of the aesthetic as a discrete category of experience and understanding is seen as integral to the historical process of secularization. To apprehend and appreciate an object in aesthetic terms—that is, to recognize and regard it as an artifice productive of discernible and describable effects—is ultimately to disenchant it, to deprive it of the overwhelming power typically associated with the "religious" or "spiritual." Call it the Wizard-of-Oz effect. The aesthetic object offers its own enjoyments to be sure, but these are understood as distinct from and even at odds with the feelings aroused by the "religious" or the "spiritual." Imagine the specific kind of pleasures afforded the clever novelist who plants a portentous allusion or extravagant metaphor, drawn from a "religious" tradition, at a crucial juncture in the text and the astute reader who catches the reference. In one iteration of this aestheticization-as-secularization thesis, the "rise of fictionality," as evidenced by the success of the novel as a cultural form, marks the ascent toward secular modernity. To be a secular modern is precisely to have developed the ironic sensibility that allows one to perceive and receive a story that achieves verisimilitude as a mere fiction, an object in relation to which one winkingly, temporarily suspends disbelief but not in which one, in any sense, believes.[19] Aesthetic autonomy—here signified both by the massive influence attributed to a literary form, the novel, and the worldly habits of mind allegedly inculcated by that form—spells the end of certain prospects for belief, which are discredited as naïve.

Beneath these various expressions of the modern aesthetic's replacement anxiety is a concession of human "making," in the broadest sense, to the secular and thus a surrender of the possibility that things can be made robustly sacred, authentically and widely consecrated. This, I am saying, is on a deep level a betrayal of the highest hope carried by the aesthetic in modernity, a quailing at the triple dog dare that I see Mormonism as taking on. Indeed, this concession often seems to be predicated, consciously or not, on a dualistic ontology of divine creation that Mormonism, in some of its strains at least, explicitly and emphatically rejects.[20] For those, like the novelist Marilynne Robinson, who find ways in a secular age to maintain a theistic position, whatever human beings create constitutes a second creation that asks to be compared to and contextualized within a first creation authored by a sovereign God.[21] Human making can only be fully valorized insofar as it is perceived to reverberate within and thereby amplify the first, divine creation. Human making, we might say, is thus typically secular and becomes something more only when it manages to tap into a transcendent givenness. Put another way, human beings can't make anything sacred; they can only reveal through their making something "always already" sacred because divinely made. By the same token, for those who find themselves, within the immanent frame of a secular age, unable or unwilling, for understandable reasons, to confidently claim access to the transcendent, then human making is secular either by default (transcendental reference is just deemed unavailable) or as a defiant gesture (think of Marx's foundation-shaking assertion that the objective of the most strenuous human thought and activity ought to be the revolutionary transformation of material reality toward maximal human flourishing). The

echo chamber here is constituted by the human rather than the divine: what humans make is by humans and is or should be for humans alone.

But Mormonism arguably proceeds from different premises. At least in certain moods, Joseph Smith dismissed creation ex nihilo and with it an ontological dualism that positioned the human and the divine on either side of a gaping gap. He pictured a cosmos uniformly made of matter attaining different degrees of "organization" relative to their suffusion by "intelligence."[22] The game would thus seem to be configuring matter in ways that concentrate intelligence, creating assemblages on various scales that exponentially multiply intelligence, magnifying it into superintelligence—in other words, might we not say, making objects sacred? How better to understand Joseph Smith's seerstones or golden plates or the living body of saints that follows in his train? In Smith's scheme, to be a prophet—or a god, for that matter—is simply to have gotten really good at generating a sense of the sacred through a soulful and searching constellation of objects. This may be the ultimate manifestation of what I mean when I call Mormonism an art of consecration—a skillful practice, a honed expertise at putting things together in ways that spark. Hence, insofar as consecration is understood to be the highest hope vested in the modern aesthetic, I might now venture, with greater precision, that Mormonism, historically speaking, can be construed as, in some sense, avant-garde art. If Mormonism itself is already art, then "Mormon art," in a way, is a redundancy. Put another way, art that understands itself or aspires to be Mormon in some authentic way might envision its task as that of Mormonism itself as I've described it—practicing art in extremis, art at its most mad and ambitious where it dares, amid the "cross-pressures" of a secular age, to try to generate a sense of the sacred—in the first place, to ask what the sacred is, to what extent it remains possible, and then to attempt to cultivate those possibilities, however small or strange they may be.

Some of the Mormon art I most admire, some of which I'm happy to say is on display here, is already doing this in provocative ways. Page Turner's meticulous, quasi-infinite concatenations of seemingly mundane minutiae, made and found, she has herself described, in the pages of *Exponent II* (which deserves a shout-out for discovering and featuring Mormon women artists), as "turn[ing] scraps," particularly those left by (and for) women, "into sacred objects."[23] As a viewer—and proud owner—of her work, I can attest to its successful incitement within me and my wife Aimee, at least, of something like those bosom-burnings and mind-quickenings Mormons have been taught attend the presence of the divine. Also in *Exponent II*, Rachel Farmer has characterized her elegant pioneer figurines as "ancestor spirits"—representations in which "time and space [are] collapsed," objects offering the living a therapeutic reckoning with the dead to whom, for better and worse, we owe our very being; in Farmer's account, these objects even attain a kind of fetishistic quality insofar as they effectively externalize the deepest wishes and worries and thus facilitate self-revelation and transformation.[24] I also think of Joe Bennion's exquisite pottery, sold from his shop in the picture-perfect pioneer town of Spring City, Utah, which is fired in a hand-built kiln on

which is inscribed—if you steal a peek, as I have—the words "Holiness to the Lord." When I eat off Bennion's plates, I fancy the food tastes as good as Joseph Smith said the truth ought to;[25] I feel health in my navel and marrow in my bones. Any such meal, objective sumptuousness aside, I'm inclined to consider, may indeed be "after the order of the son of God," to stick with Smith's terms. Here, now, gracefully surrounded by and thoughtfully attending to such work, dare we pronounce this occasion "after the order of the son of God" or some comparable honorific? To entertain such a pronouncement, I have suggested, may, in the end, just be a way of acknowledging that this experience right now is occurring within an ongoing interactive art installation set in motion by Joseph Smith and the ancestor spirits without whom, he taught, we cannot be made perfect.[26]

ENDNOTES

[1] "Journal, 1835–1836," p. 101, The Joseph Smith Papers, accessed September 21, 2017, http://www.josephsmithpapers.org/paper-summary/journal-1835-1836/102. See editorial note that this "feast for the poor" was also understood to be "after the order of the Son of God" in the sense that it seemed to follow an injunction in Luke 14:12-14.

[2] Richard Lyman Bushman, *Joseph Smith: Rough Stone Rolling* (New York: Alfred A. Knopf, 2005), 305.

[3] Charles Taylor, *A Secular Age* (Cambridge, MA: Harvard University Press, 2007).

[4] See Odo Marquard, *In Defense of the Accidental: Philosophical Studies*, trans. Robert M. Wallace (New York: Oxford University Press, 1991), especially the essay, "Unburdenings: Theodicy Motives in Modern Philosophy."

[5] For a rich recent historical and theological consideration of this concept in Mormon practice, see Joseph M. Spencer, *For Zion: A Mormon Theology of Hope* (Salt Lake City: Greg Kofford Books, 2014).

[6] "Journal, December 1841–December 1842," p. 200, The Joseph Smith Papers, accessed September 21, 2017, http://www.josephsmithpapers.org/paper-summary/journal-december-1841-december-1842/77.

[7] For a brilliant reading of this passage, similar to my own, see John Durham Peters, "Recording Beyond the Grave: Joseph Smith's Celestial Bookkeeping," *Critical Inquiry* 42, no. 2 (Summer 2016): 856-57; also Bushman, *Rough Stone Rolling*, 478.

[8] Richard T. Hughes, "Soaring with the Gods: Mormons and the Eclipse of Religious Pluralism," in *Mormons and Mormonism: An Introduction to an American World Religion*, ed. Eric A. Eliason (Urbana and Chicago: University of Illinois Press, 2001), 23-46; Jan Shipps, *Mormonism: The Story of a New Religious Tradition* (Urbana and Chicago: University of Illinois Press, 1985), 41-65.

[9] Kathleen Flake, "Translating Time: The Nature and Function of Joseph Smith's Narrative Canon," *The Journal of Religion* 87, no. 4 (October 2007): 497.

[10] Harold Bloom, *The American Religion: The Emergence of the Post-Christian Nation* (New York: Simon & Schuster, 1992), 96-97.

[11] "Doctrine and Covenants, 1835," p. 60, The Joseph Smith Papers, accessed September 21, 2017, http://www.josephsmithpapers.org/paper-summary/doctrine-and-covenants-1835/68.

[12] Talal Asad, *Genealogies of Religion: Discipline and Reasons of Power in Christianity and Islam* (Baltimore: Johns Hopkins University Press, 1993); *Formations of the Secular: Christianity, Islam, Modernity* (Stanford, CA: Stanford University Press, 2003).

[13] On Joseph Smith as a Romantic, see Terryl L. Givens, "Joseph Smith, Romanticism, and Tragic Creation," *Journal of Mormon History* 38, no. 3 (2012): 148-62.

[14] See Nicholas Boyle, *Sacred and Secular Scriptures: A Catholic Approach to Literature* (Notre Dame, IN: University of Notre Dame Press 2005); Jonathan Sheehan, *The Enlightenment Bible: Translation, Scholarship, Culture* (Princeton, NJ: Princeton University Press, 2005).

[15] The first English-language American edition of Herder's *The Spirit of Hebrew Poetry* appeared near Joseph Smith's stomping-grounds, in Burlington, Vermont in 1833, translated by James Marsh.

[16] For a couple resonant accounts of this Romantic aspiration, see Lawrence Buell's discussion of American "literary scripturism" in *New England Literary Culture: From Revolution through Renaissance* (Cambridge: Cambridge University Press, 1986), 166-91; and Roberto Calasso, *Literature and the Gods*, trans. Tim Parks (New York: Vintage, 2001).

[17] See Michael W. Kaufmann, "The Religious, the Secular, and Literary Studies: Rethinking the Secularization Narrative in Histories of the Profession," *New Literary History* 38, no. 4 (September 2007): 607-28.

[18] Amy Hungerford, *Postmodern Belief: American Literature and Religion Since 1960* (Princeton, NJ: Princeton University Press, 2010).

[19] For one popular account that is symptomatic, see Catherine Gallagher, "The Rise of Fictionality," in *The Novel: Volume 1*, ed. Franco Moretti (Princeton, NJ: Princeton University Press, 2006), 336-63.

[20] For one recent account, see Terryl L. Givens, *Wrestling the Angel: The Foundations of Mormon Thought: Cosmos, God, Humanity* (New York: Oxford University Press, 2015), 57-62. See also Adam Miller's response, "A Radical Mormon Materialism: Reading *Wrestling the Angel*" and "Network Theology: Is It Possible to Be a Christian and Not a Platonist?" both in *Future Mormon: Essays in Mormon Theology* (Salt Lake City, UT: Greg Kofford Books, 2016).

[21] Marilynne Robinson, *The Givenness of Things: Essays* (New York: Farrar, Straus and Giroux, 2015), especially the essays "Grace," "Givenness," and "Theology."

[22] On "organization" vs. "creation" across Smith's career, see "Revelation, 6 May 1833 [D&C 93]," pp. [3-4], The Joseph Smith Papers, accessed September 21, 2017, http://

www.josephsmithpapers.org/paper-summary/revelation-6-may-1833-dc-93/3; "Discourse, between circa 26 June and circa 4 August 1839–A, as Reported by Willard Richards," pp. 64-65, The Joseph Smith Papers, accessed September 21, 2017, http://www.josephsmith-papers.org/paper-summary/discourse-between-circa-26-june-and-circa-4-august-1839-a-as-reported-by-willard-richards/2; "Discourse, 7 April 1844, as Reported by William Clayton," p. 16, The Joseph Smith Papers, accessed September 21, 2017, http://www.josephsmithpa-pers.org/paper-summary/discourse-7-april-1844-as-reported-by-william-clayton/6.

[23] Page Turner, "The Sacred History of Remnants," *Exponent II* 33, no. 3 (Winter 2014): 14-15.

[24] Rachel Farmer and Deborah Farmer Kris, "My Pioneer Ancestors," *Exponent II* 31, no. 4 (Spring 2012): 18-20.

[25] "Discourse, 7 April 1844, as Reported by Wilford Woodruff," p. [137], The Joseph Smith Papers, accessed September 21, 2017, http://www.josephsmithpapers.org/paper-summa-ry/discourse-7-april-1844-as-reported-by-wilford-woodruff/5.

[26] "Discourse, 7 April 1844, as Reported by William Clayton," p. 17.

MICHAEL HICKS

THE SECOND COMING OF MORMON MUSIC

Imagine using a 15th century map of the world in the age of GPS. It would not help you locate anything so much as the minds of the old mapmakers. Were those men ambitious? Yes. Were they imaginative? Yes. Were they skillful? Yes. But did their maps accurately portray the objects they were meant to? No. The maps were grand and visionary. But they were mostly beautiful fantasies about coastlines.

That's how I feel about Spencer Kimball's "gospel vision of the arts" in his "Education for Eternity" talk at BYU in 1967. It dreams grandly, but about what? When it comes to composers, for example, he offers as ideals Wagner, Verdi, Bach, and Handel, the youngest of whom had died in 1901 and all of whom were West Europeans.[1] In other words, no one pertinent to 1967 and no East Europeans or North Americans, let alone anyone from South America, Asia, Africa, etc. No Stravinsky or Shostakovich or Copland or Ginastera, for example, all well-known masters still alive when he spoke. The pantheon of composers Kimball holds up is a myopic map of a bygone world.

But what troubles me more than his ideals is his method. If one makes maps, only better ones, one begs the question of our relationship to map-worthy information. Paul Valéry described what he saw as the "conquest of ubiquity" in 1928.[2] And that quest for conquest has never stopped. It's now in the palm of our hands. So what is the relevance of maps now in a GPS age? In the same way, what is the relevance of a gallery of long dead icons in this wholly new era—this new *dispensation*, to use a favorite Mormon word?

Now let me shift the metaphor. Let's talk about Jesus. He was often told that the Messiah should be the "Son of David." He bristled at that. The term demoted him. He offered something different, not just a sequel to David, but a higher form entirely. His resurrection only made the misnomer worse. He did not rise from death as Lazarus did—the same except for the hangover of death. He came back unrecognizable, even to his friends. He had to reintroduce himself to Mary, Peter, disciples at Emmaus, and so on. Because the image of the Jesus they knew was no longer valid. It was an obsolete map of the real Jesus. As Paul puts it about all who will be resurrected, Jesus was "changed."[3]

Still, the risen Jesus was only a whistle stop on the way to the Second Coming. That event offers a Jesus changed in both magnitude and essence. The Second Coming is always described as an overwhelming planetary awareness. All people will see him, every knee shall bow, every tongue confess to him. And, by the way, the whole world will hear a trumpet blast.

In what ways can one speak of something so overwhelming with respect to anything called "Mormon music"?

Here are the three traits that will characterize what I call the "Second Coming of Mormon music":

1. Everywhere

2. Everything

3. Everybody

Let me explain.

EVERYWHERE

One thing that makes Jesus' Second Coming differ from his first is not the message or the style, but the audience. Just so with Mormon music's Second Coming. We Mormons associate the words "Lo here, lo there" with Joseph Smith describing the religious competition of his boyhood. But those phrases appear first, of course, when Jesus predicted his return: don't listen to people who say "lo here, lo there," he said. Because he won't be local or regional or bound by any geography. "For as the lightning cometh out of the east and shineth even unto the west, so shall also the coming of the Son of Man be."[4] His return will be the *parousia*, that tantalizing Greek New Testament word for Jesus' return. It has two senses: an arrival and a presence.

When I think of the Second Coming of Mormon music it is in that latter sense: a presence, a universal *abiding*. It will not be marooned at BYU or in New York or the United States or Europe or any other location you choose. It won't be map-bound at all. It will be global, aerial, pervasive, a generalized planetary infusion. And, indeed, it has already found its *parousia* on the aptly named "world wide web." It can arrive at the threshold of ears on every continent. If someone had told me when I began teaching at BYU thirty-two years ago that the music of myself and my Mormon colleagues would soon be available around the world for free at the touch of a few buttons, would I have believed them? No. But my skepticism, in retrospect, would border on sinful.

And, by the way, "everywhere" refers to *points of origin* as well as destinations. In giving his gospel vision of the arts Kimball was talking at BYU about BYU. That myopia had to die before it could be resurrected—and thankfully, it has, partly because of the Barlow Endowment at BYU, about which you'll be hearing more later. The truth is, Mormons compose music everywhere that Mormons live. The quaint presumption

that Mormon culture has its home address in Utah is as dead as Lazarus the second time around.

EVERYTHING

Just as Jesus had many styles—which is why we needed *at least* four gospels to portray him—there is no one Mormon musical style. There is, to my mind, only a controlling idea. One of my teachers, Alexander Ringer, said this about Jewish music: it must express "universals, not particulars" and

> go beyond more or less obvious affinities with liturgical or folk-tunes, not to speak of mere textual references or the parochial effusions of composing chauvinists. For in art the ultimate test is rarely *what* but *how*, not the nature of the material but its treatment, its unique 'intonation.' And 'intonation' in that sense reflects not merely the individual psyche but the total historical experience of the community, physical and spiritual, to which the artist belongs, whether he [or she] identifies with it consciously or not.[5]

Contrary to that idea, Kimball yearned for new vocal music that could narrate Mormon history or be good press for Mormonism.

> In the field of both composition and performance, why cannot the students from here [BYU] write a greater oratorio than Handel's Messiah? The best has not yet been composed nor produced. They can use the coming of Christ to the Nephites as the material for a greater masterpiece. Our BYU artists tomorrow may write and sing of Christ's spectacular return to the American earth in power and great glory, and his establishment of the kingdom of God on the earth in our own dispensation. No Handel (1685-1759) nor other composer of the past or present or future could ever do justice to this great event. [Moreover,] how could one ever portray in words and music the glories of the coming of the Father and the Son and the restoration of the doctrines and the priesthood and the keys unless he were an inspired Latter-day Saint, schooled in the history and doctrines and revelations and with rich musical ability and background and training? Why cannot the BYU bring forth this producer?[6]

My response to that *as a composer* is neither assent nor refutation but transcendence. I hope we're beyond thinking that our religion is our history. If I'm right, we need something better than vocal settings of authorized narratives. Why music about the First Vision when you can portray visionary experience itself? Why write about Jesus coming when you can explore the mysteries of incarnation and embodiment?

I usually talk and write about other Mormon composers' work. But let me talk today a little about my own. Consider what some non-Mormon reviewers have said about it:

- it is "sacred, poetic and philosophical"

- it is "essentially meditative," with "all the luminosity and sharp edges of a stained glass mosaic"

- it "seems to come from another world"

- it "is founded on an idea that is allowed to expand, ultimately reaching the boundary between sound and silence where the listener is exposed to sacred space"

All of those things were said about my *solo piano* music.[7]

Or consider my string quartet entitled *of the*, in which the spirit of Schubert (via quotations from his last string quartet) keeps flashing onto the scene, just as angels do in Mormon history. The piece, as the program note says, evokes "a catalogue of sound sources . . . from insects to slot machines to Hebrew cantillations [with] various hallucinatory scenarios and enclosures, always returning to [a] house of mirrors, in which . . . Schubert fleetingly reappears from time to time." Moreover, the title is "a preposition and article detached from subject or object [which] conveys a feeling of alienation and longing for, if not home, at least some kind of belonging."[8]

My instrumental music also takes up broader Christian traditions. My mixed chamber piece *Relics* plays with sounds suggested by the remains of sacred objects in Christendom. My *Stations of the Cross* muses on those panels on the walls of Catholic churches throughout the world. My *The Annunciation* portrays Mary's startled mind at the news of her son's conception. And what happens in my music with no religious titles often treats Christian behaviors. *Diode*, for example, a piece for two violins, *three hands*, depicts triumph over injury through the help and adaptation of a partner.

But if you want vocal music, consider my pop songs. They often invoke faith without churchiness, let alone Mormon history. Broadcaster Marcus Smith asked about my album *Valentine St.*, "To what extent [are these love songs] religious inquiry?" Consider one basically country song from that album. It's called "Born Again." (I wrote the words and music, play guitar and accordion, and sing.) The chorus reads: "I was born again to the nature of the world / It's always something about a boy and a girl / Everyday people, amazing grace / And all the miracles you've got to face."[9]

When I first read the Book of Mormon in high school, it puzzled me. Clearly here was a 19th-century book in 17th-century English, quoting Paul centuries before he existed, putting Protestant revivalist sermons in the mouths of Isaiah-era Jews, and making Israelites out of Indians in New York. I could only love this book if I surrendered to such audacity as the scaffolding for a larger cause—Mormonism, a new-breed philosophy and code of habits. A year and a half after joining the church, I went to the temple for the first time. There I saw Adam and Eve talking with a Protestant minister and the Apostle Peter in a B-movie that included stock clips of wild animals and depicted a stage filled with plastic plants, interspersed with gestures straight out of the Freemasonry manual in my Baptist dad's nightstand.[10] The temple taught me what the

Book of Mormon should have: time in the Mormon worldview never flows; it leaps and stutters and overlaps. So when we read in Ephesians "that in the dispensation of the fulness of times he might gather together in one all things in Christ, both which are in heaven, and which are on earth," why shouldn't this all-time everythingness pervade our music?[11]

Which leads me to ...

EVERYBODY

Let's get two things out of the way. First, although Kimball mentions four women whom Mormon *singers* should emulate, he mentions no female composers. Given the musical canon with which he was raised—as was I—that makes sense. But Mormon women are writing some of the most ingenious music in our lifetime. (I think, for example, of Leilei Tian, Margot Glasset Murdoch, Esther Megargel, and, yes, Janice Kapp Perry—question me on that later, if you want.) Part of the "everybody" that Mormon music's second coming requires is an entire gender that's been ignored as if it were the Western Hemisphere in the 15th century.

Second, Kimball dwells on character. Now, maybe a temple-worthy Wagner would have written better music. But let's face it: a transgressive personality goes hand in glove with exploration, which we instinctively attach to the idea of art. For me, the character trait of *sincerity*, to echo Tolstoy, seems more vital than that of, say, chastity, for making great art.[12] I'll leave it to historians to make or refute that case. But if I thought that making better music meant possessing better morals, I'd have to enroll in a different universe.

Still, let me turn my lens in a different direction. In 1975 Truman Madsen published in *BYU Studies* an article with this title: "Are Christians Mormon?" Throughout his essay Madsen shows parallels in modern Christian thought to Joseph Smith doctrines that seem at odds with the evangelical Christianity in which I, at least, was raised. But the greatest insight in this article was not in the parallels, but in the question itself, "Are Christians Mormon?" Because, I believe, it is the mind of the hearer that construes Mormonism in any speech, not the intent of the speaker.

How does this relate to Mormon music? Well, I as a listener hear Mormon music everywhere, because I am a Mormon attuned to the Mormonism in everybody. Bernstein's *Mass*, for example, is, to me, one of the great codes of religious experience for Mormons of all faiths. But let's get scruffier. In Jim Croce's hit song "Operator" I feel so much of Christ's "path of disappointment" of which President Monson speaks.[13] If "prayer is the soul's sincere desire," as the hymn says, that song is a prayer. And when Chick Corea and the Akoustik Band play their version of "Someday My Prince Will Come" I hear the wild fervor of the return of the Prince of Peace. But to be fair, I've been known to teach people to hear eternity in tape hiss or to hear genealogy in the scratches of vinyl records.

Creating what we intend to be Mormon music is one thing. I do it and I teach it. But, as Jesus often said, "he that hath ears to hear, let him hear." To me, that includes hearing the Mormonism in everybody.

Which brings me back to Dr. Ringer's statement: "in art the ultimate test is rarely *what* but *how*, not the nature of the material but its treatment, its unique 'intonation.'" As Mormons we have what actually might seem a particular disadvantage in this. Because Mormonism prizes truth from *all* sources. Brigham Young said, "If you can find a *truth* in heaven, earth or hell, it belongs to our doctrine."[14] The religious symbol of the compass means a single circle must surround all truth and the hinge of the compass expand till it can hold it all. Remember that the compass is a tool for drawing: a globe. In readying ourselves for the Second Coming of Mormon music, how are we tuning ourselves to the circumference of that globe? I believe that Mormon music's unique intonation is tuned to a favorite Mormon word: *gathering*. A gathering from everywhere of everything musical made by and for everybody.

That may sound like a cross between anarchy and ambivalence. You may find it too blurry an image of Mormon musical aspiration. And you may look—as I sometimes do—for a map of Mormon music with far clearer and cleaner boundaries. But to prepare for the Second Coming of Mormon music, we don't need better maps. We need to erase boundary lines. Paul said that when Jesus comes again we "shall be caught up together in the clouds, to meet the Lord in the air."[15] That's the vision of second-comingness. So rather than hammer our stakes down, it's time to pull up the tent and turn it into a flag.

ENDNOTES

[1] He mentions a few virtuoso performers who also composed (e.g., Lizst and Paganini), but the four I mention seem to be the composers Kimball notes particularly for their compositional prowess.

[2] Paul Valery, *Aesthetics*, trans. Ralph Manheim (Pantheon Books, Bollingen Series, New York, 1964), 225.

[3] 1 Cor. 15:51.

[4] Matt. 24:23, 27.

[5] Alexander Ringer, *Arnold Schoenberg: The Composer as Jew* (New York: Oxford, 1990), 201.

[6] Spencer W. Kimball, "Education for Eternity," https://ucs.byu.edu/sites/default/files/readings/EducationforEternity-Kimball.pdf [10] (accessed 6 July 2017).

[7] The quotes are from reviews of my *Felt Hammers: The Complete Works for Solo Piano* (Tantara TCD0314FHM) in *Fanfare* 39:2 (November/December 2015), 106-108, and *The Whole Note* (thewholenote.com; 1 November-7 December 2015), 65.

[8] See the dress rehearsal of the piece here: https://www.youtube.com/watch?v=XTb_ltTCudE (accessed 6 July 2017).

[9] "Born Again" from *Valentine St.* (Tantara TCD-0306VST [2007]). This track and other works cited in this essay can be seen and heard on my website: michaelhicks.org.

[10] Changes were made in this ritual-drama ca. 1990, including the deletion of the Protestant minister character.

[11] Ephesians 1:10.

[12] See Tolstoy's *What Is Art?*, trans. Aylmer Maude (New York: Thomas Crowell, 1899), 134.

[13] See Thomas S. Monson "The Paths Jesus Walked," LDS General Conference, April 1974, https://www.lds.org/general-conference/1974/04/the-paths-jesus-walked?lang=eng (accessed 6 July 2017).

[14] For this and related quotations, see my "Notes on Brigham Young's Aesthetics," *Dialogue: A Journal of Mormon Thought* 16 (Winter 1983): 124-30.

[15] 1 Thess. 4:17.

KENT S. LARSEN

TELLING, RETELLING AND RETELLING AGAIN CORIANTON: WHAT THE PERSISTENCE AND EVEN THE FAILURE OF ONE PROJECT TEACHES US ABOUT THE PRODUCTION OF MORMON ART[1]

INTRODUCTION

"And it came to pass, as he sowed, some fell by the way side... And some fell on stony ground. And some fell among thorns... And other fell on good ground, and did yield fruit..."

I want to talk a little bit about the metaphor of soil. Soil represents the resources available in our environment—the materials, systems, culture, etc. that exist to support the seeds that fall on them as well as the receptivity of the audience. Seeds draw from the soil the basic building blocks needed to grow, so having the right soil is crucial to any effort.

One of the criticisms that I often hear about Mormon Art is that it's not good enough. Those who experience Mormon Art are often disappointed when they compare Mormon Art to what they experience elsewhere, and they conclude that Mormon Art isn't worth their effort. That conclusion is, I think, unfortunate, because it is built on incorrect and irresponsible assumptions. Assuming that art is supposed to be good by some absolute standard, or better in comparison to other art, ignores the soil that the art is built on, and the audience's part in that soil. The audience is part of the culture; it influences the resources available for art and controls the attention given to a work of art and how that art is viewed. When asking how good the art is, we need to remember our role in preparing and nurturing the soil.

One of the things often forgotten in discussing Art is that it takes a lot of bad art to produce good art. In fact, I'd say that there is a strong correlation between bad art and good art. Every serious artist knows how much time they have to spend producing bad art before they can finally get to producing good art. I think this also applies to each culture as a whole. A culture has to produce a lot of bad art before it can produce a lot of good art also.

So Art, be it finished, in process or merely an idea, is thrown out on the soil of our lives and on the loam of our culture. We experience it, and the type of soil that Art receives—that it lands on, or to be clearer, that we prepare for it—can have a big effect on whether or not the Art is successful. The type of soil that the audience is, and the resources available to support Art, can't be omitted from our judgments. To explore the role of "soil" in Mormon art, I want to tell the story of a series of works of art based on the story of Corianton found in the Book of Mormon.

In the Book of Mormon the core of the story of Corianton is just two verses long. But this story was expanded, and told, and retold, and retold again in various different means, on various different soils. It became first a novella, then a play, then it came to Broadway and became a Broadway play, then it became a film. There were attempts later to make it a TV show, and eventually even a novelization was produced. Its longevity and the persistence of its authors and promoters is unusual and entertaining.

But, before I cover all of this, I will review the contexts in which *Corianton* arose and was repeatedly resurrected—describing the soil that nurtured it in its various iterations. And by discussing these environments, I will recount many details of the history of Mormon art and culture.

BACKGROUND OF THE STORY AND OF MORMON ART

In the Book of Mormon the story of Corianton occurs immediately after the story of Korihor, which is perhaps better known. Korihor is an unbeliever and is struck dumb when he comes into conflict with the prophet Alma. The Corianton story is also told right before the story of the war that the Nephites have with the dissident Zoramites and the Lamanites. It is while on a mission to the Zoramites that Alma's youngest son, Corianton, leaves the mission and pursue's a harlot named Isabel.

While Mormons knew this story from the beginning, it took decades of developing soil before it became the source material for Art. In some ways this development seemed to proceed quickly. The first Mormon poetry appeared just two years after the Book of Mormon was published, along with the first Mormon periodicals. Early attempts at Mormon short stories and plays appeared in the 1840s and 1850s. Along with these began to appear the resources required for Arts production: by the 1840s the Church owned a printing press, which was used to produce books as well as periodicals, and employed editors to produce its increasing print production. And, also by the 1840s, Mormon audiences experienced their first theatrical performances, using a fledgling group of Mormon actors and the culture's first building constructed for social events.

And as Mormons culture developed, the Mormon people went through experiences that informed Mormon Art immediately. Mormons experienced an extensive period of residing with the rest of the United States while being outsiders, being different. As

a result, when they tried to gather together in a single place the Mormon people were persecuted. Repeatedly, Mormons immigrated and found themselves in mass exoduses. They came from foreign lands to be with the main body of Mormons and, of course, that main body traced an exodus from Nauvoo to Utah that remains the largest in U.S. history. It must have seemed like everything that the Mormon people tried to do had political implications. And even after arriving in Utah there were political conflicts over the relationship of Mormons with the rest of the United States—especially over the practice of polygamy. All of these experiences were reflected in Mormon literature—principally in poetry.

While Mormon cultural development was certainly interrupted by the exodus to Utah (which shifted the center of Mormon cultural output to Liverpool, England), this was only temporary, and that development quickly continued in Utah. By 1850 Mormon periodicals were established there, and the Mormon writers and editors quickly began producing works again. And that was followed quickly by theatrical performances, performed in a variety of ad hoc venues. These soon led to the construction in 1862 of perhaps the premiere venue for theatre in the early Western U.S., the Salt Lake Theatre. Boosted by his experience acting in one of the first theatrical productions in Nauvoo, *Pizarro*, Brigham Young supported the theatrical arts in Utah and had the Church construct a venue where plays could be staged. For most of the latter part of the 19th Century, the Salt Lake Theatre was the only significant theatre between Chicago and San Francisco, making it a must for touring groups.

As a result, theatrical resources developed among the Mormon people. Salt Lake had actors, scenery producers, set designers, costume designers. The construction and maintenance of the Salt Lake Theatre led to a whole group of resources that wouldn't have been there otherwise.

HOME LITERATURE

In the 1880s, as the Church was going through a period of intense persecution—because the practice of polygamy had become intolerable to the rest of the nation—a second generation of Mormons arose. During the first generation, especially during the period before 1880, Mormons reacted to literature in general and especially to fiction—to novels—in a way that was common among Christians in the United States. Novels were not looked on kindly, and often were even seen as evil. And Mormon leaders said as much from the pulpit. For example, in 1853 Apostle Parley P. Pratt said, "We have no time to spend in reading novels or false things. Read the best books: the Bible, the Book of Mormon, the Doctrine and Covenants, and those things that contain truth." In 1862 Brigham Young damned novels with faint praise, saying, "Novel reading, is it profitable? I would rather that a person read novels than read nothing."

But, in spite of this preaching against fiction—against novels—many Mormons weren't listening. Novels and magazines made up a steady portion of the mail from the

rest of the United States and when the railroad reached Utah in 1869, the quantity of novels and fiction available in Utah only increased. In the midst of this flood of undesirable literature, Orson F. Whitney, President of the Young Men's Mutual Improvement Association, suggested a different strategy. In an 1888 speech entitled "Home Literature" Whitney suggested that instead of prohibiting novel reading Mormons simply needed a literature of their own:

> Choose between the false and true, between the unreal and the genuine. Seek ye out of the best books, the best newspapers, words of wisdom. Write for the papers, write for the magazines, especially our home publications. Subscribe to them and read them. Make books yourselves that shall not only be a credit to you and to the land and people that produced you, but likewise a boon and benefaction to mankind.

The movement that arose at the time of his speech is known today as the Home Literature movement.

Susa Young Gates, in 1888 the editor of the *Young Woman's Journal*, was another proponent of Home Literature. She described her view of literature this way:

> Novels are true or false according to the way they picture life. If characters, events, and scenes are unnatural then the story may be said to be false, and is hurtful, inasmuch as it creates ideals that can never be realized and often bring sorrow and disappointment in life. Such are the novels against which our girls are properly warned. But a true work of fiction, that is a story whose counterpart can be found in real life, educates the mind and the heart as no other literature can. Such fiction is often truer than history.

Another proponent of this change in intellectual understanding was B. H. Roberts. The same year that Whitney gave his speech, Roberts wrote an essay entitled "Legitimate Fiction", in which he wrote:

> What in the main I wish to call attention to is the fact that it is becoming generally recognized that the medium of fiction is the most effectual means of attracting the attention of the general public and instructing them. The dry facts of a theory respecting social reform must be made to live in persons and work out the results desired. The essayist is a character of the past, the novelist of a certain type is taking his place.

Under this logic, Home Literature became the dominant form of Mormon literature.

B. H. Roberts' Novella "Corianton"

The year before B. H. Roberts wrote this explanation of literature, he had just returned from his third mission and was soon called to the presidency of the seventy. He was 32 and had also just married his second wife. It was at this point that Roberts put

his 'money where his mouth is' and wrote a short story called "The Story of Zarahem-la," which attracted little attention and has now largely been forgotten. His next work was much more enduring.

Roberts continued his literary efforts a few months later with Corianton, published in 5 installments in the *Improvement Era*. In this novella, Roberts conflates several stories in the Book of Alma. He starts with the story of Korihor, melding it into a political story about Corianton and his attempts to reconcile himself with his father and go out to be with the mission to the Zoramites. In the story Roberts draws a parallel between Korihor and Corianton, as they are both finding ways of reconciling their faith with their doubts. With this background, the story of Corianton pursuing the harlot Isabel becomes a political attempt to deceive Corianton, discredit the mission to the Zoramites and destroy the government of Zarahemla. Probably better than average for most works of the Home Literature movement, the novella was clearly a success.

MORMONISM IN THE 1890S

In the year's following *Corianton's* initial publication, Mormonism changed significantly. President Wilford Woodruff issued a manifesto in 1890 beginning the end of the practice of polygamy among Mormons. And during that decade the Church made an outward turn, looking to find ways of connecting with the rest of the world. Utah became a state in 1896 and the Home Literature movement led to Mormons publishing novels. Probably the most famous Mormon novel of the 1890s was titled *Added Upon*, written by Nephi Anderson. A "plan of salvation" story, *Added Upon* tells of a family passing from the pre-existence through this earth life (converting to Mormonism while in this life, of course) and on into the next life. *Added Upon* is likely one of the influences on the popular play, *Saturday's Warrior*, which is also a plan of salvation story.

ORESTES UTAH BEAN'S "CORIANTON" (1902)

Sometime before 1902 a schoolteacher from Richfield, Utah, with the unusual name Orestes Utah Bean, became enamored with Roberts novella *Corianton*. He combined Robert's story with elements of another popular Book of Mormon story, *A Ship of Hag-oth*, which was Julia McDonald's sequel to the B. H. Roberts novella. Bean melded these two stories together and created a melodramatic play that included a love interest for Corianton named Relia. In the play, Bean maintained the political and military conflict from Robert's original story. He also changed the name of the harlot in the Corianton story to the more exotic "Zoan ze Isobel."

Bean convinced a Logan-based entrepreneur, George Blair, to produce the play. Blair brought in experienced actors from New York, including the then well-known Joseph Haworth and the future Broadway star Thais Magraine, who played Relia. He also brought in a New York City Church member, Agnes Rose Lane, also an actress of

some renown, to play the part of Zoan Ze Isobel. The cast also included local actors, such as Brigham Young III,[2] who played the part of Alma the Younger, Corianton's father; the well-known Mormon actor John Lindsay, who played the part of Nephihah; and a group from a local Young Ladies MIA, who played Zoan Ze Isobel's fellow harlots. Perhaps reflecting Utah views of local capabilities, Blair declined to use theatrical materials and resources that were available in Utah. In fact, an advertisement for the play trumpets the fact that scenery was imported from New York, set design from from Boston, and costumes from New York. The imported materials and resources may have, in fact, been better than what could be provided in Utah, but the advertisement also betrays local values.

The play was a resounding success. It opened in August of 1902; at least 12 of the performances were such a resounding success that the producers were very, very encouraged. Quickly it went on the road to Logan and Ogden, where it also did well. The critics, however, weren't that impressed. One was outright blunt, he said, "In literary merit, it is downright bad." Another was somewhat hopeful and suggested that the first two acts held the audience spellbound, but by the last act the play was too melodramatic to be taken seriously. And a third critic said that the play was too long (the running time was reported to be about 4 hours) and he recommended that it should be shortened "by eliminating scenes that can only be improved by elimination."

Given the success, *Corianton* went on the road. To broaden the play's audience, performances were mounted first in Denver, then Helena, Montana, then Omaha, finally in Kansas City. But in all these places audiences failed to materialize. The producers ran out of money in Kansas City and Bean fought with the producers over what to do. The conflict led Blair to write,[3] "I think of all idiots, he (meaning Bean) was the bluebird of the bunch." In the end at least some of the actors had to find their own way home. Joseph Haworth, however, still believed in the play and even asked for an ownership stake, claiming vociferously that he could get it produced in New York.

Over the next decade revivals of *Corianton* appeared in Utah regularly, including a production with a brand new cast in 1903, less than a year later, perhaps to earn back the losses from going on the road. Licensed amateur performances occurred all around Utah. Another revival appeared in 1909, and even as late as 1918 an amateur performance appeared in the Salt Lake Theatre.

CHANGING MORMONISM 1900-1930

During the same time that *Corianton* was being revived the environment for Mormons and Mormonism was changing significantly, especially in politics. In 1904 Mormon Apostle Reed Smoot, newly elected to the U.S. Senate, was embroiled in a dispute over whether he should be seated in the Senate. While that controversy ended a few years later, it led to attacks on Mormonism in periodicals across the U.S. that were initi-

ated and encouraged by Mormon dissident politician Frank Cannon. This environment influenced the next iteration of *Corianton*.

The first part of the 20th Century also saw the development of motion pictures and the industry for producing and distributing film. Mormons didn't hesitate to get involved. The first filmmaking efforts in Utah and the rise of film theaters in Utah occurred in the decade following the first performance of *Corianton*. A couple of brothers, Lester and Byron Park, owners of a few early film theaters, were an important part of the early Utah film industry. And while the film industry grew, the role of live theaters changed, with some converting to showing films and others changing how they operated. By 1928, the Church determined that the Salt Lake Theatre was no longer useful for its message or for the Utah audience, so it was torn down.

BROADWAY PLAY: "AN AZTEC ROMANCE" (1912)

As a person, Orestes Bean was nothing if not persistent. In 1912 he opened an office in New York City, anxious to get his play produced on Broadway. He had worked a lot on the script for *Corianton* over the previous decade—he'd received a lot of feedback and had made many changes. The play was shorter and probably better, but it was still Orestes' baby, and he seems to have resisted a lot of changes. He hired a New York theater agent to help him, and by the summer of 1912 they were ready. Given the public view of Mormonism, they changed the name of the play from *Corianton* to *An Aztec Romance*. The cast was composed of well known Broadway actors, including Robert Warwick (Corianton) and Minnie Titel Brun (Zoan Ze Isobel). The play opened on the 16th of September of 1912 in the Manhattan Opera House (West 31st Street between 8th and 9th Avenues). Now called Manhattan Center, it was originally constructed as an Opera house and may have seated as many as 2,000 people. Obviously, Bean and his producers expected great things from the play.

Critics didn't see it as great, however. One critic called it "Ben Hur minus the chariot race." Another called it "A mixture of Shakespeare and the Bowery." *The New York Times* said "Its sound and fury, signifying nothing." And the *Brooklyn Eagle* suggested that Bean should have regrets, "Orestes Bean did it. Now perhaps he is sorry he did it." *An Aztec Romance* lasted for the minimum of a week (8 performances) and closed.

FILM: "CORIANTON" (1931)

Following the failure of *An Aztec Romance* in 1912 Orestes Bean apparently took a break from his play for nearly 15 years. Sometime during the beginning of this interval he met and married Effie Sweeney Bond—sometime before 1918 since in 1918 he listed Effie as his wife on a draft registration. He also listed his residence as 94th Street and Broadway and his profession as "inventor." That profession resulted in news reports in 1925 of a gas utility testing a manufacturing process he invented.

It is perhaps not a coincidence that Orestes returned to his play about 1928, a year after his wife Effie, who was not Mormon, died in 1927. Orestes may also have been influenced by meeting, at about this time, Lester and Byron Park, who owned film theaters in Ogden. After the Park brothers purchased the rights to produce a film of the play *Corianton*, Bean accompanied them on tour, especially in Utah, to raise money to make the film. The three were also accompanied by self-help guru Napoleon Hill, himself touring the country promoting his first book *The Laws of Success*.[4] These efforts to raise money were ultimately successful, in spite of the stock market crash of 1929. To direct the film, the Park brothers hired a retired film director named Wilfred North and again the show involved veteran, non-Mormon actors, Herschel Mayall, Lillian Savin, and Joseph W. Smiley, among others. Filming was at Metropolitan Studios in Ft. Lee, New Jersey, a large sound stage dating from before the 1920s, when most film studios moved to Hollywood. As a result, the studios in Ft. Lee had excess capacity, making it easy to get films done very cheaply there.

Sometime while he was working to get the film made, Orestes Bean met the younger sister of one of the girls who was in the 1902 production of *Corianton* in the Salt Lake Theatre, Eddavene Houtz. She and Orestes married in May of 1930, perhaps distracting him from the filming.

While Bean was gone, apparently visiting his wife, Wilfred North hired in a New York City burlesque dancer named Bunny Weldon and her "Greenwich Village Dancing Girls" to play the supporting roles of the other harlots who worked with Zoan Ze Isobel. As a result several scenes in the film feature these scantily clad dancers, leaving the modern viewer perplexed about how this film could have been written and produced by Mormons.

Corianton was made right after the 1930 Hayes code, Hollywood's first attempt at controlling and censoring the moral content of film. Before 1934, when the updated code first included an enforcement mechanism, many mainstream movies included scenes that even today many viewers would find objectionable—nudity, graphic violence, etc. But because the code was new and unenforced in 1930, the director, Wilfred North, likely didn't feel too restricted in how he presented *Corianton*. In addition, North had come out of retirement to direct the film and was working far from the industry center in Hollywood, so he may not have known much about the code or given it much consideration. As a result, less than 2 minutes into the film, a scene of running text giving background information features a young woman who appears topless. Between this and the scantily clad "Greenwich Village Dancing Girls," Mormon audiences had reason to object to the film.

Corianton opened on LDS General Conference weekend in October of 1931, when the promoters assumed they would maximize the audience for the film. Whether because of the disregard of the audience's feeling about nudity or for some other reason, the audience failed to support the film, even in Salt Lake. The expense of the film and

the large number of small investors brought in by the fundraising tour led to a number of lawsuits, which dragged on for six years or so as participants blamed each other and investors tried to recoup their losses. Lester Park, one of the producers, took his copy of the film and the related materials that he had and went home to a farm he owned in North Carolina and put them away in the barn.

Despite the film's failure, Edaveene Houtz Bean, Orestes' new wife, legally changed her name to Zoan, and went by that name for the rest of her life. She and Bean moved to California in 1934, and, when he was teaching Sunday School there, Bean was known for quoting from his play as if it were part of the scripture. That didn't last too long, for Bean passed away in 1937. But his wife Zoan lived until the 1960s.

MORMON CULTURE SINCE THE FILM "CORIANTON"

By the time the film *Corianton* was finished, Home Literature was changing to reflect contemporary tastes. A form of Home Literature continued through the 1960s in magazines like the *Relief Society Magazine* and the *Improvement Era*, where it continued to provide Mormons with literature acceptable to their tastes and standards, but otherwise similar to popular literature. But because its purpose was so oriented towards supporting the gospel and teaching gospel principles, a "lost generation" of Mormon writers arose. This group included writers like Vardis Fisher, whose novel *Children of God* won the Harper Prize in 1939; Virginia Sorensen, author of *A Little Lower than the Angels*; Paul Bailey, author of *For Time and All Eternity*; and Samuel W. Taylor, author of *The Absent Minded Professor*. Their novels represent a separate period in the history of Mormon literature.

Alongside the transition in Mormon fiction, Mormon theatre went through a renaissance period following the film. The Mutual Improvement Association, the church's group for both youth and young adults, encouraged every local congregation's MIA to put on a play every year. Under this policy, the MIA produced a Book of Plays each year, which included short, reasonably and easily done plays, generally from Broadway, and then provided the books to ward and branch MIAs throughout the church so that they had the materials they needed to produce the plays. By the mid to late 1940s the MIA Book of Plays usually included a play by a Mormon playwright. Although the last Book of Plays was produced in 1968, this theatrical heritage led directly to the popular Mormon plays of the 1970s—especially *Saturday's Warrior*, but also *The Order Is Love*, *My Turn on Earth*, and others.

DENOUEMENT

Despite the failure of the film and the death of Orestes Bean, *Corianton* didn't completely go away. Zoan Bean tried to get her husband's play produced over and over again. She tried to get it made for television, but she was unable to convince anyone in

Hollywood to do so. Late in life she tried again to make new art out of *Corianton* by writing a novelization of it. It was never published, however.

The film itself, as happened with many films of the 1930s and earlier, was thought lost. No one had seen a copy. While copies of the original novella and copies of the play, both of which had been published in book form were available in libraries, the film seemed to be gone. But in the 1980s the popular Mormon novelist Orson Scott Card found that his family had a copy of the film and associated materials that his grandfather, Lester Park, had stored in his barn.

FINAL THOUGHTS

This unusual ending to *Corianton*, with the film discovered in Card's grandfather's barn, is both amusing and instructive, I think, about the size of Mormonism and the connections of Mormons today with their history. It may also suggest something about our ability to find hidden gems among the materials that our ancestors have.

This history of how *Corianton* became a novella and a play and a film is, I think, relevant today, especially when considering the resources and environment required for Mormon art. It is notable how much Orestes Bean persisted in trying to get his works produced. He tried multiple times, in multiple different soils, both in the theatre and in film. He tried inside Utah and outside Utah. He believed in his product, but that apparently wasn't enough.

It is perhaps surprising to note that there was a decline in the Mormon resources that were used with each iteration of *Corianton*. B. H. Roberts' novella was thoroughly Mormon: written by a Mormon, edited by Mormons, and published in a Mormon magazine. It is very possible that no gentile hands ever touched it before publication. But by the time *Corianton* became the 1902 stage play, the producer brought in outside resources to get it done. And, of course, the 1912 Broadway play and the 1931 film were produced almost exclusively by non-Mormons. Does that matter? When exactly are Mormon resources needed for a work of Mormon art? And when are outside resources and why?

Another question that arises from this story is why no other Mormon plays followed *Corianton*. Why weren't there other Mormon plays that followed on its heels and were produced? The Salt Lake Theatre still existed for almost three decades past when *Corianton* was first produced there. Other theaters existed in Utah. There were actors and stagehands and set designers. From a resource perspective, there wasn't any reason why other Mormon plays couldn't be done. Yet few, if any, Mormon plays were produced.

In my view these questions help us a little bit to understand what the Mormon Arts Center Festival is about. Mormons need a space to figure out how to make a Mormon Art—one that has impact in our lives, one that uplifts and makes Mormons better

people, one that allows Mormons to create—for creation is a fundamental concept to the Mormon understanding of eternal life, as well as to the understanding of this life.

So, what soils does Mormon culture have now? What soils are needed? Can the soil that Mormon culture has be enriched? I believe so. And I hope that the Mormon Arts Center Festival is part of that.

ENDNOTES

[1] I acknowledge here the debt that I owe to LDS researcher and historian Ardis Parshall, a great friend whose work on *Corianton* represents the bulk of the factual information I've drawn on for this presentation. Ardis has done more work than I will ever do on compiling and studying the history of Mormons and Mormons in Art, and in many other fields. She deserves more credit than she is often given.

[2] My great grandfather.

[3] Writing from Kansas City on October 31st of 1902.

[4] This was Napoleon Hill's first book. He is best known today for a book he published in 1937, *Think and Grow Rich*.

ADAM S. MILLER

WHY JESUS LOVES NOVELS

1. THE POWER OF FICTION

Do you remember the first real grown-up book you ever read from beginning to end? The first book that, unlike the *Hardy Boys* or the *Chronicles of Narnia*, was meant for adults? Do you remember how old you were? How heavy it was? Do you remember the cover?

In sixth grade, I read my first two grown-up books at the same time: I read the Book of Mormon all the way through and I read Frank Herbert's sci-fi classic *Dune* all the way through. The Book of Mormon was bound in stiff, brown, imitation leather as part of a triple combination. I used an orange highlighter that bled through the pages. *Dune* was a fat, yellowed, mass market paperback from my brother's collection of books and the cover was printed in dark blues, browns, pinks, and blacks, dominated by sweeping, alien, dunes of sand. When he handed over the book, my brother took pains to impress upon me that *Dune* was "*the best science fiction novel ever written.*" I received it from his hands with reverence and I took up the hard work of reading it with devotion.

I read both of these books for the first time at the same time. I've been reading the Book of Mormon ever since. But, just last month, I read *Dune* again for the first time in maybe twenty years. I'd forgotten a lot of details. Reading it again was harrowing, revelatory—and a bit embarrassing. Re-reading *Dune*, I felt like my mind's veil—the veil that conceals from me the hidden, inner logic of my own psychic economy—had been pulled back for a moment. And behind that magic curtain? *Dune*.

From the start I've been keenly aware of how thoroughly the Book of Mormon had colonized my heart and mind, of how profoundly my life had been appropriated by it. But it wasn't until a couple of weeks ago that I began to appreciate the size and depth of the emotional and cognitive crater that *Dune* had left in my eleven year-old mind. Anyone who's read anything I've written knows that there are only a handful of ideas that interest me. There are only a handful of ideas about religion that have shaped all of my work in philosophy and theology and I circle back to them again and again. And, it turns out, all of them are clearly and explicitly central to *Dune*.

It seems that *Dune* is, for me, a kind of primal scene. I don't think it's an exaggeration to say that, without quite knowing it, I've spent the last thirty years thinking about *Dune* and trying to replicate *Dune*. I suspect that I have, essentially, spent the last thirty years subterraneously treating *Dune* as a secret key to understanding my own religion. For better and worse, *Dune* and the Book of Mormon are hopelessly tangled in my eleven year-old mind.

What is *Dune*? What is it about? *Dune* is, in essence, a long, philosophically sophisticated meditation on what it means to be a messiah. Herbert intentionally designed the novel as a living, breathing, complex staging of what a real world messiah would look like.

I'm not going to offer an actual reading here, but let me just note three key ideas that are central to this staging:

(1) Herbert sees the expansion of consciousness—especially the disciplined work of training and refining the raw human capacity for just plain *paying attention*—as the key to a messianic condition. In retrospect, it seems obvious to me that my own life-long (practical and theoretical) interest in contemplative practices grew directly from my reading of *Dune*.

(2) Herbert sees this messianic expansion of focus, attention, and consciousness as intertwined with family and genealogy. Messianic consciousness is, as he puts it, a "race consciousness" that wakes up to itself as the nexus of the past and future genealogical threads that define the human race as such. Without quite realizing it, I think Herbert's articulation of a genealogical consciousness has long been my template for understanding Joseph Smith's genealogical account of salvation.

(3) Herbert's approach to religion is profoundly pragmatic. He simultaneously treats religious forms and prophecies as intentionally cultivated fabrications and, nonetheless, as real and realizable. On his account, the messiah is both a fiction and a reality. On his telling, all messianic prophecies have been, to some degree, cynically fabricated and propagated by the powers that be—but these prophesies *still* come true and overturn those same powers.

Perhaps I'll come back to these particular themes another time. But in this essay I just want to leverage this bit of psycho-biography to reflect on the power of fiction itself. And, in particular, I want to reflect on the *theological* power of fiction.

My working thesis is this: theology, especially the academic kind, should be practiced a form of fiction. Or, academic theology is best understood as a kind of science fiction that extrapolates from what is currently given in order to explore the full shape of the messianic powers that are only partially expressed at present. To borrow a phrase from Marilynn Robinson, academic theology is like excellent, hard science fiction writing in that both "fling some ingenious mock sensorium out into the cosmos so that it can report back what it finds there."[1]

On my account, then, academic theology generally ought to practice what, following François Laruelle, we might simply call *christo-fiction*,[2] a kind of fiction that frames hypothetical scenarios for the sake of mapping Christianity as a power that has been only partially expressed in both the past and the present.

2. THEOLOGY AS CHRISTO-FICTION

In general, on my view, theology should treat Christianity as a power rather than a thing. On my view, all *actually* existing things are just the presently exposed face—a presently exposed sliver—of the *power* that they really are. We might say, then, that I'm aiming, in a philosophical vein, to avoid the problem with those professors that Christ outlines for Joseph Smith in the First Vision.

In the canonized account of his First Vision, Christ addresses Joseph and, echoing 2 Timothy 3:5, warns Joseph against the "professors" of the Christian creeds because they "draw near to me with their lips, but their hearts are far from me, they teach for doctrines the commandments of men, having a form of godliness, but they deny the power thereof" (JSH 1:19).

This is a philosophically provocative formulation. Classically, Christian theology has been almost entirely consumed with the work of reflecting on and pinning down forms and essences. That is, it has been almost entirely consumed with the work of defining the "form" of godliness.[3] Basically the business of thinking about God and religion has been the business of identifying the fixed forms and essences that define such things.

But, in my view, when we treat things (perhaps, especially, godliness) primarily in terms of static forms and essences, we risk "denying the power thereof." The key to treating things as powers rather than as forms or essences—the key to not denying their power—is to consciously resist a metaphysical equivalence to which we almost irresistibly default. The metaphysical equivalence is this: we treat reality and actuality as co-extensive. That is, we define what is *real* in terms of what is *actual*.

Philosophically, the problem with equating the real with the actual is that power is a potential. Power aligns with potentiality rather than actuality. A power that is wholly actual is no longer a power because all of its potential has been exhausted. And, moreover, if reality is defined in terms of actuality, then power, as potentiality, is by definition *not real* (or it is real, at best, only in an attenuated, derivative way). By default, Western metaphysics has traditionally treated power as a function of formal properties and it has ontologically subordinated potentiality to actuality.

But my question is this: what would it look like to describe power in its own right? What would it look like to treat power—even when it is inoperative and unactualized; maybe especially when it is inoperative and unactualized—as nonetheless fully real? What would it look like to treat power and potentiality as coextensive with reality and then, in turn, treat actuality itself as just a derivative, local expression of a given power?

One model for describing power as such is what Gilles Deleuze calls the "virtual."[4] Virtuality names a *structured space of possibilities*—a given power with a specific shape—that is real and definable even if it is not, by definition, reducible to what is actual.

Let's say, then, that as a Christian theologian what I specifically want to investigate is the power of Christ. Let's say that I want to investigate Christ *as* a power. If so, then I will clearly need to take into account the available descriptions of what Christ has actually done in the past and what Christ is actually doing in the present. I will need history, psychology, anthropology, sociology, etc. But this is not enough. If I limit myself to what is actual, then the power of Christ will only have been sketched in the barest, thinnest way. Rather, to address the power of Christ as such I need to treat these descriptions as just preliminary data points that, in turn, reveal something essential about the *virtual structure* of the power of Christ. Then, working from these accounts of the actual, the theologian can tentatively and hypothetically construct fictional simulations (as a hard science fiction writer would, extrapolating from the present a fictional scenario) that can then be explored in order to help flesh out the shape of Christ's power. The structure of this virtual space can be mapped both by way of historical events and by way of fictional simulations.

If truth is a description of what is real—and, too, if reality is not reducible to actuality but must also take into account the structured powers and potentialities that give, shape, and reshape what is actual—then truth itself can (and, perhaps, must) include not only history but fiction. Let me repeat that claim: *truth itself must include not only facts but fictions in order to offer a full account of what is real.* Theology is about what is real, even if reality is only partly determined by what is actual. Why is it only partly determined by what is actual? Because power is real and power is, by definition, not actual. As a result, theology must work not only by way of representations but by way of fictions, hypotheses, and simulations.

3. A CASE STUDY IN THEOLOGY AS FICTION

I want to consider then, a case study in theology as christo-fiction. Let's take Ted Chiang's short story "Hell Is the Absence of God."[5] You can find this story in the book *Stories of Your Life and Others* (a collection that includes the short story upon which the excellent science fiction movie, *Arrival*, was based).

In "Hell Is the Absence of God," Chiang posits a world where angelic visits are common. They're just an ordinary part of everyday life and, when they happen, they're reported like the weather on the evening news. As a result the story's protagonist, Neil, has a pretty typical, blasé response to these supernatural phenomena. Neil "became an adult who—like so many others—viewed God's actions in the abstract until they impinged upon his own life. Angelic visitations were events that befell other people, reaching him only via reports on the nightly news."[6]

More, in this hypothetical world, in addition to angelic visits, life after death is demonstrable, heaven's reality is well attested, and hell is frequently visible.

It meant permanent exile from God, no more and no less; the truth of this was plain for anyone to see on those occasions when Hell manifested itself. These happened on a regular basis; the ground seemed to become transparent, and you could see Hell as if you were looking through a hole in the floor. The lost souls looked no different than the living, their eternal bodies resembling mortal ones. You couldn't communicate with them—their exile from God meant that they couldn't apprehend the mortal plane where His actions were still felt—but as long as the manifestation lasted you could hear them talk, laugh, or cry, just as they had when they were alive.[7]

What kind of response did such visions solicit? For Neil, these manifestations didn't make much of a difference either way. "Like every other non-devout person, Neil had never expended much energy on where his soul would end up; he'd always assumed his destination was Hell, and he accepted that."[8] Or, as Chiang also says: "Of course, everyone knew that Heaven was incomprehensibly superior, but to Neil it had always seemed to remote to consider, like wealth or fame or glamour."[9]

If you're unfamiliar with the story, you might suspect that Chiang's set-up is a way of staging these traditional Christian beliefs as the stuff of farce. You might suspect that he is mining this christo-fictional simulation for the sake of comedy. But Chiang never does this. He never kids, winks at the reader, or makes fun. The brilliance of his story flows directly from the fact that Chiang always plays it straight. His christo-fiction is dead serious. He wants to know what would really happen, how would people really act and react, if the basic elements of a Christian worldview—like the existence of God, angels, heaven, and hell—were obvious, commonplace, and verifiable. What if the basic outlines of a Western (mostly Christian) monotheism were an uncontested fact? What difference would it make?

The temptation is to think that, as a result of this knowledge, everyone would surely straighten up and fly right. The temptation is to think that, with this knowledge, the big questions of human existence would finally be settled. But this isn't what happens at all. Just the opposite. Even with this knowledge, all of the same, basic, human problems remain in play.

It's true that Chiang's christo-fiction gives the world's governing, theological frame a kind of verifiable clarity and definition that our world lacks. But, Chiang suggests, for the most part, that kind of frame isn't decisive. It doesn't decide for us what we might hope it would decide. Even in this scenario, people are still people. Even knowing what they know, some are religious, some are indifferent, some are distracted, and some are rebellious. People are still busy working, shopping for food, mowing the lawn, falling in love, having children, and mourning the loss of loved ones. People are still preoccupied with themselves and they're still firmly rooted in the very local troubles and pleasures of life.

And, what's more, even when they know these supernatural facts, people still have to bear responsibility for deciding what these facts mean. People still have to wrestle with how to *live* in response. In this vein, reflecting on one of the story's secondary characters, Chiang notes that:

> Ethan had been raised in a family that was devout, but not profoundly so. His parents credited God with their above-average health and their comfortable economic status, although they hadn't witnessed any visitations or received any visions; they simply trusted that God was, directly or indirectly, responsible for their good fortune. Their devotion had never been put to any serious test, and might not have withstood one; their love for God was based in their satisfaction with the status quo.[10]

Or consider the story's inciting event, an angelic visitation in which Neil's wife dies, collaterally damaged and mortally wounded by the overwhelming power accompanying the angel's manifestation. The loss of his wife—who visibly ascended into heaven at her death—forces Neil to reconsider his prior indifference to God.

> Neil could have taken it as a reminder that no one can count on having decades left. He could have been moved by the realization that, had he died with her, his soul would've been lost and the two of them separated for eternity. He could have seen Sarah's death as a wake-up call, telling him to love God while he still had the chance. Instead Neil became actively resentful of God. Sarah had been the greatest blessing of his life, and God had taken her away. Now he was expected to love Him for it?[11]

Neil could have responded in any number of ways. But instead of being moved to gratitude or repentance, he found himself filled with anger and resentment. Knowledge doesn't free Neil from responsibility for his life, it just resituates that responsibility. Even knowing that his wife is dead but not gone, that life after death is real, and that heaven (and hell) are live possibilities, Neil must still bear the burden of living his own life from the inside out. This responsibility can't be outsourced and no amount of knowledge could relieve him of it. This existential problem is not simply an epistemological problem. Even with angels flying around, God's existence verified, and windows regularly opening onto hell, the existential responsibility is still basically the same.

Chiang's serious staging of this christo-fiction is provocative, but it seems to me that he is almost certainly right. It seems obvious to me that definitive revelations of a supernatural order would certainly cause an initial stir, but that in short order people would digest the news and go back to the business of living their ordinary lives.

Consider, for example, a parallel case involving the Book of Mormon. What would change, how would the world be different, if we could *prove*, say, that an angel sent from God personally delivered the golden plates to Joseph Smith? Or if we could unequivocally demonstrate that the people and events described in the book were historical?

How would the world be different if the Book of Mormon weren't so obviously implausible?

Following Chiang, I expect that very little would be different. I suspect the Book of Mormon's verifiability wouldn't make much difference at all. Why? Because all of the same, basic human problems would remain in play. If God definitively and simultaneously revealed the truthfulness of the Book of Mormon to the whole world during breakfast tomorrow morning, it would certainly cause a stir and cable news networks would pull in record ratings. But, in short order, people would absorb the news and go back to the business of feeding their baby, walking their dog, filing their paperwork, doing their laundry, and finding something to watch on Netflix.

As a convenient kind of shorthand, we might simply call this test for the existential impact of a revelation something like "the Netflix test." If the Book of Mormon were proven true, would Netflix go out of business? Would we stop watching? Such an outcome seems extraordinarily unlikely to me.

Well, then, so what? What does this mean? Does this mean that people are, in general, irredeemably hard-hearted and stiff-necked, just congenitally indifferent to God and the miraculous? Maybe. But even if we are, I don't think that's our main problem. In fact, I would argue that we should not understand our inevitable re-absorption in the ordinary as, in itself, a way of avoiding God or what's at stake in religion. Rather, I think that our inevitable re-absorption in the ordinary is, in fact, a good indication of where all the *real* religious action is at. It's an indication of where the real drama of life and salvation unfolds.

Even if I could see Hell through the tile of my kitchen floor, even if I had authenticated video of Moroni delivering the plates to Joseph Smith, even if I regularly entertained angels, or had confirmed sightings of God, all of my basic human problems (that is, all of my *real* religious problems) would remain same. Unable to verify the Book of Mormon's historicity, I'm faced with a certain set of deeply serious religious questions about how to love both my neighbor and my enemy. But even if I could verify the Book of Mormon's historicity, I would still be face with that same set of deeply serious religious questions about how to love both my neighbor and my enemy. I'd still have to manage the hard work of suffering all the love, indifference, beauty, and entropy of everyday reality. In short, I'd still have to live. And these kinds of decisions can't be made by anyone but me, on the ground, in real time, as I handle the most ordinary troubles and pleasures of life.

4. CONCLUSION

The events described in Ted Chiang's "Hell Is the Absence of God" didn't actually happen. His story is a fiction. But it's a powerful fiction that, even if it fails to be actual, squarely connects with what's real. Chiang's christo-fiction runs a simulation that, by

tweaking the parameters of what is actual, manages to reveal something crucial about the role that knowledge, in general, plays in our relationship to God. His fiction reveals something not just about the collection of *things* we actually know, but about the *power* such knowledge does and doesn't have. This kind of knowledge—knowledge about supernatural facts—cannot save us. By helping to reveal the limits of this power, Chiang reveals something crucial about what knowledge really is and, by extension, what it really means to be both human and religious. Something deeper, something more human, something more ordinary than supernatural facts is in play with respect to redemption. Something that no amount of information can, of itself, decide. Something that we often try to capture with words like "faith" and "love."

The revelatory force of stories like Chiang's is, it seems to me, part of what makes fiction so powerful. And, more, their revelatory force is part of why theology itself, aimed as it is at the fullness of reality, must learn to practice the art of fiction and never settle for actuality.

ENDNOTES

[1] Marilynn Robinson, *The Givenness of Things* (New York: Farrar, Straus and Giroux, 2015), 220.

[2] François Laruelle, *Christo-Fiction: The Ruins of Athens and Jerusalem*, trans. Robin Mackay (New York: Columbia University Press, 2015).

[3] Though it's worth noting that the word in 2 Timothy 3:5 is *morphosis* rather than *eidos*.

[4] See, for instance, Manuel DeLanda's astute and relatively accessible account of the "virtual" in his *Intensive Science and Virtual Philosophy* (London: Continuum, 2002).

[5] Ted Chiang, "Hell Is the Absence of God," in *Stories of Your Life and Others* (New York: Vintage Books, 2016).

[6] Chiang, "Hell Is the Absence of God," 206.

[7] Chiang, "Hell Is the Absence of God," 208-209.

[8] Chiang, "Hell Is the Absence of God," 208.

[9] Chiang, "Hell Is the Absence of God," 209.

[10] Chiang, "Hell Is the Absence of God," 214.

[11] Chiang, "Hell Is the Absence of God," 218.

GLEN NELSON

JOSEPH PAUL VORST AND POLITICAL ART OF THE GREAT DEPRESSION

In 1967, to goad BYU professors into an amplified vision of training future generations of Mormon artists, then-Elder Spencer W. Kimball invoked the names of canonical artists of western culture. By doing so, he opened a discussion that has continued within the Mormon arts community for 50 years. He asked, "Why cannot we discover, train, and present many Paganinis and other such great artists?"[1] He listed sterling examples in a grand, rhetorical *what if.* These included creative artists Shakespeare, Wagner, Verdi, Bach, Handel, Shaw, Lizst, da Vinci, Michelangelo, Goethe, Rembrandt, and Raphael and another group of performing artists of similar stature. In essence, he asked, Where's the Mormon Michelangelo? Can't Mormon artists be great?

He did not, however, define what "great" means.

I think we would all agree that an ingredient list of greatness includes superior technical mastery and astonishing innovation. Such attributes alter the courses of art history by creating artworks that so far outshine or out-think their peers that they elevate the very idea of what is possible—and President Kimball's roster of artists exemplifies these qualities. I would also argue that a key component of artistic greatness is relevance. Beyond technique and creativity, there must be content, and it ties into influence. I ask myself, what did the plays, poems, and essays of Shaw and Shakespeare *mean* to theatergoers and readers? What influence did the music of Verdi and Wagner have on the *actions* of politicians and patrons in Europe? What *power* did Goethe exercise? What *effect* did Bach have on court? And so on and so forth. This concept of relevance is key to an understanding of why art matters in society, whether it lasts, and what its powers ultimately are. I also believe it to be a missing component in the discussion of Mormon art and often absent from a wish list of qualities from LDS artists themselves.

Rather than discuss the philosophical possibilities of art and how Mormon artists in particular have achieved (or not) the vision of President Kimball, today I would like to present the example of a single Mormon artist, whose name might be new to you, and explore how his art, fashioned in a time of global turmoil provides a template of how Mormon artists can engage in the world, affect change, and create work that aspires to greatness.

Joseph Paul Vorst was born in Essen, Germany in 1897, joined The Church of Jesus Christ of Latter-day Saints in 1924, immigrated to the United States in 1930, and lived the rest of his life in St. Louis, Missouri. He died in 1947 at the age of 50. Lest you discount his importance to the history of American Art and to Mormon Art because you may be unfamiliar with him, here is a partial listing of his American museum exhibitions during his lifetime: the Metropolitan Museum of Art, the Whitney Museum of American Art, the Art Institute of Chicago, Library of Congress, San Francisco Museum of Art, Corcoran Galleries, the New York World's Fair, Kansas City Art Institute/ Nelson-Atkins Museum, Pennsylvania Academy of Fine Arts, Carnegie Institute, St. Louis City Art Museum, Art Institute (Dayton), Museum of Art (Toledo), Golden Gate Exhibition, Virginia Museum of Fine Arts, even the White House. (What would the visual artists in this room today give to exhibit in any *one* of these institutions?) These are Vorst's museum credits. And after his death, his art entered into additional public collections of significance including the National Gallery of Art, the Smithsonian, Crystal Bridges Museum of American Art, and others. He also showed in commercial fine art galleries of distinction and historical importance in St. Louis, here in New York City, and elsewhere.

I want to get to Vorst's artwork as quickly as possible rather than spend too much time on his biography, so here is the briefest possible overview: he grew up in poverty in a family of 10 children in Western Germany; his father died before Vorst turned 21; as a teenager, Vorst fought and was injured in WWI; his art studies included unsurpassed access to German Modern masters; his conversion to the Church altered the path of his work; he knew and drew royalty and heads of state; after being roughed up by Nazi stormtroopers, he became, as he put it, "of anti-Nazi mind";[2] his peers and teachers were labeled "degenerate" by the National Socialist German Workers' Party (the word "Nazi" is a truncation of "Nationalsozialist"). A "degenerate" artist was forbidden to exhibit or sell their work, or teach; upon arriving in the U.S. at the beginning of the Great Depression, Vorst settled near relatives in St. Louis. His commitment to his Mormon faith continued, and he visited Salt Lake City to do temple work and exhibited art in Utah; he became involved with the Ste. Genevieve Art Colony in Missouri and its leading artist-teachers, Thomas Hart Benton and Joe Jones. These two led important American art movements of the day Regionalism (a style that depicted the people and landscape of America's heartland) and Social Realism (similar subject matter but with a goal of affecting change, politically). Vorst's award-winning and widely-exhibited work fits in both philosophical camps.

Vorst knew poverty intimately. Here is a passage from the only document the artist wrote about his childhood:

> I was not very old, however, before my father found that I showed talent in drawing with pastel and managed to send me to an art school aided by several scholarships which I was fortunate enough to have awarded me. Although I

did not have to pay any tuition, I nevertheless had to supply my own art materials. Of course, most of the time it was impossible for me to buy these materials and so I picked up from the floor of the schoolroom pieces of charcoal and thumb tacks which the more fortunate students had thrown away. For drawing paper I used the back side of wallpaper. My teacher, Carl Hepke, soon noticed these things because he himself had gone through similar experiences in his early training. Occasionally he would give me a piece of good drawing paper or the drawings done by previous students the backs of which I used.[3]

By 1929, Germany's political landscape was unsettled. The waning years of the troubled Hindenburg presidency were leading to the seizing of power by Hitler in 1934. Vorst left Germany, but he traded it for something almost as perilous: the Great Depression in America. The Depression hit St. Louis hard. In 1932, 20,000 businesses fell into bankruptcy in the United States, and wages fell 40%. In St. Louis, 30% of the population was unemployed. But for African Americans in the city, the rate of unemployment or underemployment was dramatically higher; it breached 80%. Furthermore, for a city of its size, St. Louis, the fourth largest city in the nation, spent far less on relief than others: 38% less, per capita.[4] The St. Louis poet Orrick Glenday Johns noted that the poor in St. Louis camped in a Hooverville shantytown one mile long. He wrote:

> ...I had never seen such stark destitution as that on the river front of South St. Louis. The people were practically imprisoned there, discouraged by police and watchmen from going into the city.[5]

There is no doubt that Vorst suffered financially as a recent immigrant artist. He spoke later of these lean days, of trying to sell paintings at Sears and on crowded St. Louis street corners for as little as fifty cents, and even that without success.

But there were others worse off than he. In the final week of 1936, the rains began in the Ohio Valley. Over a period of roughly one month, the storms continued, and rivers rose to historic levels throughout Ohio, Tennessee, and Arkansas. The United States Weather Bureau estimated at the time that the 1937 storms brought 165 billion tons of water into the region, enough to submerge 200,000 square miles to a depth of 11 inches.[6] The devastation was immediate and overwhelming.[7]

Entire cities were evacuated. These were winter storms, and they were accompanied by temperatures that dropped into the teens. The rain turned to sleet. Melting snowfall exacerbated the challenges, and rescue crews of several thousand WPA workers dispatched from Washington, as well as Coast Guard and other responders, battled large chunks of ice that capsized their boats. Gas supplies were flooded and leaked into the rivers, which caught fire. The result was a horrifying scene: burning buildings recently capped in snow, sleet, and ice were now surrounded by a smoldering lake of contaminated water.

To aid those whose land was damaged, the Federal Resettlement Administration initiated a program to help suffering farmers. Loans of assistance granted $18 a month until the next harvest, but this money was paid to landowners, not sharecroppers and tenant farmers. The result being that the workers of the land, who were already living tenuously, became destitute. In all, 385 people died during the Great Flood of 1937. It is estimated that the damage was $500 millions dollars (its inflation-adjusted amount today is about $8 billion). The flood made 1 million people homeless.

Vorst's celebrated images of the flood brought him national recognition. They differed from documentary pictures created by his peers who were dispatched by local newspapers in that Vorst's works transcended illustration. They were intended to be seen as fine art work. It is notable that in his subject matter, he concentrated on those already most at risk, including animals.

Other natural disasters captured his attention as well. These stirring images of crop failures and storms tied to the Dust Bowl, west of Missouri, include a series of prayer pictures in which the people in the paintings are so utterly distraught and physically battered that they have no choice but to fall to their knees. These are more than documentary pictures, however. Vorst used natural catastrophes as a metaphor to warn of the oncoming political storm of another world war. Related to these disaster images are World War II works like *For Thine Is the Kingdom*, in which a father of a soldier prays for his son. The newspaper opened on the floor of his dilapidated room notes the Yanks have entered Germany.

Vorst was saying in these works, it is not enough to acknowledge tragedy and disaster, to document it, and to attempt to achieve sympathy for its victims; a truly Christian response requires its believers to do something to alleviate suffering, to stand up against tyranny, and ameliorate inequality through action. Vorst's 1930s paintings are often a call to arms.

I believe the untapped potential of Mormon art is something that would transcend its frequent pathways of retelling its own story or illustrating its scriptures. It is one thing that would nudge it toward greatness. Simply: to make art that matters.

Vorst's success in capturing the Great Depression—not from a theoretical vantage point of a nation or city in the distance, but from a closely-observed lens of his own community relationships—empowered and emboldened him to tackle hatred and fear elsewhere. This is paradoxical because in the U.S., his German background was constantly thrown in his face by the press as a veiled way to minimize his voice as a commentator on American issues. He was never able to escape the association with Germany and be as all-American as he wished. Still, this unfair treatment did not preempt his American patriotism as WWII neared nor his desire to tackle social issues that would make the country better.

Now, I'd like to give an example of a single social issue of the 1930s and demon-

strate how Vorst and other artists reacted to it. I think it shows how artists can use their work to build public awareness for moral issues, change minds, encourage action, and seek to rally consensus for progress.

Mob lynching had been on the decline in the early 20th century, but it re-emerged forcefully in the 1930s. Scholars have pointed to numerous causes for the mob violence aimed at African Americans. Yet, lynching included the murder of women, children, Native Americans, Jews, Chinese, Italian, and Mexican immigrants, too. Nevertheless, most often, lynching involved black men murdered in public at the hands of white men. Lynching was more common than many have supposed. A recent, multi-year investigation by the Equal Justice Initiative uncovered documented cases of "3,959 racial lynchings of African Americans in Alabama, Arkansas, Florida, Georgia, Kentucky, Louisiana, Mississippi, North Carolina, South Carolina, Tennessee, Texas, and Virginia between 1877 and 1950."[8]

Vorst likely first encountered lynching almost immediately after immigrating to Missouri. On October 12, 1930, less than three months after his arrival, in Ste. Genevieve where Vorst initially settled, two black men and a woman fought and killed two local white, male quarry and kiln workers. They said they were defending the woman against rape, but angry citizens of Ste. Genevieve retaliated by driving all of the 200 African American residents out of the small town and threatened lynchings.

Most Americans outside of the South had no exposure to murder and terrorism of this kind. Two art exhibitions in New York City in 1935 sought to change public opinion and support two anti-lynching bills working their way through the legislature. The first exhibition, sponsored by the NAACP, *An Art Commentary on Lynching*, featured an introductory essay to the exhibition catalog titled, appropriately, "Pictures Can Fight!"

These were not fringe exhibitions. In addition to Benton and Jones, participating artists included John Steuart Curry, George Bellows, Reginald Marsh, Isamu Noguchi, José Clemente Orozco, Paul Cadmus, Louis Lozowick, Harry Sternberg, Julius Bloch, among many others. It is also worth noting that a number of the artists were Jewish, and their immediate experience with anti-Semitism informed their sympathies with racism of all kinds. Further, many of the artists commonly used the imagery of the crucifixion in their works related to lynching and thereby imparted a Christian zeal into their documentation of violence.

The two exhibitions brought many citizens face to face with lynching for the first time. Newspapers reported that some gallery visitors were physically overcome. But *An Art Commentary on Lynching* and *Struggle for Negro Rights*, organized by the John Reed Club, Artists Union at ACA Galleries, proved that visual artists could harness their outrage and engage the public with an aim to affect change.[9]

Vorst, as yet, had not shown his work in New York City—that would take place the following year at the same ACA Galleries that had mounted the *Struggle for Negro Rights*

exhibition—but he created an image, *Gallows*, that easily fits into the group of Social Realists and anti-lynching. In this work, Vorst paints the aftermath of a hanging. A makeshift scaffold is partially surrounded by a loose timber structure. High above is an empty noose, and the smoke from a fire directly below the rope wends its way up into the sky and converges with white clouds against a darkened night and full moon. The site is on a hill alongside a river, and in the painting, the men and women descend down a path in single file, away from the gallows. A woman has collapsed into the arms of an old man, and a Missouri farmer (noted by the large-brimmed hat that Vorst frequently used as a symbol of his adopted state) sits on a log fence, his head bowed. At the far right in the image, a Missouri mule sips innocently from a trough of water.

A number of symbols appear in the image. These include the mule, the farmer, the river, and a dead tree whose leafless branches reach upwards to the sky. Perhaps the most central symbol of all is the pole that stands atilt, between the figures and the gallows itself. It is long and thin, with a horizontal beam at the very top that echoes the cross.

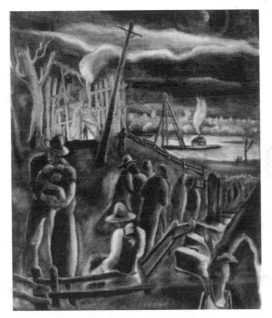

Joseph Paul Vorst, *Gallows*, ca. 1935
oil on panel, 30 x 25 in.
courtesy Treadway Gallery, Cincinnati, Ohio

Vorst's Missouri Mormon identity informed his reaction to hatred and violence, just as anti-Semitism mobilized American Jewish artists. Around 1939, Vorst prepared submissions for a public mural commission. One of the works was *Religious P[ers]ecution*. It was created 100 years after the Haun's Mill massacre, known locally in Missouri as "The Mormon War."

Vorst would tackle additional social issues throughout his career, including fascism in Europe. This must have been especially troubling to him as his entire immediate family remained in Germany. His hometown of Essen, a primary source of German munitions during World War II, was a nearly-constant target of Allied bombing from 1939 to 1945. All told, 272 air raids destroyed 90 percent of the center of Essen, the remaining city was 60% destroyed, as someone said of the relentless bombing, making ruins of ruins. There were fissures in the Vorst family, as well. Joe was staunchly anti-fascist, but one brother was a Nazi soldier who was ultimately captured by the Allied troops. The two brothers never reconciled, as can be seen in the tone of paintings of him by Vorst.

After years working as a WPA-era artist creating public murals, Vorst joined the U.S. war effort, like many artists of the day, and created propaganda for war posters. In the last century, WWII propaganda is probably the readiest example of the government's use of artists to influence the population for a cause.

Vorst was sincere, however. One week before the surprise Japanese attack on Pearl Harbor, Vorst prepared for a solo show of his paintings in New York. He published an essay in the exhibition catalog that ended with this statement:

> As a token of my appreciation for the privilege of living as an American citizen in this great country of freedom of expression, and for the honor of being commissioned to paint three murals for United States Post Offices, I donate all proceeds over and above expenses to National Defense Organizations.[10]

Finally, I want to discuss two Vorst works from the late 30s and early 40s. The first is a WWII propaganda work, *This Is the Enemy*. Its title was taken from President Roosevelt's first war message, given to Congress, January 6, 1942. I don't think for a minute that this is what President Kimball had in mind when he was projecting the idea of greatness onto future Mormon arts, but Vorst cannot be faulted for doing his part for the war. And given his personal, complex German identity and his meeting of Hitler in 1932 to draw him for a commission, this is more than an uninformed cartoon.

Here is another work, *Drought*, from 1938. Look at the individual narrative and symbolic components of it. Note how every visual element speaks to this tortured man's state of mind. He is without options. Everything has failed, and he has been forced to his knees.

In my life, I have felt this helpless a time or two. Perhaps you have, as well. To me, this painting is one of the most powerful works by a Mormon artist. I had seen reproductions of the painting, but when I walked into a dimly-lit space in a private collector's home and stood before it, last year, I was emotionally overcome. My thoughts raced. Gradually my mind led me to the question of Mormon artists' relevance. What would it be like, I wondered, if from the thousands of living artists in the Church—including writers, composers, filmmakers, etc.—even a handful of the best of them looked more

frequently to current events for their subject matter? What kinds of works might come from such a shift?

Back to *Drought*, I wondered what Church members in 1938 would have thought of this work had Vorst been more widely known to them. Maybe I'm wrong, but I imagine that Spencer W. Kimball might have liked the painting very much. He wanted Mormon artists to lengthen their stride, too. Isn't social engagement part of the package that accompanies artists of importance? Maybe this kind of work isn't for every artist or for every viewer, but I question whether an entire artistic culture can avoid contemporary relevance and still aspire to greatness.

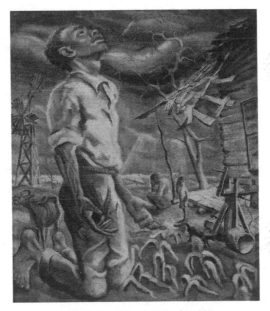

Joseph Paul Vorst, *Drought*, 1938
oil on masonite, 39.5 x 35 in.
private collection, Illinois

My own experience working with LDS artists over decades has led me to the conclusion that many Mormon artists want, almost more than anything else—including an ability to pay the rent—to be of use to the Church. This yearning for institutional utility runs very deep in our artists. Increasingly, they also want to matter.

How can these impulses be reconciled? I wonder whether Vorst's artworks aren't one solution: Dear artist, he seems to say, take the high ground on social issues that are also clearly moral issues, show the dangers to men, women, and children of disasters natural and man-made, draw upon your own experience and passions, and react with the love of Christ to those most in need of help—not merely those down-on-their luck, but the disadvantaged.

One of Vorst's private collectors was the Pulitzer Prize-winning author John Hersey. In 1947—the year that Vorst died of a brain aneurysm while leading the ward choir in St. Louis—Hersey wrote of Vorst and his work,

> He loves his family; he has integrity about his work...But when Joseph Vorst is at his best, he catches, I think, a glimpse of humanity—of suffering and happiness at once, of all those things in men, and around them, that make them what they are. That is why I like Vorst's work.[11]

ENDNOTES

[1] Spencer W. Kimball, "The Gospel Vision of the Arts," *Ensign*, July 1977, adapted from "Education for Eternity," *Speeches of the Year*, 1967-68, 12-19.

[2] *St. Louis Post-Dispatch*, August 9, 1936.

[3] *Joseph Paul Vorst: Missouri Artist*, by William Edward Hoffmann, n.d., circa 1938, self-published, unpaginated.

[4] See M. Melissa Wolfe, "Joe Jones, Worker-Artist," *Joe Jones: Radical Painter of the American Scene*, St. Louis Art Museum, University of Washington Press, 2010, 33.

[5] Orrick Glenday Johns, *Time of Our Lives: The Story of My Father and Myself* (Stackpole Sons, 1937; reprint: Octagon Books, 1973), 338.

[6] Bennett Swenson, "Rivers and Floods," Monthly Weather Review, River and Flood Division, February 1937.

[7] See Christopher Havern, "The Great Ohio, Mississippi River Valley Flood of 1937," *Coast Guard Compass*, official blog of the U.S. Coast Guard, originally posted June 4, 2011; accessed August 26, 2015.

[8] "Lynching in America: Confronting the Legacy of Racial Terror," report conducted and published by Equal Justice Initiative, Montgomery, Alabama, 2015.

[9] See: Marlene Park, "Lynching and Anti-Lynching: Art and Politics in the 1930s," *The Social and the Real: Political Art of the 1930s in the Western Hemisphere*, Pennsylvania State University Press, 2006. Also, specifically about the NAACP exhibition: Margaret Rose Vendryes, "Hanging on Their Walls: An Art Commentary on Lynching, the Forgotten 1935 Art Exhibition," *Race Consciousness: African-American Studies for the New Century*, edited by Judith Jackson Fossett and Jeffrey A. Tucker, New York University Press, 1997. Also: Bryna R. Campbell, "Radical Regionalism in American Art: The Case of Joe Jones," *Regionalists on the Left: Radical Voices from the American West*, edited by Michael C. Steiner, University of Oklahoma Press, 2013.

[10] See *Vorst*, ACA Galleries, exhibition catalog, November 30-December 13, 1941, New York, unpaginated, checklist laid in.

[11] John Hersey, "Joseph Vorst," exhibition catalog, Noonan-Kocian Galleries, St. Louis, April, 1947, unpaginated.

STEVEN L. PECK

READING AND REFLECTION ON MY NOVEL GILDA TRILLIM: SHEPHERDESS OF RATS

Gilda Trillim will be published by Roundfire Books in September 2017.[1] It is a plea-sure to share it at the Mormon Arts Center Festival in New York in this beautiful setting at Riverside Church. I often get classified as a post-modern writer because I eschew con-ventional forms of narration and style, but in everything I do and write, I am exploring what being Mormon means to me. In Scott Parkin's *BYU Studies* review of my collection of short stories, *Wandering Realities* he said,

> His stories explore how *being* Mormon affects the way his characters per-ceive and interpret and act, rather than cataloging the special challenges of being *a* Mormon in the midst of an often hostile world. That difference rep-resents a powerful vision of literature that I find profoundly important, and praiseworthy.[2]

This vision was never just an explicit aim for me but rather arises simply because being LDS is such an important part of who I am and how my church has shaped the person I am. I cannot be disentangled from my Mormonism any more than all the wood can be dislodged from an oak and still claim that something called a tree remains. To stretch the biological metaphor perhaps too far, Mormonism is not just part of my DNA (something I've often heard claimed by other Saints), it is part of my cell struc-ture, embryology, physiology, and ecology.

My books are often challenging, perplexing, troublesome, and vexing to those used to more mainstream literary tropes. But in everything, they reflect lived Mormon-ism, or its potential, or at least my lived version of such.

The novel opens with the epigraph "An academic work disguised as novel disguised as an academic work." Gilda Trillim takes the form of a master's thesis being composed by the son or daughter (it is not entirely clear which pronoun should be used) of sheep-herding parents. The student is named Katt Mender whose academic career this far has been, shall we say, less than stellar. Katt is collecting source documents for Trillim, an obscure minimalist Mormon novelist, poet, and world champion badminton player who

before her death retired in the La Sal Mountains near Moab where the Menders ranch. In a series of vignettes from Gilda's uncanny life, Katt explores the question whether Trillim is a bald-faced liar, mad, or one of the great spiritual mystics of our time.

Early in my novel *Gilda Trillim: Shepherdess of Rats*, Gilda is trying to recapture the enchantment the world held when she was a little girl living on a farm in Idaho. She laments to her friend Babs Lake:

> *I remember when I was young, ten or twelve perhaps, all things had a peculiar aspect—one that has since fled and no longer exists for me. I miss it terribly. It was a feeling of animation, a kind of visual hue, or perhaps better expressed, an existential flavor that could be discerned everywhere. I don't know why it went away, perhaps it has something to do with the demands and perceptions of adulthood, but back then everything had a living dimension, an active, almost fixed personality. I could recognize in objects a longing to belong. To fit in. Not that human preoccupations were theirs, no, but they had their concerns and these could be apprehended.* p. 25

After describing encounters with this lost dimension of the world, she tries to trace its origin and wonders how it might be reobtained:

> *I think it was in the University that the roots of my animated world were wrenched from their rich, imaginative soil. And not just to the cold non-living objects of the world, but even life itself. As if it turned every singing bird or bouncing dog into just so many machines that tick tock to the beat of their own internal motions, movements established long ago when the universe came to be.* p. 31

> . . .

> *And I am left wanting to shout at my professors, and to the empty self-thing that I have become, and who now seems so blind compared to that little girl who heard the silent voice of a book shout to her and who felt the weight of a shadow's dark watchfulness . . . can we bring it back?* p. 32

She recognizes that some truths have been lost that she wants to regain and begins a quest to find them. She has come to believe that perhaps the only way to capture certain truths is through Art (Perhaps anticipating the Mormon Arts Center!). She holds that the Platonic transcendental triumvirate, Beauty, Truth, and Goodness are intertwined—and that one may be approached and apprehended through the others.

She travels to the Soviet Union and enters an orthodox convent in an attempt to rediscover some of the truths she has lost from childhood. She approaches the attempt through painting. She begins a series of chiaroscuro oil paintings of a lone brown apple seed on an autumn-orange cloth serviette lit by a single candle. She is trying to capture some unquantifiable element that the seed contains—one that cannot be ascer-

tained through empirical study or quantification. As she proceeds she begins to suspect this approach too is lacking:

> *I sit down after my 45th painting and sigh and cry and then sigh again. I am no closer to understanding this seed than when I started. It sits there on the orange cloth, baiting me, calling me, daring me to find it out, to discover its way of being, to capture what it is under that brittle brown shell. I've painted it again and again, turned it nearly every angle, captured subtle nuances of its given aspect. I have been presented and handed all sides of this simple object, and yet nothing of what it is enters me. I've painted it in morning sun and gloaming cloud, in two seasons, and in afternoon and evening. I've placed the candle at numerous angles. I seem not to have come to know it at all. I thought by looking at it, its nature would slowly reveal itself. Give me what was hidden. I don't mean 'know' its soft inner fruit. Obviously, I could crush it, and smear its greenish pulp over a glass and peer at it until blurry eyed, but isn't that just another angle? Wouldn't that mess just be painting 46 through, say, 67? Would I be any closer to getting to it than I am now?*
>
> *It is silent. I've put it under a drinking glass and pressed my ear against its base for hours, not to hear the noise it makes—it makes none—but to sense its silence. To learn of the noises it does not make and in that quiet revelation find the seed as it is.*
>
> *It haunts my dreams. It appears as mother, father, sister, lover. It comes to me as useless background and empty quest. And when I awake, I turn it ever so slightly and paint it once again.*
>
> *Come to me! Come to me sweet masked apple seed. Let me know one thing in this universe well enough to call it captured. Dear, dear apple seed, let me enter you. I welcome you! Enter me!*
>
> *I have not bathed in days. If Babs saw me now, she would think me mad. Perhaps I am.*
> pp. 34-35.

Her quest takes a different turn because her painting points her in the direction of the spirituality she once experienced growing up a Latter-day Saint. She wants to communicate with the power that animated the lives of her father and mother, hoping to find that dimension of existence that seems to be eluding her. The novel follows her through several attempts, one of which results in the loss of her hand.

The narrative arc of the novel takes a sudden turn when Gilda is taken prisoner in Vietnam when her USO helicopter strays off course and is shot down. There she experiences the horrors and depredations of being a prisoner of war. But in the midst of these horrors, she finds unexpected meaning getting to know the large rats that frequent the camp. These she befriends, and with mutual recognition and gratitude, they form a bond, one of trusting friendship (in a very ratty/human way). In an act of accidental violence, some of the rats are killed. In morning, pleading with deities in which she thinks she no longer believes, she has a beautiful vision/visitation. Here is the opening scene,

I won't spoil it by giving it in detail, without the context of the novel its full impact cannot be appreciated. But here is a sampling. Here she is holding the body of one of her rats who has just been killed:

I fell to my knees in agony and despair holding her little body, wailing. I held her warm body to my chest and spilled tears over her wetting her fur in patches of sorrow. Willing her to live. Please. O, please. If there are gods or goddesses. If there is a Heavenly Father or Mother. If you shepherds who can command the creation of universes can help me please bring her back to me. Please. Please. Please. Oh. Little Lumpkin. My little Lumpkin, don't leave me now. I pressed my lips against her mouth and breathed softly to fill her tiny lungs with small breaths. I pushed in the air so gently, so carefully, until I saw her sides rise with my breath. But when I released my kiss to let the air back out, with each exhale, blood seeped bubbling from her nose. I knew she was dead. [p. 143]

She tries to give her rat a blessing like she had seen her father do a horse once back on the Idaho farm but it fails. Then suddenly:

Still on my back looking straight upward I saw a figure descending from the sky as if from an immense height but oddly still within the room giving the impression that I was seeing into a new dimension, something like mirrors facing each other with reflections scattering light back and forth into a forever of ever smaller and more distant mirrors. The woman, for woman it was, descended until she stood above me. She was dressed in a robe de style of a lovely blue silk, with several long strings of white pearls. A red sequin cloche hat just covered her short styled and straightened hair. Her shoes were gorgeous blue heels that shimmered like emeralds. Her black skin glowed like a shimmering pool on a moonless night and her eyes were bright and alive beyond life.

Most amazing of all was her smell. It was of newborn babies, fresh autumn hay, rich moist soil, and lavender in the sunshine. It was of honey dripping from the comb, baked bread, and red sweet wine. It was of newness and pine. Just opened books and incense and beeswax. And oddly the fresh scent of manure and spring planting, and the milk of a mother's breast. It seemed so complex and full I wanted to melt into her. [pp. 147-148]

Gilda's experience with the divine feminine in a vision of Heavenly Mother explores what is possible to glean from our experiences with divinity. What theological inferences can we make about God and Goddesses when we read the accounts of others experiences with the divine or even what do we make of our own? Should it comport with contemporary science to be true? And if so in what ways?

In this next scene we will look at, and which appears late in the book, Gilda is being interviewed by a reporter (called 'DK,' writing for the *Paris Review*) investigating negative reports about Gilda coming from some of her fellow prisoners of war. The reporter tries to get her to clarify what happened to her in the prison and address the

rumors that she experienced some divine manifestation.

DK: OK. To move on I'm going to read you something that I think you will find painful. But I think it is important to clear this up. This is from one of your fellow prisoners, Silke Peeters. She has been fairly vocal in her condemnation of you.

GT: I know.

DK: I should tell you I don't believe her. Or at least I don't want to.

GT: It doesn't matter to me if anyone believes her or not. What she says is not true.

DK: OK, but let me read what she said and we can go from there.

GT: If we must.

DK: She says in this translation of an interview in the German magazine, Der Stern: *She arrived with two others. The rest of us had been there about three months. We noticed she got special treatment from the very beginning and we suspected almost immediately that there was something odd going on. Our cells were in a long cement block building. Her cell was near one end, so that she could come and go without being seen by the rest of us. It was also the largest and had the best ventilation. While we would spend every day laboring in the fields doing backbreaking work she always stayed behind f[#$]ing the guards and giving sexual favors to the camp officers in horrible and unspeakable ways. She was paid well for it. While we were nearly starving she was well fed until in the end she was as fat as a pig. There was a squeaky mattress in her cell and on rainy days when we all stayed behind because it was too muddy to work, she would still be working the bedroll with whatever Cong wished it. She had no shame. Although she spent the day nibbling on delicacies and the fine food the officers ate, she would still line up with us and take a portion of what little food we were offered. One year there was a terrible famine and several prisoners died. We were like bones walking. All except Gilda, who was as plump as a Christmas goose. She claimed she was eating rats, as were many of us, but they gave little nutrition and were wily and hard to catch. An obvious lie. When the Russians arrived they were so enamored with her sexual tricks they demanded of the Vietcong that she be allowed to go with them. She did not even hesitate. No one was sorry to see her go. She was a constant reminder that there are those in war who lose all their morals and turn into a corrupt and fetid shadow of what humans are supposed to be. She was a whore and now that she is some big deal novelist I find my mind even more disturbed about the attention she is getting. I find it disgusting that anyone can praise the work of such a vile creature.*

GT: Sad. None of it's true of course.

DK: Why do you think she is lying about you?

GT: I don't think she is lying. I think she is mistaken. I did not work in the field because my missing hand kept me from handling tools. I suspect that because I was not there helping with the labor, resentment built and these are stories that came to them as a way to feed these resentments. My last year there I was treated very badly by my fellow prisoners . . . The major

would tell them to knock it off but he did it in a voice that let everyone know including me that I deserved it, but he was of a more chivalrous bent, and as such was against their lower standards. I laughed because I did not know what to do. After they left I would cry and wish myself dead.

DK: What did you do during the day?

GT: I sat in my cell.

DK: And did you grow fat?

GT: By camp standards I did not lose as much as they did. To them I likely did appear fat, but I was much thinner than you now see me. But I found a source of food that they did not enjoy.

[During the famine year that occurred while she was a prisoner of war, the rats, acting on a maternal instinct, helped Gilda survive on rat vomit by regurgitating food stolen from the camp dump.]

DK: So you never slept with any of the guards?

<<Here she became very uncomfortable, agitated, and asked to be excused. She literally ran from the room. She did not return for several minutes, but when she returned she seemed composed. >>

GT: Where were we?

DK: I asked if you slept with your captors.

GT: No.

DK: OK. Did you have a mattress in your cell while they slept in straw?

GT: I slept as they did on a bamboo mat.

DK: If you did not work in the fields how did you spend your days?

GT: Largely bored almost out of existence.

DK: You've intimated that you had some life-changing experience. There are rumors from your stay in New York that you claimed that you trained rats.

GT: I will not say anything about that.

DK: Won't you tell me what happened?

GT: No. It was holy. Sacred.

DK: Shouldn't it be shared then? At least to dispel the claims by Silke Peeters?

GT: No, I will not share them.

DK: We could all use more stories of encounters with the sacred. Don't you think?

GT: The holy must be experienced. I stood alone. A single individual in awe of what had unfolded into the world. To try to share it would cheapen it. Only two things could happen.

One, you might believe me and take my experience and embrace it. Appropriate it. But you could only do so intellectually. It could only become another fact in the world. You might make rituals of it, or art, but eventually it would become codified, institutionalized, there would be authorized and unauthorized forms, sects.

DK: Wait. Are you saying that your experience was so profound that in hearing it I might start a new religion based on it?

GT: Maybe. But not likely. Let me give you the second scenario, which I think is what would actually happen. If I were to tell you, you would not believe me. You would strip it of awe and wonder. You would fossilize it. Solidify it into a mere supposed fact of a world that is subject to analysis, such that it might be accepted or rejected. But this happening was born into a world into which it will not easily fit, therefore by your lights it would have to be rejected. You would strip it of possibility and of actuality. Your only response could be to mock it. To ignore it. To declare me mad or simply a liar. All my experiences then would have to be reinterpreted to fit in this sterile world. What scares me most is perhaps even I could be convinced by your dismissal. Maybe I could be brought to forget the wonder born in those soggy afternoons in a prison in Southeast Asia.

Memory is a fickle thing. What if I tell the world and teams of psychologists and philosophers all agree that I am mad and proclaim it with such force and conviction that I cannot bear the weight of their wagging fingers at my story's impossibility? What if under their therapeutic eye they lead me away from my experience and clothe me in the garments of their skepticism? They might declare my memories the imaginations of a mind oppressed with the terror of my captivity. They might say it is a brain breaking under the strain of torture, malnutrition, degradation, filth, disease. Which is more likely, that Gilda Trillim lost her mind in a place where anyone would lose their mind, or that Gilda Trillim experienced a thing of such beauty and magnificence and breathtaking awe that it cannot be understood by the mortal mind? No, I will not tell you. To tell you will be to make it impossible. I know what I experienced and to lose that would be to lose everything. Do not cast pearls before swine and all that.

DK: So when others are presented with Peeters's story they must believe either your fellow prisoner's detailed accounts or believe you were engaged in activities so sacred and awesome and holy that in a filthy cinderblock prison, suffering the most humiliating and awful of conditions, that to tell them of it would strip it of meaning? Should we just trust you on this?

GT: Trust me? Heavens no. All I can do is encourage you to enter into the world with open and daring eyes and see how the wonder and grandeur of this world manifests itself to you. To trust me would be absurd. [pp. 200-204]

The idea that the sacred gets lost when expressed in our reality, came to me several years ago under the guidance of a Hawaiian woman who told me one of her sacred stories. I share here only a minimum of the details but it has stayed with me and perhaps

was one of the influences that brought me to writing this book.

When I lived in Hawaii one of my favorite things was taking my boys to scout camp at Camp Honokaia on the North end of the Big Island on which we lived. The camp offered a special school for scouts and leaders that would let one earn the Hawaiiana Award, which required learning basic Hawaiian cultural skills and knowledge and basic familiarity with legends from Hawaii's past. The class met each day for an hour (or two) in the afternoon. It was taught by the redoubtable Auntie Lokalani (name changed), a stern, yet kind, grandmotherly Hawaiian woman who expected each of us to master well the requirements of this award—requirements she took very seriously. On the day before graduation, she told us the story about how that before she was born, her mother had given birth to a shark. It was a long and beautiful telling, which out of respect I will not share here although she placed no restrictions on us to keep it secret. Nevertheless, I was struck that this story was sacred and should not be repeated without due respect. She talked about what it meant to have a brother who was a shark and about how it offered certain protections, honors, and duties to her family. At the level of biology, this story was quite impossible. In that light, one side of me turned a skeptical eye to the story acknowledging the genetic, evolutionary, and physiological absurdity of such a story. She held it as true. And I realized it was. Not in some lukewarm sense that it was 'true for her,' but in a deeper sense of truth. Truth has more than one valence, and I worry too often we grant it only in the narrowest sense—in the materialist sense. I believe this a misstep.

I have always been struck by the phrase from Doctrine and Covenants 93:30:

All truth is independent in that sphere in which God has placed it, to act for itself, as all intelligence also; otherwise there is no existence.

Independent *kinds* of truth is a powerful idea, and this applies to Auntie Lokalani's story. It was a true story in a sense, or a dimension, that matters. It gave her family identity and allowed them access to a province that in their natural environment and cultural context allowed them to engage with their world in ways that produced authentic modes of being. It allowed her and her family to enter into new possibilities for their lives and world. The truths of this story actually ran deeper than the cheap actualities that science provides (which also has a necessary role in establishing certain kinds of truth, as when we want to gain access to, or manipulate, the material world). These possibilities were only limited if the truths her story revealed where dismissed and ignored.

Art functions like this. If we return to Plato's three-fold higher forms, we can begin to fathom that the truths that art captures, is to enter reality in a way that the objective world misses. And is unassailable from objective fact-driven science. Again, not that these methods and perspectives are unimportant. Science is the best way to discover the physical nature of the universe. But it does not capture all that is real for subjective beings.

This is why Gilda refuses to talk about her vision. Those who want to objectify it will strip it of the very dimensions in which it exists. As if the essence of painting could be descried by someone grinding it up and putting into a mass spectrometer and declaring, "Ah yes, this Van Goeth is a group of colors formed by chemicals X, Y, and Z with these given light refracting and reflecting properties." The truths of everything from Auntie Lokalani's family history, to the Book of Abraham, to Gilda Trillim's encounter with the divine, are all conditioned on truths accessible to higher things. Truths realizable only to certain kinds of art, music, literature, and poetry.

The Honors Program at Brigham Young University has an activity in which a professor is invited to meet with a group of students over chocolate milk and explore a single question, which is discussed for an hour. When I participated in this, I asked, "Suppose a group of advanced space aliens arrived and said that humanity must pick either Art or Science, and that based on the choice, they would completely take away the other from off the face of the earth (don't get bogged down in the details about how this would be done, or boundary conditions which overlap between the two), which would you choose?"

The ensuing discussion was interesting because at first, the consensus was science was the better choice, giving us medicine, rocket ships, computers, and such, but it soon became apparent that meaning and values would quickly melt away if we did not have music, art, and literature. (No resolution was ever made of course).

But art, broadly construed often gets set aside, in favor of science. As a practitioner of both, I find this an abysmal situation.

That's why the Mormon Art's project is so vital. So necessary. We need such frameworks to help us not only understand the unquantifiables of our faith, but to give meaning, Truth, Beauty, and Goodness, their place. It is a way to explore deeper truths that I worry that the usual kind of Mormon apologetics too often ignores in favor of objective rather than subjective truths. It is my hope that my Gilda Trillim novel offers something that explores and participates in these ideas.

ENDNOTES

[1] Steven L. Peck, *Gilda Trillim: Shepherdess of Rats* (London: Roundfire Books, 2017), 296 pages.

[2] Scott Parkin. "Book Review: Wandering Realities: The Mormonish Short Fiction of Steven L. Peck," *BYU Studies* 55, no. 2 (2016): 183-186.

JOHN DURHAM PETERS

ETERNAL INCREASE

ANXIETY'S BENEFITS

One of the many striking things about Spencer W. Kimball's call for a Gospel-inspired vision of the arts 50 years ago is how healthy-minded and sunny it is. Of a long list of artists he mentions whose personal lives might have given an apostle reason to blanch—Wagner, Leonardo, Michelangelo, Goethe, Paganini, and Lizst among them—it was only Rembrandt who he gently called out for suspect morals. The talk is thoroughly free of the long smoldering suspicion that art is fueled by transgression and deviance—perhaps both because of Kimball's optimistic, generous spirit and the limits of his sample. President Kimball says: look what great artists did without the benefits of the restored Gospel—imagine what we could do with it! And imagine how the Gospel could be communicated with these amazing means! He sees the arts as an open field waiting to be cultivated by those with greater gifts of the spirit. His talk is a refreshing counterpoint to the sometimes spoken but often felt nervousness about the arts in Mormonism.

Is there anything to be worried about? Are the arts really dangerous? I should hope so! Fire and sex are dangerous—and they are also the fonts of life, creativity and invention. Genuine art will never be safe, and thankfully so. Safe art would be like fire that could not burn. The novelist Margaret Atwood recently wrote: "Artists are always being lectured on their moral duty, a fate other professionals—dentists, for example—generally avoid."[1] She's right (and funny) about the undue burden that artists carry and yet, with all due respect, artists and dentists *are* different. One affects the teeth, the other affects the soul. Perhaps Mormons fill the ranks of accountants, agronomists, and dentists precisely because these fields seem safe from soul-wrenching questions, although perhaps they are not. Perhaps it is the task of the artist to show us that the fate of the soul is at stake in anything we do.

And perhaps the religious artist has an unfair advantage over the secular. Much of our utilitarian Americanized global civilization is utterly indifferent to the fine arts. In religious settings the high stakes are more apparent. At least art matters, and matters profoundly. Take two novels with similar names: Chaim Potok's *My Name Is Asher Lev*

(1972) and Orhan Pamuk's *My Name Is Red* (1998). Both concern the tortured place of art in religious communities—Hasidic Jews in postwar Brooklyn and Muslim minia-ture-painters in the Ottomon court of sixteenth-century Istanbul—where you make images at the peril of your soul and at the risk of offending God and your community. The pressure is great and also generative. For Mormons too art poses genuine risks—transgression, loss of faith, idolatry, depiction beyond the bounds the Lord has set. The stakes are body and soul, belonging and leaving, violence and sex, life and death.

We should be grateful for angels and demons to wrestle with. Hang ups? Yes please! What if the risks were signs of opportunity? What if our complicated taboos were the inspiration and not the hindrance to art? What if restrictions on expression were a source of its power? What would a visual culture look like that took distance from two of the central themes of western painting—the crucifixion and the nude? (Not surpris-ingly, these are the subjects—obviously taboo—that Asher Lev is particularly drawn to.) What if the winning strategy were to revere the prohibitions, to cultivate the edge spaces instead of bulldozing them, in short, to make the desert of Mormon contraries blossom like a rose? Bans and prohibitions can produce dejection and debility but they can also be gargantuanly fruitful: cherubim and a flaming sword made the human race possible by denying the return to Eden. Nothing provokes creativity like having a law to break. The Fall of Adam and Eve brought liberty of choice into the world with all its dangers and opportunities. The new geometrical discipline of Renaissance perspective stimulated an explosion in the painting of clouds, objects that defy the rules of the grid by existing more in shape and color than in line and depth.[2] "No one hates censorship more than I do," the Spanish surrealist film-maker Luís Buñuel supposedly said, "but only God knows how much I owe to it."[3]

Hang-ups, prohibitions, danger—you will note that we have drifted a bit from President Kimball's sunny landscape. We need to assess the larger, perhaps darker his-tory of the arts over the past two centuries. The British Romantics, inspired by the most compelling character in John Milton's epic poem *Paradise Lost*, made admiration of Milton's Satan into an article of artistic faith. A preference for the energies of hell over the order of heaven has been the ideology of avant-garde artists from before Mor-monism even existed. Politically, the Romantics were revolutionaries, at least when they were young, and liked calling for the uninhibited overthrow of power and taboos. The Romantics also had the unfortunate habit of dying young, reinforcing their idea that death is the mother of beauty. (The classic is healthy, the romantic diseased, said the old Goethe.) The specter of morbidity has stalked artistic practice since: Keats and Chopin died from consumption, Shelley in a boating accident, Kleist in a double-suicide, Byron fighting for the Greek cause, Poe (it seems) from alcohol poisoning, Rimbaud from cancer, Nietzsche from madness. The artistic template of finding genius or sublimity in excess, self-destruction, or a season in hell continues today, as does the mystique of dying young. And it is hard to imagine anything less Mormon than an artistic culture of disease and death. We celebrate life, health, the Word of Wisdom, and a long youthful lives!

Of course, romantic transgression is not the only tradition in the arts. I don't want to exaggerate. But Richard Oman is right to note that Mormon art as a rule is free from nihilism.[4] You can't say that for a lot of art—visual, literary, sculptural, cinematic, or musical—over the last two centuries. Art in the modern world has been edifying, uplifting, beautiful, and sublime, but it has also been coy, naughty, disturbing, sickening, funny, angry, obnoxious, sly, spellbinding, tranquilizing, obsequious, rabble-rousing, ironic, perplexing, and ravishing.

How should the Mormon arts position themselves with regard to this legacy? I see two viable options. In an earlier book, I called them *abyss-avoidance* and *abyss-redemption* (a book which I now see was probably written subconsciously with questions about the Mormon arts in mind).[5] Abyss-avoidance is relatively straightforward: it means to skirt or limit the negativity and get on with the work of edification. The other option is to work through the opposition, becoming stronger through exposure to small doses of the toxin. The first approach preserves what Jacob in The Book of Mormon called "tender feelings"; the second cultivates what he called, in the same breath, "firmness of mind." Both options have clear warrants in Mormon thought.

ABYSS-AVOIDANCE

The idea that some things should not, and cannot, be uttered or shown is familiar from Mormon scripture, especially with regard to heavenly manifestations. But it also shows up in cases of pain and mayhem. Consider Mormon's concern about "harrowing" his readers. The Book of Mormon has lots of very violent content. Its editor apologizes: "And now behold, I, Mormon, do not desire to harrow up the souls of men in casting before them such an awful scene of blood and carnage as was laid before mine eyes; but knowing that these things must surely be made known, and that all things which are hid must be revealed upon the house-tops, . . . therefore, I write a small abridgement, daring not to give a full account of the things which I have seen, because of the commandments which I have received, and also that ye might not have too great sorrow because of the wickedness of this people" (Mormon 5:8-9). "Harrowing" comes from agriculture, and refers to disturbing the soil so as to break up clods and clumps; its expanded sense implies the inflicting of distress. The Book of Mormon also associates harrowing with the painful but redemptive work of memory (e.g. Alma 36:12, Alma 39:7). Mormon provides a "small abridgement" as a preemptive strike against the eventual full revelation of the "awful scene" he witnessed. The phrase "a small abridgement" could serve as an artistic principle of caution or limits in depiction. Just because we don't want burnless fire doesn't mean we don't want fire-extinguishers.

The first-person account of the atonement in D&C 19 also stops short of a full disclosure: "Which suffering caused myself, even God, the greatest of all, to tremble because of pain, and to bleed at every pore, and to suffer both body and spirit—and would that I might not drink the bitter cup, and shrink—Nevertheless, glory be to the Father,

and I partook and finished my preparations unto the children of men" (D&C 19:18-19). Here the word "shrink" suggests a horror in recollection that blocks a full account. It may be not just that the atonement is too painful to remember but that it would be too awful for the listener to hear. That dash leaves us hanging—even God's syntax fails—as we pause before the triumphant, stoic "nevertheless" carries us forward. Perhaps the Atonement takes place in that punctuation mark. The dash suspends us, pointing to a description that is passed over. It bridges a chasm into which we cannot look.[6]

Gentle reticence could be a kind of aesthetic policy.[7] There is no loss of meaning due to this blackout or blank spot but rather an enhancement. Such withholding is quite unlike the tradition running from medieval altarpieces to Mel Gibson's *Passion of the Christ*, a tradition that advocates dwelling on the anatomical details of Christ's wounds and sufferings as a kind of spiritual benefit. Mormons would never say that one shouldn't ponder Christ's sufferings but that some things cannot (or should not) be represented. The holy sometimes defies utterance.

ABYSS-REDEMPTION

The unwillingness of Mormon to show all and Jesus to tell all is clearly not blindness or a whitewash; it is an effort to calibrate the right dose for a necessary, even redemptive exposure to evil or pain. When I was an undergrad at BYU, I heard someone give a talk on B. H. Roberts' complaint about "the sewer air of modern literature."[8] I asked the great Ed Geary what he thought about that when I was in his class on modern British literature. He replied by reciting a point from Joseph Conrad's *Heart of Darkness*, which we had just read: the task was to inhale the stench of dead hippo meat without being corrupted. Conrad's original line could, I think, serve as a charter for Mormon arts: "The earth for us is a place to live in, where we must put up with sights, with sounds, with smells, too, by Jove!—breathe dead hippo, so to speak, and not be contaminated."[9] Except perhaps we should change "put up with" to "experience" or even "celebrate"!

Geary's reply channeled for me the fundamental Mormon view that we have been placed in a mortal world to learn through opposition and experience, and that such learning can require, at times, some wrenching of the soul. Consider the notable phrase, "bowels of mercy," which is scattered throughout LDS scripture. We can read it as authorizing an attitude of aesthetic boldness in the name of a higher moral purpose. The bowels ally us to the earth, to the *humus* that names us *humans*. Their products often give rise to disgust, and yet it is in the bowels of mercy that the atonement is worked out (e.g. Alma 34:15). That we find the bowels, of all things, at the center of our theology might be suggestive for how we think about art: What would music be without dissonance or perfume without civet? Maybe harrowing is needed to improve the soil of the soul.[10] Such a thought was never better expressed in Mormon literature than in Joseph Smith's letter from Liberty Jail: "Thy mind, O man, if thou wilt lead a soul unto salva-

tion, must stretch as high as the utmost Heavens, and search into and contemplate the lowest considerations of the darkest abyss, and expand upon the broad considerations of the eternal expanse—he must commune with God." Smith clearly thought the mind must both stretch to the heights and peer into the abyss, but note the asymmetry: the mind stretches upward to the heavens but only looks into the abyss. Abyss-redemption can mesh with abyss-avoidance.

The greatest spokesman for abyss-redemption was John Milton, whose influence on early Mormonism may have been much greater than we realize.[11] "Heav'n hides nothing from thy view/ Nor the deep Tract of Hell" (*Paradise Lost*, 1.26–27). The point of life in a fallen world for Milton was the tempering of our souls, and art was a chief medium for such tempering. In his blazing tract against censorship, *Areopagitica* (1644), he argued for a bold and strenuous confrontation with the negative. "Assuredly we bring not innocence into the world, we bring impurity much rather: that which purifies us is trial, and trial is by what is contrary." This sounds a lot like Joseph Smith: "By proving contraries, truth is made manifest." It also sounds like William Blake: "Without contraries is no progression." Perhaps both Smith and Blake took inspiration from Milton's vision of a cosmic clash of good and evil that plays out not only historically during the plan of salvation but also experientially in the mind, heart, and soul of the individual. (Or perhaps all three got inspiration from the same source). Works of art for Milton were like flight simulators, ways to be educated in the consequences of sin and error without fully reaping their sting.[12] Milton thought our minds and hearts could get aerobic work-outs from antagonistic, even vile works. The sun shines into the sewer without getting soiled. The mind can contemplate the darkest abyss without spiritual jeopardy. Milton's program was strenuous and bold: the greatest works (like *Paradise Lost*) are sorties into an arena where good and evil clash. This strong endorsement of challenging art came from a devout Christian. Just as Christ descended below all things, so Christian wayfarers, armed with the Holy Ghost, could face down any human work without fear and often with great edification.

ART AND AGENCY

At the center of Milton's opposition to censorship was his conviction that the meaning of a work was not inherent: it depended on how it was received. He could have been thinking of Paul's frighteningly exigent reading protocol: "nothing is unclean in itself; but it is unclean for anyone who thinks it unclean" (Romans 14:14). The reader has the power to determine the meaning of the work. Some of my Mormon friends, for instance, justly find the work of the British painter Francis Bacon (1909-1992) nihilistic.[13] I find his paintings terrifying, profane, and also profound. You can read them as a grotesque, sick or even pornographic fascination with the human body as meat and bones, or as an ethically-informed commentary on a historical moment when history has been a slaughterhouse. It takes work, but you can read Bacon as having compassion

with our mortality and teaching us something deep about our condition "according to the flesh." On the other hand, some can read the *Ensign* with an eye to the "hotties." You would be hard pressed to find two points in visual culture more remote than Bacon and church magazines, but people can read the former as a sermon and the latter as porn. Both of these readings you might fairly think perverse, and both read against the grain of the central tendencies of the work. A steady diet of Bacon or the *Ensign* will nourish different kinds of minds and hearts. I don't begrudge anyone who has no time for Bacon: life is short and hard, and there is a lot of great, less upsetting art. And yet, reception matters deeply: our eternal destiny depends on our enjoying "that which [we] are willing to receive" (D&C 88:32). Our agency co-participates in making the meaning of art.

One risk of giving all the meaning to the act of interpretation is that it makes the work itself irrelevant—Shakespeare and Sudoku as equal intellectual engagements. It can also put a huge burden on the individual. I have a friend who attends Anglican worship services, which are always reliably graced by first-rate music and sermons. He has come a few times to Mormon meetings and recognizes their power but noted a difference. His analysis: "you guys have to work too hard!" He meant our DIY spirituality: the onus of a meeting is on the listener rather than the meeting. Mormons as a people are gifted at transfiguring tedium into spiritual gold dust. Adam Miller has written movingly on the kinship of boredom and worship.[14] Eternity nears in the midst of a yawn. What a gulf between the common puzzlement at the stylistic flatness of the *Book of Mormon* and the enormous sustenance that devoted readers take from it! President Kimball once made the guilt-inducing comment that he had never attended a boring sacrament meeting. Here the burden of uplift is entirely on the receiver. For Kimball as for Milton, the arts were the crucible of soul-making, a goad to spiritual discovery, and one gift we are encouraged to develop is the ability to experience beauty and holiness.

If all experience could be art, as John Dewey argued, then don't the fine arts lose their specialness?[15] Couldn't this argument function as an apology or alibi for poor quality? For my part, I would defend the fine arts both as something societies need to fund and treasure and as the artistry of ordinary experience. We need both greater art and a more radical and educated democracy of reception. They go together. The arts, like the earth, teach us vision. As the old joke goes, nature imitates art. Grant Wood made the Iowa landscape more beautiful for me. Dutch masters made the clouds of the Netherlands into something I could love, instead of the bringers of unceasing rain and damp that they otherwise were to a young missionary. Art can sharpen, refine and educate the senses. Alma endorses the training of sensation as a religious mission in his call to "awake and arouse our faculties" (Alma 32:27). If our task is to develop compassion for the neighbor and an eye single to God, then what could be more central than the arts?

That the senses needs care, cultivation, and constraint is clear in D&C 59, a revelation that could be a central treatise in Mormon aesthetics. Given on a Sunday in August

1831, in Jackson County, Missouri, its first two words announce a kind of sacramental vision fit for a Sabbath in the land of Zion: "Behold, blessed." The Sabbath, like the good things of the Earth, is designed "to please the eye and to gladden the heart . . . and to enliven the soul" (DC 59:18-19). The Sabbath is the day of suspension when utility no longer rules. Work gives place to glory on the seventh day. But note the caution about the use and enjoyment of the fruits of the earth: "Unto this end they were made to be used, with judgment, not to excess, neither by extortion" (DC 59:20). The cultivation of judgment and avoidance of excess and extortion is an aesthetic credo—and also an environmental and economic one. Distortion is a more typical word in moral and aesthetic vocabularies, but extortion is exquisitely apt here. In contrast to some artists who rage at existence, Mormon artists rarely want to blackmail the Earth.

Here aesthetic perception is both ordinary and sublime, something built into our condition as earthlings. If Mormon thought knocks the arts off of their transcendental perch, this is only the same thing it has done to traditional notions of deity. A cosmic vision that whittles away at the boundaries between heaven and earth, the next-worldly and this-worldly, cannot leave art as lofty and transcendent. Critics say the Mormon flattening of heaven and earth reduces the glory and otherness of God. Defenders say it makes God's power and glory more real and present. Something similar happens to art if we see its greatest work and glory as already unrolling in our midst: it is both taken out of the celestial heights and put into powerful effectivity in the here and now.[16]

ADDED UPON

What if life were the mother of beauty? Is there a cosmology or metaphysics within Mormonism that is a warrant for an expansive conception of the arts? I think there is and that it lies in the notion of eternal increase. Metaphors of birth and art have long been intertwined. An artwork is a revelation of a truth just as a newborn child alters the world forever. Romantic Promethean fire-stealing is a poor fit with Mormon culture not only because it makes rebellion or pathology the price of authenticity, but also because it is too lonely and sees the artist as a solitary genius. It is too masculinist a view of creation. Mormonism is a massive project of making the whole world kin through procreation and baptismal adoption (of both the living or the dead). Such arts are always arts of linkage and require two participants at least. Many of the arts traditionally assigned to women—midwifery, weaving, cooking, nursing, caring—are left out of the romantic narrative. My point is not, of course, to reinforce a stale gender division of labor—of course women make art and of course men make babies—but to celebrate the work of soul-making as one of the fine arts. Mormonism can be read as immaterial art, social art, a vast work of performance art of bringing the universe into being, of participating in God's work and glory.[17] My colleague Wai Chee Dimock calls such work "infrastructure art."[18] Mormonism could be what Hegel called a "community work of art" or Wagner called a *Gesamtkunstwerk*, a total work of art.[19] To adapt the last line of George Eliot's

great novel *Middlemarch*, the growing good of the world is dependent on unhistoric acts, and maybe unhistoric arts. A just society would be the ultimate work of art. Zion must arise in beauty and holiness.

The notion of eternal increase implies a perfection that is not complete. Artworks and the human family share the character of being growing totalities. They are complete and yet open. Novel creation is like ice cream or children: there is always room for more. New works and events change the universe and its meaning. We know things belatedly. Zhou Enlai's famous verdict on the historical significance of the French Revolution was that it was too early to say. Things do not yet exist that, once they exist, will seem to be a necessary and eternal part of the universe. Traditional philosophy assigned to God alone the power to make necessary things. But we humans have that power in art and nature, in work and biology, in creation by artifact and progeny. We can bring things into the world that are both entirely new and entirely necessary. History managed fine before Shakespeare or Beethoven, and yet we now cannot imagine the world without them. I did not feel a lack in the cosmos before my children were born, but now their existence seems as absolutely necessary as that of the Earth, the Sun, or God. Once upon a time, many things did not exist that are now absolutely essential: symphonies, hymns, paintings, poems, knowledge, and people! Some things, if they were somehow to vanish without a trace, would leave the universe irreparably diminished. In Mormon terms: Added Upon! And it is always *glory* that is added upon.

Here is the philosophical theology we need to ground Mormon arts. The universe grows by play. There is something both excessive and indispensable about creation. It is a work and glory from which you need never retire. Would a celestial world need lawyers or doctors, entrepreneurs or plumbers? Maybe, maybe not. But with much greater confidence we can say that there will always be poets, painters, composers, gardeners, friends and parents. The primacy of the aesthetic is found herein, that it is the one mode of being guaranteed not to lose its eternal relevance. Once health and wealth are givens, there is still a lot of music to compose, poetry to write, gardens to cultivate, people to know and care for. There is plenty of matter to organize. Artists are guaranteed eternal employment; perhaps not so much doctors, lawyers, or politicians. In Mormon thought, the capacity to contribute to Creation is generously parceled out to many beings. It is not solely a divine monopoly. The ability to make things that are cosmically necessary is the province of intelligent creatures endowed with powers of creation. Mormon cosmology might not even recognize the classic philosophical contrast of art (the made) and nature (the grown). All of creation would be God's artwork. Planets, oceans, stones, DNA, life in all its varieties—are not astronomy, geology, and biology divine art works?

In sharing such creative powers, we humans are on the brink; every act is a creative one that puts at stake the future of everything. Science fiction sometimes imagines exotic ways of changing the future but that is not so rare: we do it in every act we make. (The really remarkable thing would be to change the past.) We are not just downloading

the heavenly script, but are free to make things that exist necessarily from this point on. Thus we rearrange how things have always been. Revelation is a collaborative process between humans and God. The atonement opens the awesome power of rewriting the past. That a human deed can be necessary in the strictest philosophical sense is one argument for the divine share-holding of human beings. It is also an endorsement of our inherent artfulness and a description of our terrible freedom. Humans are responsible for everything; even God's work and glory depends upon our choices. The cosmos stands in need of us, awaiting our arts and acts to bring about its growing perfection. This is the beautiful and terrifying cosmology that should inspire the Mormon arts.

THREE WONDERINGS: SOCIOLOGICAL POSTSCRIPT

1. What is Mormon Art?

The term *art* may be just as problematic as Mormon. So many definitions have been given. Art consists of that which humans wrest from chance (Roland Barthes). Art is a truth process that reveals the relation of heaven and earth (Martin Heidegger). Art is that which foregrounds the medium out of which it is made (Clement Greenberg). Art is "consummatory" experience (John Dewey). Art both offers and negates beautiful illusion (Theodor Adorno). Art is that which compels recognition of its makers as human beings (W. E. B. Du Bois). Art is what you can get away with (Andy Warhol). There does not seem to be a single feature that describes all forms of art. Does art need to be lasting? No, it can be a performance. Does it need to take a sensuous form? No, it can be conceptual. Does it need to follow an individual author's vision? No, it can be a collective creation. Does it need to by human beings? No, elephants can paint and computers can compose, and the cosmos could be God's art. Does art need to be appreciated? No, some art is meant to be abrasive and inaccessible. Does it need to be free of technology? No, many genres—photography and film, for instance—would not exist without machines.

We could go on at length. One provisional solution comes from sociology: art is a system of social activities, a network made up of institutions such as museums, galleries, universities, publishers, distributors, suppliers of materials, and markets; of actors such as artists, critics, conservators, brokers, agents, scholars, collectors, and audiences; of literary genres such as catalogs, manifestoes, reviews, criticism, and canons; and of media of popularization such as exhibits, anniversaries, artist-novels, tote bags, and websites. Indeed, the artists got there before the sociologists, and one trend in the twentieth-century avant-garde has been to toy with and expose the operations of the art world. Marcel Duchamp's moustache and salacious caption on the *Mona Lisa* from 1919 are the most famous example. With his "readymades" he was testing the limits of what counted as art. Is a reproduction a work of art? Does a signature make a work or art? Is an object consecrated by its display in a museum or gallery—a toilet, for example—a work of art? Art is a social practice,

whatever else it is. We can see art as whatever galleries show, critics write about, curators arrange, conservators preserve, and somebody pays for. This answer is not very inspirational—sociologists don't mind popping romantic bubbles—but it is at least clarifying.[20]

These reflections are relevant for the creation of a Mormon Arts Center. New York City is the place that invented the idea of modern art and is the global capital of the art trade, which is a double-digit billion-dollar business.[21] This festival is a step in a tried-and-true recipe of building of an art world and art market in a place where such things have been done many times before for different genres and traditions of art. One key step is to get critics and intellectuals involved, writing pieces like this one. Critics define canons, articulate strands and traditions, arbitrate fashions, compare and contrast styles, offer underlying cultural or philosophical motives, and generally provide "brilliant sentences" as Claudia Bushman put it, thus contributing an indispensable piece of the puzzle. One key step in the valuation and appreciation of new or old works is writing. (Would anyone pay $142 million for a Francis Bacon triptych otherwise, as occurred in 2013?) Very few works are ever valued, collected, and sold without the yeast of intellectual excitement. It is good for us writers to know what we are doing!

2. What is *Mormon* Art?

How works belong to a community—religious, ethnic, national, regional, etc.—is a messy problem. Nazi efforts to specify what was a "Jewish" science or a "degenerate" art have given the question a bad odor. Marxists had ferocious debates about the nature of political art; my favorite quip is from Walter Benjamin, that a work of art, in order to be political, first had to be a work of art! Nationalist efforts to define the essence of, say, American philosophy, Finnish music, or Irish literature bumped into trouble because every stab at uniqueness also reveals a foreign debt (pragmatism starts from German ideas, Sibelius is part of an international post-Romantic movement, Irish literature is written mostly in English). So then you have to start looking for more mysterious features—American philosophy is fond of money metaphors, Finnish music celebrates the lonely woods, Irish literature pioneers a post-colonial view of things. It keeps the critics busy sorting these elusive features out!

One useful shift is to look for clues beyond the content of the art itself. The question of who owns culture has been the topic of much debate in my home field of media studies and in the sociology of culture. The venerable media scholar Elihu Katz has suggested a handy sorting device for such questions by repurposing Abraham Lincoln's definition of democracy as government of, by, and for the people. A work can be American, Finnish, Irish, or Mormon by being about the people (content), by the people (production), or for the people (audience). A "black" TV

show can be about blacks, produced by blacks, aimed at a black viewership, or some mix of them. A "French" film can have French themes, be produced in France, or appeal to a Francophone audience. The Broadcasting Act of Canada calls for a minimum quota of "Canadian content" to aired (an act designed to prevent Canada from being flooded by popular culture from the colossus south of the 49th parallel). The definition of "Cancon," as it is known, can get baroque: in the case of radio music, the (1) music and/or (2) lyrics must be composed or (3) performed by a Canadian or (4) recorded in Canada. Clearly, defining what is "Canadian" is as hard as defining what is "Mormon." We can learn a lot about what counts as Mormon art from work by those who build on film genre theory to ask what is "Mormon cinema."[22] Whatever it is, Mormon art has many potential dimensions: of, by, or for Mormons!

3. Beauty and/as Holiness?

The scriptural source for the pairing of the two terms is a revelation to Joseph Smith in 1832: "For Zion must increase in beauty, and in holiness," echoing Isaiah about the city of Jerusalem putting on its beautiful garments. Note the careful phrasing and punctuation, alerting us that beauty and holiness might not be the same. Indeed not. Holiness is not always beautiful. Holiness in Mormonism generally refers to a high state of personal spiritual refinement, a condition of being clean, pure, without spot. However, *the holy* is much larger, especially if we view it as an aesthetic category and not only a measure of personal worthiness. The holy can be ugly or repulsive, haunted or enchanted, but it is always riveting. Lutheran theologian Rudolf Otto's classic definition of the holy, published one century ago, underscored its otherness, the tremendous mystery of a "numinous" presence beyond our ken.[23] In the same period the French sociologist Émile Durkheim traced the concept of the sacred to the practice of animal sacrifice, and argued that the sacred had a double face: it is both transcendent and accursed, the sweet-smelling savor of the smoke and the pitiable corpse of the sacrificial victim. (An etymological hint is the word *blessed*, meaning *happy* or *rewarded*, which is a cognate with the French word *blesser*, to hurt. The common origin seems to be blessing as an anointing with blood.) Holiness is always binding and compelling, but it is not always pretty. Its range of meaning is as wide as the arts themselves.

Beauty need not be holy. Modern artists have mined the profane with great gusto. Holiness need not be beautiful and is sometimes terrifying. Art can be none, one or both. Nature can be beautiful and holy, plain and profane. Whatever else it is, Mormon art cannot be defined in advance. Art is not safe, and there is no reason to want to put Mormon arts in a box. Mormonism is a theology of risk and of choice; Lucifer's plan was the one with safety and guarantees. We all wait to see what the next moves will be.

ENDNOTES

[1] Margaret Atwood, "What Art Under Trump?" *The Nation*, 18 January 2017, https://www.thenation.com/article/what-art-under-trump/

[2] See the wonderful book by Hubert Damisch, *Théorie du nuage. Pour une histoire de la peinture* (Paris, 1972), translated as *Theory of /Cloud/*.

[3] I cannot locate the source for this quote, but heard it in a lecture by the Russian film-maker Alexander Sokurov, who may have invented it for the occasion.

[4] Richard G. Oman, "Artists, Visual," *Encyclopedia of Mormonism* (1992), http://eom.byu.edu/index.php/Artists,_Visual

[5] *Courting the Abyss* (Chicago, 2005), esp. chap. 2.

[6] See Eugene England, "Easter Weekend," *Dialogue* 21:1 (1988): 19-30, at 23.

[7] Compare Kristine Haglund's discussion of "with all tenderness" in this volume.

[8] Either my memory or the speaker enhanced that quote, which I cannot now find.

[9] Joseph Conrad, *Three Short Novels* (New York, 1960), 59.

[10] See my "Bowels of Mercy," *BYU Studies* (1999), 38.4 (1999): 27-41.

[11] See the brilliant work of my Yale colleague, John Rogers, on Milton and Mormon materialism.

[12] Compare Aristotle's idea that poetry is universal but history is particular: imaginative art shows what could happen, not only what did happen.

[13] Such was implied in the wonderful keynote of Terryl Givens, this volume.

[14] Adam S. Miller, *Speculative Grace* (New York, 2013), 146, 153-4.

[15] John Dewey, Art as Experience (New York, 1934).

[16] See Glen Nelson's discussion of "relevance" as a category for Mormon art in this volume.

[17] See Jared Hickman's contribution in this volume.

[18] Wai Chee Dimock, "Editor's Column: Infrastructure Art," *PMLA* 132:1 (2017), 9-15. http://www.mlajournals.org/doi/abs/10.1632/pmla.2017.132.1.9

[19] Compare Jana Riess's discussion of "collective Shakespeares" in this volume.

[20] See the classic works by Michael Thompson, *Rubbish Theory: The Creation and Destruction of Value* (New York: Oxford, 1979) and Howard Becker, Art Worlds (Berkeley: University of California, 1982).

[21] Estimates of global art market sales in 2016 ranged from $16.9 to 56.6 billion. Scott Reyburn, "What's the Global Art Market Really Worth? Depends Who You Ask," *New York Times*, 23 March 2017 (online).

[22] Randy Astle, "Defining Mormon Cinema," *Dialogue* 42:4 (2009): 18-68, and the articles

in *Mormons and Film: A Special Issue*, eds. Gideon O. Burton and Randy Astle, BYU Studies 46:2 (2007).

[23] *Les formes élémentaires de la vie religieuse* (Paris, 1912).

JANA RIESS

GENRE TRIUMPHS: THE OUTSIZED MORMON PRESENCE IN YOUNG ADULT AND MIDDLE-GRADE FICTION

At the opening of the school year at Brigham Young University in September 1967, Elder Spencer W. Kimball addressed the faculty in a speech called "Education for Eternity." At the time, Elder Kimball had been an apostle for nearly a quarter century, having been called in 1943 at the age of 48. He proposed a sweeping vision not just for the church-owned university, but for the Mormon people as a whole. He had had a vision, he said, of BYU faculty members, students, and alumni not only contributing to worldly knowledge and artistic success, but dominating in those fields "till the eyes of all the world will be upon us."

> In our world, there have risen brilliant stars in drama, music, literature, sculpture, painting, science and all the graces. For long years I have had a vision of the BYU greatly increasing its already strong position of excellence till the eyes of all the world will be upon us.

He then quoted a September 1857 sermon by John Taylor in which Taylor prophesied of greatness for the Mormon people: "You mark my words, and write them down and see if they do not come to pass. You will see the day that Zion will be far ahead of the outside world in everything pertaining to learning of every kind as we are today in regard to religious matters. God expects Zion to become the praise and glory of the whole earth, so that kings hearing of her fame will come and gaze upon her glory."

So, Mormon artists, no pressure.

It's a bold and fascinating vision. Both leaders had yet to become church presidents, but both spoke prophetically of a future day in which Mormon artists, writers, and musicians would dominate in their respective spheres.

It probably seemed a pipe dream in 1857, when John Taylor spoke; Mormonism in that year experienced a net loss of more than eight thousand members, which for a church of barely 55,000 people total represented more than a 13% decline. It was also embattled on every side, fighting the federal government in the Utah War and some of its own members in the context of the Mormon Reformation. In fact, Taylor's sunny

vision of the LDS Church becoming the "praise and glory of the whole earth" came just nine days after the Mountain Meadows Massacre. This was a strange time indeed to imagine Mormonism blessing the peoples of the world.

Things were certainly looking up 110 years later when Spencer W. Kimball was thinking along these same lines. Mormonism in 1967 had just surpassed 2.6 million members and was growing at a rate of more than 5% a year.[24] New lands seemed to be opening constantly for the preaching of the gospel.

Fifty years after President Kimball's bold mandate, we are yet without our Shakespeares, our Michelangelos. There is no single individual that we can point to in an artistic field and say that one Mormon has achieved artistic dominance in that field of endeavor. Just so we can better understand the context of President Kimball's thinking, here is a list of the famous individuals he singled out from history as masters of art, music, science, and literature:

W. Richard Wagner (composer)

Giuseppe Verdi (composer)

J. S. Bach (composer)

Enrico Caruso (singer)

Adeline Maria Patti (singer)

Jenny Lind (singer)

Nellie Melba (singer)

Mme Schumann-Heink (singer)

G. F. Handel (composer)

George Bernard Shaw (playwright)

Niccolo Paganini (violinist)

Franz Liszt (composer)

Ignacy Paderewski (composer)

Leonardo da Vinci (artist and scientist)

Thorvaldsen (artist)

Michelangelo (artist)

Johann Wolfgang von Goethe (writer)

Robert Bolt (*A Man for All Seasons*)

Boris Pasternak (*Doctor Zhivago*)

Lew Wallace (*Ben Hur*)

Rembrandt (artist)

Raphael (artist)

Louis Pasteur (scientist)

Marie Curie (scientist) ✓

Albert Einstein (scientist)

William Shakespeare (playwright)

Abraham Lincoln (president)

Daniel Burnham (architect)

What do we notice about this list? Without exception, these two dozen-plus people are all from Europe or America. The list has no one from Africa, East Asia, South Asia, South America, or Oceania. President Kimball envisioned the whole world praising the rich cultural capital of the Latter-day Saints, yet it was a very particular kind of culture he was praising.

Also largely missing on the list are women. Of the five he mentions, four are singers and only one, Marie Curie, could be considered an innovator or creator. Women in this list are essentially either absent or they are interpreters and muses for the creative works of men.

I point this out not to criticize President Kimball for his artistic vision; even in the smaller male and culturally western world he hoped Mormons would excel in, we haven't managed to produce a single creative genius who has bucked tradition enough to make the world stand up and take notice.

Or have we?

Maybe the problem is that we're valuing and honoring the wrong things, the things that Mormons don't do as well. Many of the names on President Kimball's list are individuals who fall into the "lone genius" archetype—iconoclasts who bucked the artistic or scientific conventions of their time, breaking through to new directions. They were not always popular. In some cases, their moral behavior was not what leaders of the LDS Church would wish its members to emulate, perhaps resulting in President Kimball's cautious statement about any future Mormon Wagner: he hoped a Mormon iteration of the composer would be "less eccentric, more spiritual." Presumably he was referring to Wagner's infamous temper.

Mormons haven't had much luck with the lone genius paradigm. In music, we excel at choral singing; the Mormon Tabernacle Choir is indeed one of the best and most cohesive choral groups in the nation, even the world. In television, we've seen that Mormons have an unusually robust presence in reality TV, particularly in contests and shows where teamwork is involved, like the rigor and classical beauty of ballroom dancing. And in writing, we excel in genre fiction.

So what is genre fiction? The debate about literary fiction vs. genre fiction is an old and we might say outdated one. The best writers can meet genre expectations *while also* making keen observations about human nature, family, and life and death. Writers like Michael Chabon, for instance, have cleverly blurred the lines.[25] But for the sake of clearer argument, let's break the categories down into two camps.

Literary fiction features more artistic risk and fewer conventions. This is fiction that pushes artistic boundaries. Considered to be "serious" literature, literary novels are the ones that win the National Book Award and the Man Booker Prize. They are not typically novels that sell especially well compared to genre fiction, mostly because they are often challenging reads and are not primarily intended as entertainment.

Literary fiction is not tied to a particular reading community other than the author's own fans. One Zadie Smith novel is *not* like another, for example. Earlier this year, George Saunders published *Lincoln in the Bardo*, which was one of the most interesting and beautiful novels I have ever read, but I would be willing to bet that whatever Saunders comes up with next will be completely different.

Literary fiction seeks to better understand reality and the human condition. This is the point, most of all. These novels want to plumb the depths of life, relationships, and the unknown; they do not guarantee their readers a particular kind of ending, just as life comes with no guarantees for those who live it. Within literary fiction, there are many styles and authors are always testing the limits of form and structure. Narrators are not necessarily reliable; time is not always portrayed in a linear fashion; the plot is far less important than the theme and character development.

Genre fiction contrasts in most of these ways. It is primarily plot-driven and does not privilege theme and characterization over that plot. Genre fiction is called such because it is grouped into various types, or genres, that have defined parameters and expectations: Science fiction, mystery, romance, fantasy, horror, Westerns. Within each of those broad categories are various subgenres, like Regency Romance versus erotica, or the cozy mystery versus the legal thriller. Unlike literary fiction, genre novels are written for a popular and defined audience. The expectations are clear. A reader who wants a cozy kitchen mystery is going to be appalled by the graphic violence that characterizes darker crime fiction, just as one who reads bonnet fiction wants any sex to happen only from the neck up, thank you very much. By the standards of bonnet fiction, stealing a kiss in the barn is acceptable, but groping is not.[26]

Genre fiction is intended first and foremost as entertainment. It quite wonderfully and unabashedly presents itself as a good time, not as an attempt to drag readers through the dark night of the soul. We read genre fiction mostly to escape from reality, not to delve more deeply into reality.

For this reason, genre fiction is usually not taken seriously by critics (and often wrongly so). Again, the very best novels blur the lines here. A few that come to my

mind are in the science fiction/fantasy realms, because those are the genres I read most frequently. In sci fi, one of the best novels I can think of is Mary Doria Russell's *The Sparrow*, which is a futuristic story that positions a Jesuit priest as among the first group to explore a distant planet. It is beautiful and heartwrenching and true, *and* it's set in outer space. More recently, Emily Mandel broke the barrier between genre fiction and literary fiction with *Station Eleven*, which has many of the elements of dystopian fantasy but takes it to such a profound level that it's like eating your first real meal in Italy after you've only ever judged Italian food by the standards of the Olive Garden.

Just to make it clear here, if it hasn't become clear already: I enjoy both kinds of fiction. I probably read an average of one sci fi or fantasy novel a week, some of which are aimed for the YA, or young adult, market. And this is the market where we see Mormon genre writers shine.

Journalists and others have long noted the outsized presence of LDS writers in this particular slice of the literary world. When Stephenie Meyer's *Twilight* books achieved international bestsellerdom in the mid-2000s, it began a phenomenon of people noticing just how many successful genre writers, in addition to Meyer herself, were Mormons. Since that time, the list of *New York Times* bestselling authors who are LDS includes Shannon Hale (*Princess Academy* and *Goose Girl*), James Dashner (*The Maze Runner* series), Brandon Sanderson (*Steelheart*), Brandon Mull (*Fablehaven*), Ally Condie (*Matched* trilogy), and most recently Kiersten White (*Paranormalcy*; *And I Darken*).

Why this outsized presence? Some of the articles about LDS writers' success has focused on, for example, Mormons' success in science fiction and fantasy as being a natural outgrowth of the outlandish nature of their theology. In this view, science fiction is an organic outlet for beliefs that outsiders see as potently bizarre. As you can imagine, I don't find this particularly compelling. Near the end of the chapter I will briefly discuss the way that Mormon writers' fiction does often reflect Mormon themes, so I am certainly not saying that theology is irrelevant here. However, to dismiss these writers' success as merely the result of an unusual openness to eccentric theology is facile at best and insulting at worst. Mormon theology may indeed be mind-bending, but that is not an adequate explanation for the disproportionate presence of Mormon authors in science fiction and fantasy in particular, and genre fiction in general.

Instead, let me propose an alternative: Community is the Mormon Shakespeare. This argument is one I thought I had come up with myself. In March, when speaking about this conference to blogger Rosalynde Welch, I mentioned the basic thesis I wanted to present here: that community is our Shakespeare. I stated that Mormons' unique blessing is that we are conditioned to help one another, to always see ourselves as a part of something whole. Our authors are no different. And I found out that Rosalynde, who has a doctorate in early modern literature, had already presented a similar thesis about a decade ago. But here's the thing. She sent me the paper she had given and encouraged me to use those ideas and build on them as I developed my own.

That's Mormon art, that collaboration, right there. Rosalynde made my paper better, by talking about it with me in March and again last week when I saw her at a conference in Utah, by offering her written but unpublished work for me to use. It has been a kind of beautiful experience—and very "meta"—to have this paper's development mirror the argument I am trying to make in my thesis!

Rosalynde observes that:

> In the case of Mormon culture...it's pretty plainly not the case that Mormon artists have devised new unique artistic forms from their ethnic-religious milieu; rather, Mormon artists have borrowed the genres and media circulating in their particular social contexts.... Mormon culture values the superior performance of shared forms over the originality of invention.... But for the Mormon writer, it is precisely the accessibility of the genres that makes them successful cultural figures for an affirmative performance.[27]

In other words, Mormon success is about *genre*. Genres are of the people and for the people, whereas literary fiction can be legitimately intended for an audience of one: the author. This works so well for Mormon genre novelists because they are steeped in community already, and the fulfillment of community expectations is vital for success in genre fiction.

There are several facets to this. First off, there's a contract with the reader. As I mentioned earlier, readers in genres and subgenres come to the book primed for a certain experience of reading. In an adventure novel, you need to have a heroic protagonist who has a transformative, quest-like adventure. In a romance, you want two people to fall in love and live happily ever after despite the inevitable bumps in the road. And in a fantasy, it really helps if there is magic and a fantastical creature or two. Authors who conform to those expectations with style and love will be rewarded with loyal and enthusiastic readers. Authors who don't conform to those expectations will have a harder time building a following, though of course there are exceptions.

But secondly, successful authors in genre fiction realize also—now more than ever in this age of social media—that the community they are building and reinforcing with readers does not begin and end with the reading experience itself. This is another area where Mormon writers shine. I can't really think of any top LDS genre novelists that don't make themselves accessible to their readers through travel, book fairs, Twitter posts, Comicon appearances, and other means. Kiersten White posts not only about the new work she is doing (*And I Darken*, out in June 2017 as the sequel to her groundbreaking feminist interpretation of Dracula lore), but also about family, popular culture, politics, and perhaps most importantly, her tremendous support for other writers. She is constantly pointing her own fans to the work of other writers she admires, both Mormon and non-Mormon.

Why YA, though? Even if it's true that LDS novelists come to the table of genre

fiction with a built-in advantage of a lifetime of training in how to uplift a community, that does not account for why they have found some of their best success writing for teenagers rather than adults. Here again there is an "obvious" explanation, but here again I don't find it wholly adequate. The obvious explanation for outsized success in YA is that Mormon sexual ethics aren't perfectly in step with modern adult fiction, in which nonmarital sex is the norm. The idea behind this observation is that Mormon novelists may have clustered in YA and middle-grade fiction simply because that literature is directed at age groups that won't be expecting nonmarital sex to be a feature in their books. This is what the *New York Times* concluded in a 2013 op ed:

> Realist literature for adults often includes aspects of adult life like sex and drinking, and the convention is to describe them without judgment, without moralizing. By writing for children and young adults—or in genres popular with young people—one can avoid such topics. Mormon authors can thus have their morals and their book sales, too.[28]

I find this a cynical view, and not even factually accurate since it doesn't take into account the fact that many of these same authors also write successful adult fiction while managing to avoid overt sex scenes—Meyer with *The Host*, Hale with *Austenland*, and Sanderson with his many fantasy novels, including *Mistborn*. Moreover, the tone focuses only on what's missing rather than what's present in these authors' works, making them sound puritanical. As the *Salt Lake Tribune* sniffed in response to the *Times* piece, "These must all be prudish Mormons, afraid to grow up and write real books for serious adults."

I would like to augment the *Times*'s sex-planation with something that is less *via negativa* and more focused on the ways that Mormonism can and does bless the world: we are a child-focused and child-friendly subculture. Mormons have more children than the national average, and while that figure is declining in the younger generations, we are still looking at adult Mormons having grown up in families of 4.02 children, nearly twice the national average.[29]

For an example of this let's look at one of my favorite YA novelists, Shannon Hale, who is herself a mother of four. "Having kids while writing for kids is a constant and valuable reminder of what really matters—spoiler: it's not me," she has stated. That is a succinctly and beautifully Mormon expression of why some of our writers make art. We are looking to inspire, to educate, to uplift. We are creating for others and not just ourselves; we are conscious of the ways our work might influence people for better and for worse. We are aware of what it means to live in community.

Mormon YA novelists' ideals of supporting younger readers and writers is coming to fruition just this week in the southern Utah "write out," taking place right now in Cedar City. According to organizer Ally Condie, the event not only features writing practice and keynotes from major authors, but also a costume ball, swimming, rock climbing, an evening at the Utah Shakespeare Festival, and a game called pickleball.

Clearly, the point here is not simply to convey information to teens who want to become writers, but to create community with them.

This kind of writerly community is available to many of the adults involved in the form of the Rock Canyon writers' group. This is a group based in Utah but open to all writers regardless of religion. Some, like *Story of a Girl* novelist Sara Zarr, are not LDS, but most are. In many ways this community is due to the efforts of Rick Walton, a picture book author who passed away in 2015. By all accounts Walton had a singular gift not only for writing children's books but also encouraging other writers with advice and introductions. Here are some of the many YA and children's authors Walton shepherded through the years, including:

- Mette Harrison, known for her YA fantasy and romance books but also more recently for her adult mystery series *The Bishop's Wife*

- Brandon Mull, whose *Fablehaven* series is unusual in this group because it was published by a Mormon press, not a New York trade house, and crossed over to a national audience

- Shannon Hale, as mentioned above, author of *The Princess Academy*, *The Goose Girl*, and most recently, *Princess in Black*

- James Dashner, whose *Maze Runner* series has sold more than ten million copies just in North America

The Rock Canyon writers meet regularly, have ongoing discussions online. Most are also involved in an annual conference called Writing and Illustrating for Young Readers. When I interviewed Mette Harrison in preparation for this talk, she said that every summer, someone gets a book contract out of that gathering. They are supportive of one another's successes: "We don't see each other as competition, and we see projects as community projects rather than solo projects."

The success of that network is evident in the story of Idahoan Jessica Day George. According to the *Salt Lake Tribune*, George "spent eight years trying to get published while living on the East Coast, working in bookstores and writing in her spare time. The only writing conferences were hours away in New York. Within months of moving to Utah in 2001, she'd gone to two writing conferences—one just a mile from her house— and met her agent and editor. She's since published more than a dozen fantasy novels."

We've seen that Mormon novelists have had outsized success as YA genre novelists in part because of the Mormon genius for understanding and building community. I do also want to point out that in very recent years, Mormon authors have been especially successful in one particular subgenre that has been popular in recent years: dystopian or postapocalyptic fiction.

Many of these novels center around the role of the individual in community, and of the value of choice and free will. Ally Condie's *Matched* trilogy, for instance, is very much

about the essential nature of agency, the idea that free choice is worth dying for. This is a question that drives other genre fiction by Mormon authors, such as Stephenie Meyer's absorbing adult novel *The Host*. Many dystopian novels, in fact, feature a society in which individual choice has been taken away, and obedience is enforced. To Mormons who have been steeped in a cosmology of a "war in heaven" in which Satan's plan has been to remove free will from individuals to ensure their perfection, there is a natural point of consonance.

Perhaps there is a sense in which Mormons are more theologically equipped to see the dangers of enforced obedience and false perfection because Mormons believe in a God who was willing to sacrifice fully one-third of the host of humanity in order to protect the human ability to choose. "Know this, that every soul is free..." has been a tenet of the faith since the idea was enshrined in the first LDS hymnal.

And on the darker side, I have to add that perhaps contemporary Mormons are more equipped to see the dangers of enforced obedience because despite a theological foundation that so strongly emphasizes agency, the rhetoric that gets the most play from church leaders is obedience and the importance of following. There is a sense in which Mormon artists and writers may be working this out for themselves on the page, this balance between freedom and obedience, this paradox of our people, as Terryl Givens has aptly pointed out.

In conclusion, Mormons have been told that we should, and we will, have our Shakespeares. But what if we have been thinking about that too narrowly? As Mette Harrison told me, "we already do have some of our Shakespeares, if that means we have writers who will be profoundly influential to other writers." The lone genius archetype is one way of defining success. But another may be building community with readers and with fellow writers. And in that, Mormons excel.

ENDNOTES

[1] At the end of 1967, the LDS Church boasted a worldwide membership of 2,614,340 people, a 5.38% increase over the previous year. See the almanac records at http://lds-church-history.blogspot.com/2010/04/lds-history-1967.html.

[2] For example, Chabon's 2007 novel *The Yiddish Policemen's Union* employs the genre of the hard-boiled detective story while also exploring some of the alternative-reality paradigms of science fiction.

[3] See Valerie Weaver-Zercher, *The Thrill of the Chaste: The Allure of Amish Romance Novels* (Baltimore: Johns Hopkins University Press, 2013).

[4] For more of this argument see Rosalynde Welch, "Oxymormon: LDS Literary Fiction and

the Problem of Genre," Patheos, May 17 2011, http://www.patheos.com/resources/additional-resources/2011/05/oxymormon-lds-literary-fiction-and-the-problem-of-genre-rosalynde-welch-05-18-2011.

⁵ Mark Oppenheimer, "Mormons Offer Cautionary Lesson on Sunny Outlook vs. Literary Greatness," *New York Times* November 8 2013, http://www.nytimes.com/2013/11/09/us/mormons-offer-cautionary-lesson-on-sunny-outlook-vs-literary-greatness.html?mcubz=1.

⁶ The Next Mormons Survey, 2016.

⁷ Rachel Piper, "Utah's Children's Authors Credit Publishing Boom Not to Mormonism But to One Man's Insistence That They Never Quit," *Salt Lake Tribune*, January 13 2016, http://archive.sltrib.com/article.php?id=3112080&itype=CMSID&pid=2574333.

ERIC SAMUELSEN

REFLECTIONS ON THREE LDS PLAYWRIGHTS: NEIL LaBUTE, TIM SLOVER, AND MELISSA LEILANI LARSON

When I was just beginning my career as an LDS playwright and theatre scholar in the late 1970s, the animating force that drove me and my friends and colleagues was what we regarded as prophecy, the oft-cited comment from Orson F. Whitney that we would someday have "Shakespeares and Miltons of our own." I don't recall that we spent much time unpacking Whitney's comment. We just knew; there would one day arise a Mormon playwright equal in cultural impact and literary renown to William Shakespeare. (Since none of us were much interested in writing lengthy, theologically dense narrative blank verse poetry, the Milton half of the equation became rather neglected).

It wasn't just us. Beginning in the late 1970s, Church leadership actively encouraged creative work. Boyd K. Packer's 1976 talk, "The Arts and the Spirit of the Lord" cited Whitney specifically, though suggesting that our progress towards fulfilling Whitney's vision was proceeding more slowly than it needed to. In 1977, the Ensign repurposed an older talk by President Spencer W. Kimball, for a special edition dedicated to the arts. That talk, President Kimball's "A Gospel Vision of the Arts" was the first talk I read after returning from my mission, and has remained a constant source of inspiration. Twenty years later, Elder M. Russell Ballard's "Filling the World with Goodness and Truth" again combined admonishment and encouragement to those of us who fancied ourselves as possessing some literary or theatrical skill. We needed to reach higher; we needed to dig deeper. A Mormon Shakespeare's work would reflect the profundity of gospel teachings, while providing a clear-eyed commentary on the world. And these Brethren also expressed the hope that. while producing our art, we would also stay in the Church. President Kimball hoped for, not just a Mormon Shakespeare, but a Mormon Wagner; a composer of Wagnerian skill and accomplishment. But he also rather nervously wished that whoever answered that call would, in his personal life, not quite be, you know, Wagner. I did it myself, in my first published article after joining the BYU faculty in 1992, in *BYU Studies*, in which I suggested that a Mormon Shakespeare would require a Mormon Globe, and urged someone to start a theatre company, preferably in Utah, and preferably around Lehi, so we could draw audience from both Salt Lake and Utah counties.

It is my purely subjective personal view that the quest for a Mormon Shakespeare has become passé among younger Mormon artists. And this strikes me as an altogether healthy development. Certainly, we want to write well, and hope for professional success. But the academy has changed, and "achieving literary greatness" is no longer the desideratum for literary achievement. We now understand literary works as artifacts of culture, as the products of complex interactions between authors and subjects and audiences and milieus. We view literature today, not as a hierarchy, but through a variety of cultural and critical lenses. When Whitney, in 1888, wrote "we will build up a literature whose top shall touch heaven, though its foundations may now be low in earth," he's describing a way of looking at literature—up good, down bad—that no one much subscribes to anymore. Our contemporary post-modern approach to literature, I must add, is altogether good and right and worthy and virtuous. A quick google search of "Mormon Shakespeare" links to recent articles whose slant strikes me as unfortunately reactionary: a rather gushing *Meridian* review of a mediocre novel, or to articles both bemoaning and celebrating the successes of Mormon writers of fantasy genre fiction. Whether Whitney intended his remarks as exhortatory or prophetic—and re-reading "Home Literature," his seminal article, again, I think he meant it both ways—we don't think that way anymore. A Mormon Shakespeare would require the building of a Mormon time machine, calibrated back to 1590. Shakespeare wasn't trying to write "great literature." He was a successful commercial playwright and actor, creating material for the company in which he was a shareholder. A hack, out to make a buck. As well as the most extraordinary dramatic craftsman. His plays remain viable in contemporary production: his theatrical world, no less than his historical period, no longer exists.

Having said all that, let me add that there are LDS playwrights today who write plays, good ones, which are produced with varying degrees of commercial success. And what I find fascinating about their work are the specific ways in which their work does reflect Mormon theology writ large. That's the flip side of the various talks I cited earlier, General Authorities on the Arts. Each of them addresses this; the hope that LDS beliefs, values, culture and history will inform the best art we produce.

In this paper, I will examine the dramatic works of three LDS playwrights: Tim Slover, Neil LaBute and Melissa Leilani Larson. I chose them because I think they're outstanding writers, and because I'm familiar with their work. I do think it likely that outstanding LDS theatrical artists can be found anywhere the Church is found, in Africa or South America or Asia. I wish I knew more about them; I wish I could read their plays. But these three will do for now.

Eugene England, back in the 1970s, provided a helpful three-part definition of Mormon drama and literature. First, he said, there were works produced by people with no affiliation with Mormonism, which nonetheless reflect our history and culture. Those would include, today, plays like Tony Kushner's *Angels in America* and the *Book of Mormon* musical. Second, said England, would be works by LDS artists on secular subjects, though presumably influenced by the author's beliefs and values. All three of these

writers are known for works that meet this description. Finally, we should expect works by LDS writers that do deal specifically and directly with Mormon historical topics, culture, or theology. Again, the three writers I describe have written works in this category as well. What interests me about these writers is the very different ways in which their best work reflects their Mormonism. I should add as well that I think they're all terrific playwrights. Slover and Larson both self-identify as active, believing Latter-day Saints. LaBute did as well during the early years of his career, while he was writing the plays I will primarily examine here. LaBute has since left the Church.

I want to start with Neil LaBute. He is known today almost more as a filmmaker than as a playwright. He launched his filmmaking career with *In the Company of Men*, a Sundance hit based on his own play. From 1997 to 2003, he made films out of his best early plays, including *The Shape of Things*, *Your Friends and Neighbors*, and *Bash: Latter-day Plays*. These plays will be the primary focus of my study.

What's interesting about LaBute's plays is how they center on questions of morality. This does not mean that his plays involve characters wrestling with vexing ethical dilemmas, or trying to parse out precisely which moral imperatives should be applied to some tricky interpersonal quandary. Not at all. Typically, the plot of a LaBute play involves dreadful characters, thoroughly appalling monsters; fiends, really, deliberately trying to hurt people for their own pleasure or profit. And getting away with it.

In the Company of Men, for example, is about Chad and Howard, two young businessmen, on assignment away from the home office where they usually work. Bored and restless, Chad persuades Howard to join him in the following plan. They will find a vulnerable female co-worker—they choose a hearing-impaired woman, Christine—and they will both begin to pursue her romantically. They will try to throw her off-balance, confuse her, entice her sexually. They will declare their affection for her, and do everything within their power to get her to fall for one, or preferably, both of them. They will then dump her on the same day, to see if they can shatter her emotionally. And it works. Howard is deeply troubled by what Chad has persuaded him to do, and desperately tries, and fails, to make it up to Christine. Chad finishes his assignment, and returns to his girlfriend, to all appearances renewed and refreshed.

The Sundance movie based on this play launched the career of Aaron Eckhardt, who was superbly sociopathic as Chad. It's an incredibly disturbing film, intentionally so. But, of course, we're meant to find Chad appalling. To an audience aware that dramatic representation does not imply approval or endorsement, the play offers an opportunity for moral self-examination. Have I ever behaved that abominably? Certainly not. But have I ever behaved even close to that badly? Have I ever treated anyone, and especially, have I, as a man, ever treated any woman with anything like that level of misogyny? I found watching it—and I have seen it both in theatrical production and as a film—a profoundly troubling, but ultimately beneficial exercise in self-criticism.

In the same vein is *The Shape of Things*, a 2003 London Off-West-End hit, which LaBute also turned into a film. Evelyn, an art student, meets Paul, an insecure fellow student, at an art gallery. She begins molding him, agreeing to, and then refusing sex until he accedes to her requests. He begins working out, begins dressing more stylishly. He distances himself from friends she disapproves of. He is finally persuaded to undergo plastic surgery. Then he discovers that he has been her work of art. In fact, he's been her thesis project. He is her artistic medium, and as some artists work in clay or marble, she has been working on him, using sexuality as her primary brush or chisel. Again, Evelyn is a monster; again, Paul is her helpless victim. And at the end, he is left impotent and furious. And she is awarded her degree.

We might ask ourselves afterwards what thesis committee could possibly approve such an odious final project, just as we might ask ourselves, after viewing *In the Company of Men* what kind of trouble Chad could face if Christine were to file a complaint with the company's HR staff. But those concerns are a bit beside the point. LaBute does not provide us with that larger context, because it's irrelevant to the moral concerns that animate him. What responsibility do artists have to their models, or to the subjects of their work? If I fancy myself an artist, does that give me license to harm in the service of my art? Have I ever done anything like this, and if so, how quickly can I repent?

I might also mention LaBute's one LDS oriented work, Bash. It was first produced in New York in 1999, and has subsequently enjoyed long runs there, on HBO, and in London. It consists of three short plays, each profoundly disturbing. In the first, *Iphigenia in Orem*, an LDS businessman smothers his infant daughter in order to advance professionally; the play consists of his monologue confession, and rationalization. In the second, *a gaggle of saints*, straight young LDS men beat a gay man to death, as a lark; one of them gives the victim a priesthood blessing, while another steals the victim's ring and uses it to propose to his girlfriend. Finally, in *Medea Redux*, a woman describes her affair, at thirteen, with a married man, and the son that affair produced, who she has likewise murdered. Again, it's essential that we point out that LaBute is not suggesting that any of these events or characters are in any way typical of Mormons. These short plays are works of fiction, inventions of language. Euripides did not create Agamemnon or Medea as role models, but as cautionary tales. That is likewise LaBute's intention.

It may seem surprising to hear me declare that a playwright whose characters behave abominably, don't get caught, get away scot-free, and even profit from their despicable actions is one who reflects Mormon standards of morality. Or that a playwright whose work is as incendiary as LaBute's somehow reflects a Mormon aesthetic. One difficulty might be that there aren't any characters in LaBute's plays who represent positive ethical standards. There's never an authority figure who can declare 'that's wrong. That shouldn't happen.' Presumably, we know that for ourselves. I compare LaBute's work to Alma Chapter 47, and its detailed description of the contemptible and treasonous Amalickiah. But of course, the book of Alma is mediated by the editorial presence of

Mormon, who frequently provides contextual commentary. We're never left to wonder if there's a sense in which Amalickiah might be seen as admirable. No such mediator appears in any of LaBute's plays. He trusts his audiences to mediate their own responses. He trusts us to trust him.

Moving on from Neil LaBute, the second playwright I wish to examine is Tim Slover. Slover taught at BYU, and is currently on the faculty of the University of Utah. His plays are deeply informed by his interests in history. They are meticulously researched, and written with grace, humor and compassion. Only one of his plays deals specifically with Mormon history, *Hancock County*, about the trial of the murderers of the prophet Joseph Smith. I will return to that play momentarily.

If Neil LaBute's plays center on questions of morality, Tim Slover's center on the need for an atonement. His best-known work, *A Joyful Noise*, about Handel and the creation of the oratorio *The Messiah*, played off-Broadway, and has been a regional theatre staple for years.

As the play begins, in 1741, Handel is elderly, ill, and his career is failing. His Italianate operas, with their preposterous plots and flamboyant castrati stars, which had been the staples of his career, once popular, were now seen as ridiculous. Tastes changed, and suddenly Handel was an old-fashioned laughingstock. When the librettist Charles Jennens sends him an odd collection of scriptural passages, and suggested they might make an oratorio, Handel is initially perplexed. But when a performance opportunity presents itself, he writes *The Messiah* in just three weeks time.

Meanwhile, the actress and soprano Susannah Cibber had also seen her career prospects halted. A salacious adultery scandal had led to the publication, by her husband, Theophilus, of a pornographic, highly fictionalized account of her escapades. She had become persona non grata in the theatre world, and could see little recourse but suicide.

Instead, Handel decides to take a chance on her, and casts her as one of the two female soloists in the oratorio. And the climax of the play occurs when Slover makes explicit what was otherwise clear enough; Susannah, standing before the king and a persecuting bishop, sings "he was despised and rejected of men, a man of sorrows and acquainted with grief." Susannah, so desperately in need of redemption, has embraced Christ's atonement.

What's so lovely about this play is it's more expansive understanding of the atonement, which I have come to see as somewhat unique to Mormonism. Bruce C. Hafen, of the Seventy, expressed this understanding in a lovely 1990 General Conference talk, "Beauty for Ashes." Said Hafen, "The Savior's atonement is thus portrayed as the healing power not only for sin, but also for carelessness, inadequacy, and all mortal bitterness. The Atonement is not just for sinners." Handel's professional disappointments, the ridicule he suffered, and his own ill health; these were also human conditions for

which our Savior's sacrifice provides solace and redemption.

We see this theme play out in play after play of Slover's. In *Treasure*, Slover depicts Alexander Hamilton in the lowest point in his life, when an affair led to his disgrace, and nearly ended his marriage. Though Hamilton acknowledges fully his complicity in the affair, its publication was part-and-parcel with the political intrigues in which he was embroiled. In *A March Tale*, William Shakespeare tries to reconcile the heavy professional demands on his time with the long-distance difficulties of a marriage to a wife living a two day horse-ride away. In *Virtue*, Slover's most recent play, the visionary nun Hildegard von Bingen struggles to remain true to her divine muse, while wrestling with feelings of attraction for a particularly inspirational novice.

I am particularly taken with *Hancock County*, Slover's one play about Mormon history. Although Brigham Young is a central character in the play, the plot centers on the hard-drinking prosecuting attorney, Josiah Lamborn, who diligently tries the men who murdered Joseph Smith, while fighting through his own many demons. Lamborn is the quintessential Slover protagonist; damaged and denounced, a man who has nearly destroyed his own professional career, and is struggling to do a difficult and unpopular job. In his jury summation, again, we see the theme of atonement.

"Murder just ain't murder if you happen to dislike the victim. Well, I want to tell you, you're doing the right thing. Oh, not because of Joseph Smith's morals, or his militia. Hell, you all got one of those. No, it's his ideas. I've been reading them. And they're so dangerous and pernicious that you folks had no choice but to kill him. Just listen to what he wrote. 'Hold out to the end, and we shall be resurrected and become like Gods.' As far as I can make out, this man believed human beings can turn into Gods. How's that for blasphemy, members of the jury? But just try to grasp it for a moment if you can. All our meanness, and our fear, and our little hatreds, and our weakness, all turned into glory. (He begins to chuckle). Now imagine someone actually believing that."

I should finally mention that Slover, for all his success, has struggled with the most extraordinary ill-fortune professionally. He was busy marketing a screenplay version of *A March Tale*, a romance in which the main character is William Shakespeare, at the same time that Miramax was producing the film *Shakespeare in Love*. More recently, it happened again, as he tried to market a lovely play about Alexander Hamilton a few months before a rather well-known hip-hop musical on the subject was working its way to Broadway. If there is to be a Mormon Shakespeare, we might add pure luck as a crucial factor in his or her emergence.

The third playwright of this paper is Melissa Leilani Larson. Of Filippina/Swedish heritage, she is younger than Slover or LaBute by over twenty years. Her main successes so far in her career have been stage adaptations of Jane Austen novels. I include her here because of two extraordinary recent plays, *Pilot Program* and *Little Happy Secrets*.

Melissa Leilani Larson is a problem solver. For years, she worked as a theater stage

manager. Stage managers, in case you're not familiar with theatrical nomenclature, are the staff sergeants of the theater world. Directors decide what approach any production will take, what a show's overarching concept will be, how the show will look, move, feel, what it will mean. Stage managers make it happen. Stage managers make sure the actors show up on time, memorized and ready to work. Directors work with designers, conceptualizing a set, lighting, sound. Stage managers make sure the set gets built, on time, under budget, and that it's safe to walk on.

But it's more than that. Larson has worked on shows with big casts and budgets. But she has also worked in smaller, local theaters, with tiny budgets and unpaid, volunteer labor. She's great at working with limited resources, of making do, improvising, getting a show on its feet by sheer force of will. And she was legendary for her unflappable temperament, her resolute humor in difficult circumstances, her mild but formidable omnicompetence. A Mel Larson show works.

And what is a Jane Austen adaptation but an exercise in problem-solving? Those marvelous novels, with complex stories, with many fascinating characters (especially minor characters, who are among Austen's richest creations), pose the most demanding trials for the adapting playwright. How to condense so enchanting a story to a couple of hours entertainment? What do you cut; what do you keep? How do you tell a complicated tale simply enough so it can be understood, using Austen's rather dense language, while still retaining the charm and wit and incisive social commentary of the originals? How do you balance the three Jane Austens: the satirist and comic, the unquenchable romantic, and also the fiercely committed feminist? Larson succeeds because she is also those three things: satirist, sympathetic romantic, and feminist.

But now, in *Pilot Program* and *Little Happy Secrets*, she explores, with wit, insight and compassion, the toughest issues of her own culture. And what gives these plays their unique texture and power is our dawning recognition that these are issues that may not have a solution. The problem-solver is stumped, the stage manager confounded. We're left with sorrow, and perhaps a quiet, impotent rage.

Claire, in *Little Happy Secrets*, has fallen in love. Or maybe not; maybe she's just enthralled, in the grips of a deep romantic attraction. But she's LDS, a committed member of the LDS faith, and the person she's in love with is another woman. And how does she resolve that? She's a returned missionary, a committed and faithful Latter-day Saint. And she is in love with, or perhaps just attracted to, someone she cannot, should not, must not be with. And she knows it. And she knows, and we know, that there is no easy answer to her dilemma. There may not, in fact, be an answer at all. And the result is tragedy. Not suicide, not murder, not anything that melodramatic. Just the profoundest, life-long unhappiness.

Abigail, in *Pilot Program*, has agreed to complicate her marriage with polygyny, share her husband with another woman, as, she believes, is required of her by her Church leaders. The play has a contemporary setting; it's best regarded as a thought experiment;

what if the Church asked this of someone? She and her husband pray about it, and she is the one who receives revelation. And Abigail loves her husband deeply, and, scarred by her own battles with infertility, thinks another wife might provide him with the child she knows he wants. Both women, Claire and Abigail, are in love. Both women find, in and through their love, torment and agony. And things are unlikely to change for them, or improve.

And we know both women very well indeed, in part because they talk to us. While *Little Happy Secrets* is largely about the relationship between Claire and Natalie, the central relationship of the play may be between Claire and the audience. That is also likely true of Abigail, who blogs to us.

I call both plays tragedies. But both defy easy definitions. Mel writes with wit and affection about her own culture, and both plays have moments of humor. Above all, though, the plays lead to conversation. After seeing them, we audience members seem compelled to talk about them. The test of a great play isn't whether audiences laugh, or cry. It's the degree to which the play gets under your skin. After seeing either play in a good production, you can't let it go. You talk in the car on the way home. You wake in the middle of the night, thinking about it.

Again, it's about problem-solving. My wife and her sisters do this all the time. When we get together, they raise an issue they're facing. Perhaps a child faces a personal dilemma; how to help her resolve it? I'm in a dispute with a neighbor; what should I say, and when? Informal conversations about the challenges of LDS life, about reconciling the occasional tensions of life, from a Christian/Mormon perspective take place, I think, all the time in LDS culture. Wasn't it Joseph Smith who wrote "by proving contraries, truth is made manifest." And so, in one of our finest contemporary playwrights, we have a woman whose best work proves (tries, tests?) the contraries of our culture. She's a pragmatist, a practical woman. Deeply committed to her own understanding of what we call the Restoration. But acutely in tune with the difficult paradoxes of gender and sexuality and patriarchy embedded within Mormon culture. She poses problems that can't be solved, and gently devastates us with the pain and heartache that results.

The reality is that active Latter-day Saints of Larson's generation, even those who remain active in the Church, are located uncomfortably at the crossroads upon which the Church itself currently rests. They know about Nauvoo polygyny, and believe that many young women in that period suffered terribly. They have gay friends, and don't understand what seems like a double standard for how our LGBT brothers and sisters date, court, fall in love. They cannot contemplate patriarchy without considering it, at least to some degree, oppressive. Larson, as an active and believing young woman of color, is acutely attuned to those tensions and pressures and issues. She is the gentlest of tragedians, the least strident of feminists. But in her work we feel the genuine pain suffered by so many, who cannot figure out how to reconcile their witness of the Restoration with what strike them as retrograde cultural practices. Larson's work, at its best,

gives expression to that pain. If she can't or doesn't resolve the issues that underlie it, it may be because that's a task beyond the work of dramatists.

All three of these fine writers are deeply influenced by the culture which produced them. All three try, in their own way, to speak truth as they understand it. All three use theatrical language to pose uncomfortable questions, to reconcile difficult doubts. Plays are meant to be experienced in production. Those of us fortunate enough to see these fine works are forever altered by the experience. That's what our two hours traffic on the stage is meant to accomplish. Shakespeare said that, and if we don't have a Mormon bard, let it at least be said that we do have some very fine writers.

NATHAN THATCHER

FRANCISCO ESTÉVEZ: A CASE STUDY

When President Kimball gave his "Gospel Vision of the Arts" talk (perpetually required reading for BYU freshmen in the humanities) he spoke of his hope that the Church would produce great artists of all types and of the highest caliber. He spoke of wanting to hear singers like Caruso and pianists like Liszt, to read poets like Goethe, and to see painters like Rembrandt all emerging from within the Church. But this begs a question: if we found a genius among us, what would we do with him or her?

Indulge me in a little thought experiment.

Imagine that, say, Mark Rothko had run into the missionaries somehow, investigated, and ended up joining the church. What would we do? And what would the Church do? And, because they're probably separate questions: what *should* we, and what *should* the Church do?

I want to hope that we would have Rothko temple murals and that he would find himself with no shortage of patrons among church members and that we would proudly point to him and say, "yes, he is one of ours," but I find myself sadly doubtful. We Mormons love to rally around LDS athletes, pundits, reality TV stars, dancing violinists, and piano people. But Rothko? Probably not. And what if we changed the artist in our hypothetical situation? What if it were, say, Egon Schiele, Francis Bacon, or Marcel Duchamp? What would we as a Mormon community do with a great artist? What would we do with a provocateur?

I want to introduce you to the life and music of Francisco Estévez who, while I will stop short of Rothko comparisons, is without doubt one of the most talented, original, and excellently credentialed composers active today in the Mormon tradition. Certainly Estévez is not alone in the Mormon world; our community includes a growing number of truly great composers of art-music, including many who, like Estévez, are from far outside the "Mormon Corridor." Lei-Lei Tian is a prime example. Outside of the music world, Ultra Violet's conversion is likewise a compelling story. Francisco Estévez's story is similar—rare and intriguing—but, of course, unique, and fascinates me with reference to President Kimball's talk in that he converted to the church as an adult, coming to us fully formed as an artist, rather than developing within the church.

Francisco Estévez is a highly trained composer, conductor, performer, and teacher. He recently retired after a life-long career of university teaching. He obtained multiple degrees, studying composition, electronic music, conducting, flute, piano, clarinet, and cello performance, and philosophy at multiple universities in three different countries. He repeatedly attended the famed Darmstadt Lectures where he studied at the feet of legends of the avant-garde such as Stockhausen, Xenakis, Nono, Berio, and Ligeti. He studied personally with Olivier Messiaen and Mauricio Kagel. He co-wrote and performed in a stage work in which at one point performers sing from sheet music that is literally on fire. This was after he joined The Church of Jesus Christ of Latter-day Saints in Germany in 1982 and probably while he was still a branch president in Spain. His music has been performed and received awards across Europe and in Israel and Mexico, only recently making its way to the United States where he is today visiting for the first time. He has had family dinner with Benjamin Britten on several occasions, and collaborated and performed with original members of the band Kraftwerk. He works in the Madrid temple once a week and is a big believer in chia seeds. He is a skilled poet, an amateur painter, and a father of three and grandfather of three. He is a survivor of cancer and numerous death-threats and you've probably never heard of him before.

We often discuss the question of "What *is* Mormon art" but that is not my purpose here. While I think this can often be a useful and important discussion, or perhaps more appropriately, an internal dialogue, it tends to be somewhat tautological. Rather my focus here is, in the spirit of classically Mormon pragmatism, "What do we *do* with Mormon art." The stakes are high: "for whosoever receiveth, to him shall be given, and he shall have more abundance; but whosoever continueth not to receive, from him shall be taken away even that he hath." (JST Matthew 13:10-11) My purpose in introducing Francisco Estévez to you is partly for his interesting story but also as a case study in what to do with artistic greatness in our community.

First, I ought to start at the beginning. We should start with the story of how Estévez came to my attention. It's a story which raised two strangely paradoxical questions: "Why had we never heard of this guy before?" and "How did we even manage to hear about him at all?" Glen Nelson has spoken about the isolation felt by so many Mormon artists. This is something of a cautionary tale about the necessity of overcoming that isolation.

We begin with a mystery. Glen was conducting extensive research into Mormon composers in an attempt to form a comprehensive history. In doing this research Glen came upon a talk given by composer Merrill Bradshaw at a conference on Mormon art in the '90s. He gave a small list of prominent Mormon composers actively composing at the time. The list included the entry "Francisco Estévez: Madrid, Spain. Actively composing" and nothing more. I later learned that Francisco himself had never heard of Merrill Bradshaw and we can't be certain how Estévez came onto Bradshaw's radar. I see it as a small miracle.

Glen proceeded to seek out information about Estévez but it was tough going. Francisco has a website that consists of two photos with the wrong aspect ratio, an outdated CV, and no contact info. A handful of scores were available commercially and after seeing only two he got the picture: this was someone important. Using his rusty but most valiant Spanish he reached out to an online forum for Spanish contemporary music that looks like it hasn't seen an update in the 21st century. "WANTED:" his initial post read in capital letters, "Francisco Estévez." It wasn't long before an internet do-gooder came forward with a smattering of bootleg recordings made from radio broadcasts and a link to a radio interview that could still be found in an online archive. He has quietly been collecting Francisco's music for decades although they have never met.

It was about this time that I got involved. I was visiting Glen at his home when he pulled out the score for a piece called *Juegos*. "Juego C" is only two pages long but immediately captured my attention as I sat reading it.

video of a performance of this piece can be found here: http://tinyurl.com/juegoc

This piece is gripping. I find it remarkable for its clarity. What you see on the page is what you get. The piece begins with the simplest of materials: five descending, unaccented, diatonic notes with no articulation marked. From the beginning it is clear that this piece will not be about timbre or even about pitch, per se. Two simple and simultaneous musical processes comprise the true material of the piece: one governing rhythms, combinatorially rearranging and dividing one of the four quarter notes in each bar, every fourth bar beginning a new type of grouping, and the other governing pitches, adding a new interval above or below every three bars. The processes come to their natural conclusions at the same time and the piece is over. Nothing else needs to be said.

So, returning to our story, I was immediately convinced by the music, I'd been told the composer had studied with Messiaen (a personal idol of mine), I spoke good Spanish. I wanted to get involved. I was eventually able to get in contact with Estévez. In spite of all the information we had found and in spite of getting in touch with him, Estévez remained a mystery and an increasingly tantalizing one. It was like dealing with dark matter. It was clear that he was the real deal but mostly by inference. Communication with Francisco was patchy and difficult. So, although not quite on a whim, almost at a moment's notice, I found myself flying to Spain, questioning my nearly nonexistent credentials and hoping for the best. In fact, I was just hoping not to get turned away when I got there. I actually had no guarantees that I would even be welcome prying into Francisco's life and musical endeavors. He had conveyed to me by email that he "didn't really like to talk about it" but I couldn't quite tell whether this was out of humility or some kind of deep disavowal.

My only plan was to turn up at his ward on Sunday and see where we went from there.

I went on to write a book about this whole experience which was published by Mormon Artists Group so I'll only summarize here. Long story short: I was well received in Spain. In four and a half days I came home with a suitcase stuffed full of manuscripts, memorabilia, and notes and a stomach stuffed with paella, and have basically spent the three years since then sorting it out. The suitcase that is—not the paella. I learned that Francisco's body of work was relatively large, impressively varied, and continuously intriguing. His archive was in a terrible state of disarray, however; whole pieces were entirely missing and figuring out how many there were and tracking down all of the pieces he had written was a large effort. It is still underway. Perhaps most important to me, though, was that I also learned that his friends call him Paco—a common nickname for Francisco. My book bears the title *Paco* because progressing from calling him Hermano Estévez to calling him Paco is a lot of what the story is about. I consider him a friend and mentor now, though he continues to be a bit of a mystery.

Paco was born in 1945 in the contested region of Morocco called Western Sahara. It was a Spanish possession of some sort and his parents moved there so that his father, a Latin professor, could take a position in the post office there (obviously not teaching Latin). They spent a few years there, a few years in the Canary Islands, and then moved to Madrid, living in the back of a wine bar, sharing a bathroom with customers. The family struggled financially for many years. Paco's older brother suffered from a chronic illness which claimed his life when Paco was about 15 years old. The difficult situation of his family and the constant care that his brother required meant that young Paco spent a great deal of time alone. In this solitude he developed a deep creative instinct and found comfort in the music of great composers.

In spite of the barriers of poverty, Paco's parents prioritized allowing him to receive all the musical training his promising talents required. Soon he began studies at the Royal Conservatory of Madrid. Unfortunately Madrid was not an ideal place to be studying contemporary music at the time. This was the 1960's during the reign of Franco and, culturally, the country was repressed and falling behind. As is a tendency in authoritarian governments throughout history, artists, especially those of the avant-garde, were strictly circumscribed. It could be dangerous to make music that fell outside the regime's approval. At the conservatory, only one of Paco's professors, Gerardo Gombau, even broached the subject of 20th-century music and although Paco involved himself in all the musical goings-on of Madrid at the time, he felt disappointed by the level of experimentation open to him.

During his third year of studies in Madrid a German composer named Günther Becker visited the conservatory. Paco was immediately obsessed by his music and aesthetics, especially his work in electronic media; he told himself then and there, "I'm going to study with this man." The next year Paco moved to Düsseldorf, a year shy of finishing his degree in Madrid, and began studies at the Robert Schumann Hochschule für Musik.

He intended his excursion there to be a brief detour in his studies in Spain but he found the environment in Germany so much more encouraging and liberating that he spent the next 15 years there heavily involved in the avant-garde music scene in Düsseldorf and in other parts of the country, even commuting to Utrecht in the Netherlands to complete an advanced degree in electronic music. He eventually went back to Spain one summer and passed a test that allowed him to properly finish his sidelined degree. During this time in Germany Paco's creativity was truly fostered and exploded. He developed a unique and confident artistic voice that won recognition even in his former home in Spain.

Also during this time, he also met a talented English violinist. They married and had a son, Luis, who is now a professional violinist himself. Several short years later the couple underwent a divorce leaving Paco to raise his young son alone. These difficulties, combined with his study of philosophy and his curious attendance at various churches, swirled in his mind when he encountered the legendary French composer Olivier Messiaen. By all accounts, and Paco's especially, Messiaen was a spiritual giant. He was one of the finest composers of the 20th century and in my opinion was one of the most individual musical thinkers that Europe has ever produced. He was also a profoundly godly man—a devout Catholic all his life. His was a transcendent spirituality which, although focused on the person of Jesus Christ and the sacraments, found equally heavenly expression in the songs of birds and his own synaesthetic perceptions. Paco had the honor of studying with Messiaen and came away with more spiritual questions than musical answers.

In the wake of all this, it seems almost too perfect that the missionaries should show up at his door, but that is indeed what happened in a "last-day-of-the-transfer" story that feels straight out of the Ensign. After more than a year of investigating, Paco was baptized in Düsseldorf in 1982 and he never looked back.

Very shortly thereafter, he accepted a teaching position in the brand new electronic music lab back in Spain in the small-ish city of Cuenca. This should have been a great opportunity for him but he encountered some...difficulties. At about the time of Paco's arrival in Cuenca a tiny new branch of the church was formed there. The branch president? Francisco Estévez. This would be difficult enough for a brand new member of the church but it got worse. Much worse.

The Catholic leadership in the area led an intense attack on the small congregation, labelling them as a cult and actively turning the community against them. The building they used as a chapel was repeatedly vandalized and threats of violence toward Paco and other members of the church were frequent. Paco's career also ran up against a wall at this time due to the entanglement of the school's administration with the Catholic authorities. He was relegated to teaching introductory courses and core curriculum. The story is incredible and complicated; it includes corruption, dubious political connections, betrayed lovers, and forbidden loves, and, at various times both the Catholics and

Mormons appear to have had "spies" of some sort. I wish I could tell more of the story here. Any interested screenwriters please contact me.

One shining bit of good news from this dark period does emerge. Through his work he was introduced to Cármen Alonso Boada, a lifelong member of the church. They fell immediately in love and were married in Gibraltar, later travelling to Switzerland to be sealed. They have been married for more than 30 years, have had two daughters and raised Paco's son Luis, and are as happy a couple as I have ever seen.

The couple soon left Cuenca. After years of struggle, Paco finally put his foot down when the threats of violence escalated to include Carmen, who was pregnant with their first daughter. They had to get out. The branch in Cuenca closed soon after.

As much as his Mormonism proved a professional disadvantage, Paco obtained respectable positions at conservatories in or around Madrid through the rest of his career throwing himself fully into growing the church in Spain and, more importantly, raising his family, which grew to include his youngest daughter, Aída.

When I first visited Paco he had recently retired. His compositional output has exponentiated since then. This is partly due to having more time on his hands but also to receiving increased attention in the Mormon musical community, which makes me exceptionally proud.

It is hard to read about music. Odds are you haven't heard a single note of the music of Francisco Estévez in order to evaluate it yourself. As no recordings of his music are currently available commercially, the best I can do is direct you to this playlist I've made on YouTube.

http://tinyurl.com/estevezplaylist

And as a composer, let me assure one and all that the music of Francisco Estévez is top notch. You don't have to take my word for it either. There are a number of others in our midst who have performed, heard, and studied his music. The jury is not out on this one. I worry about being a gatekeeper for what constitutes good music but I'll quote my teacher Michael Hicks who said, speaking of Paco: "As one elitist to the rest of them, I can testify that this music is true."

Is there a Mormon sound to it, though? Is it "Mormon Music?" I'll let you judge for yourself (but the answer is yes). This piece, written in the year 1992 for a custom-made set of metal bells and electronic tape, is titled *Preludio a la Memoria del Ángel Moroni.*

https://tinyrul.com/preludioangelmoroni

This is no hymn of the Restoration. So what do we do with it?

About ten years ago, Paco had a bit of a scare. He was diagnosed with cancer and underwent surgery. Luckily it was caught early and his recovery was quick and complete,

but his brush with death gave him a renewed perspective on a line from his patriarchal blessing: something to the effect of "many will be brought to the Gospel through your music." Paco felt that he couldn't claim that this had actually come about and, admirably, began seeking to bring it to pass. He began a string of works inspired by overtly Mormon themes and cut out the experimentalism he had spent his whole career perfecting. He finished a large-scale oratorio for orchestra with chorus and soloists called *El Sueño de Lehi* (Lehi's Dream) and began working on pieces titled *Nephi's Psalm* and *The Atonement*. Then, overnight, it was all gone. His home was robbed. Jewelry, cash, and computers were stolen. Bars could be fixed on the windows but the fact that Paco had not backed up any of his digital storage and thus had utterly lost several years of work could not be changed. A modern parable: back up your storage.

He was devastated and for months could not put pencil to paper to write at all. Eventually, however, his determination to fulfill his patriarchal blessing got him to take on the almost unthinkable task of rewriting *El Sueño de Lehi*. He did so from memory as best he could but he began to feel that not writing in the voice that he had always used—the compositional method of engaging with sound that most connected him to Deity—left him uninspired. He reintroduced uncompromising experimentalism into his sound, deciding that it was not at odds with his message. In the end he has expressed that he is almost grateful for the necessity of rewriting *El Sueño* because it allowed him to be more honest. I do not know what the original version of *El Sueño* looked like but the version that he finished and which I am in the process of editing has Paco written all over it.

The best thing about Paco's music is that it is utterly honest and sincere. He has something distinct to say and he says it. What fascinates me is that his music spans so many different styles and musical languages. I think this indicates more than mere eclecticism but is evidence that Paco's message transcends style and language. And I think he would agree. In talking about his process and in talking generally he is constantly borrowing aesthetic and devotional language and practice from an astounding variety of sources. Much of his music is directly inspired by Dadaism, but he has also found great meaning in Rilke. He identifies with the struggle of Jorge Luis Borges and cites Kierkegaard in the title of one of his most recent pieces. He has used Catholic liturgical texts and borrows Bach's music in the accompaniment of a song with extremely Mormon lyrics. Pervasively, the language he uses to talk about music is reminiscent of ideas from Scriabin, Wagner, Stockhausen, Kandinsky, and Sufic and Vedic mysticism.

His own words express his worldview beautifully—beautifully enough that I feel comfortable quoting him extensively here:

> Today I think along these lines: Sound holds the great secret of the Universe, the essence of the Universe. It was a joint shout of the Creator at the fashioning of the Universe and of the Universe as it was fashioned. The more sound I investigate or generate, the more I draw near to that primordial cry in

which flowed together pain and joy, anguish and pleasure, torment and well-being, turbulence and calm, fear and safety, love, respect, and so many more things. The sound was part of the Creator and through it the Creator was manifest. The Creator had the gift of transforming it into Word and thereby was made known unto us and brought us love and fullness. Not all of us have that gift of the word, but I believe that to a greater or lesser degree we have the gift of knowing how to combine sounds in order to manifest ourselves and to be able to express what we are, how we think, how we feel and transmit our feelings and emotions. In those vibrations that we generate lies our soul. In those vibrations appears that which is essential of our being, our humanity—our human side and our divine side. Today, in the maturity of old age I have understood that sound enlarges, elevates, exalts, strikes us dumb, makes us melt, wilt, languish, makes us dream, clothes us, shelters us, comes to our defense, unites us. That is why I combine sounds: in order to share my emotions, my feelings, my ideas, my thoughts—in order to share my "I," my being—in order to unite other feelings and emotions—to become more human in order to unite with the divine.

In reality, I want to form a part of that SPIRIT WORLD which so many created works have formed, each coexisting with the rest, having its own life. I believe that all those of us who dedicate ourselves to composing want to be a part of that special and beautiful spirit world in which the only indispensable requirement to enter is to produce 'pure vibrations of the soul' as Kandinsky has proposed. We seek the development and the increased sensitivity of the human soul. At times we achieve it, other times no. The end is in the means."

To me, there is something profoundly Mormon about this worldview in that it is so expansive and all-encompassing and in the very fact that it borrows so well and so freely from other devotional aesthetics. This kind of energy, and its results, are what are needed to impel the future of Mormon art and to impel it far beyond the Wasatch Front.

So I ask again: what do we do with Francisco Estévez? He has never sought for fame. Ambition is the furthest thing from him. Paco's work is great, profoundly spiritual and devotional, and, sincerely Mormon. Could we not use more of it and more like it?

I am reminded of the story of Minerva Teichert. She received the finest training and was primed to be a rising star in American painting but, eager to paint the "great Mormon story" and endlessly faithful to her religion, she returned to the west where she lived a quiet frontier-style life. Still, she always wanted to be part of a Mormon art community. She applied to paint murals in three temples before she got to do the Manti temple. Although now so beloved by the Church and its members, the Church never purchased her wonderful Book of Mormon paintings. In one of the great disappointments of her life she finally donated them to BYU. Today her prints are sold in Deseret Book and printed in the Ensign, but I find this story terribly sobering. I wonder what

things would be like if we'd recognized her and embraced her sooner.

Great work has been done by the Barlow Endowment for Music for Music Composition. Paco received a commission from them last year which he fulfilled by writing an enormous concerto for piano with string orchestra the score of which I haven't even finished reading. But who will hear that piece? How will it enter into our canon? What is our canon? I think that this festival is an excellent start–two Estévez pieces are being performed here–but I think we have many questions to ask and answer regarding how we can create spaces for Mormon art, and particularly excellent Mormon music, not merely to exist but to influence members of the church.

As president Kimball said there would be, great artists are and will continue to grow within and join our faith. Francisco Estévez is one of them. Where much is given, much is required. What will we do now that we know?

Francisco Estévez in Riverside Park, New York, June
2017, photo: Nathan Thatcher.

Francisco Estévez, *Anulaciones*, 1977,
Impero Verlag G.m.b.H., Wilhelmsaven, 22.

AUTHORS

Paul L. Anderson

Paul Lawrence Anderson is an architect (B.A. and M.Arch from Stanford and Princeton), retired museum curator and exhibition designer (21 years at the BYU Museum of Art), and artist. He worked on LDS historic sites for about 10 years, including the refurbishing of the Manti Temple, and the restoration of several historic buildings in Kirtland, Nauvoo, and Fayette. He has published several articles and book chapters on LDS architecture, and served for a year as president of the Mormon History Association.

Richard Bushman

Richard Bushman retired as Gouverneur Morris Professor of History at Columbia University in 2001 and was visiting Howard W. Hunter Chair of Mormon Studies at Claremont Graduate University from 2008 to 2011. He is the author of *Joseph Smith: Rough Stone Rolling* and served as Co-General Editor of the Joseph Smith Papers until 2012. In 1997, he founded the Mormon Scholars Foundation which fosters the development of young LDS scholars. He is now co-executive director of the Mormon Arts Center in New York City. With his wife Claudia Bushman, he is the father of six children and twenty grandchildren and Patriarch of the New York Young Single Adult stake.

Terryl Givens

Professor of Literature and Religion at University of Richmond; author of *Feeding the Flock*, *Wrestling the Angel*, *By the Hand of Mormon* and co-author of *The God Who Weeps* and *The Crucible of Doubt*.

Campbell Gray

Currently: Director, University of Queensland Art Museum, Brisbane, Australia. Previously: Director, BYU Museum of Art, Provo preceded by Senior Lecturer University of Western Sydney, Australia. DPhil Art History, University of Sussex, England.

Kristine Haglund

Kristine Haglund was editor of *Dialogue: a Journal of Mormon Thought* from 2009-2015. Although her degrees (Harvard, University of Michigan) are in German Studies and German Literature, she usually spent more time in choir rehearsals than in classes. She has written on Primary songs as the locus of women's contribution to the formation of LDS theology and other topics in Mormon women's history and religion in social media. She lives near Boston with her three children and works as a researcher in the History Initiative at Harvard Business School.

Jared Hickman

Jared Hickman is associate professor of English at Johns Hopkins University. He is the author of *Black Prometheius: Race and Radicalism in the Age of Atlantic Slavery* (Oxford University Press, 2016) and co-editor, with Elizabeth Fenton, of *Americanist Approaches to the Book of Mormon* (forthcoming, Oxford University Press).

Michael Hicks

Michael Hicks is a professor of music at Brigham Young University School of Music. He is the author of five books published by University of Illinois Press, the latest of which is *The Mormon Tabernacle Choir: A Biography* (2015). His most recent album is entitled *Felt Hammers* (2015).

Kent S. Larsen

Kent S. Larsen is an independent scholar focusing on Mormon Art and Literature, and on the history of Mormons in New York City and in Brazil. He manages the New York City LDS History website and is currently preparing a compilation of LDS poetry published before 1848. He lives in New York City, where he currently serves as a bishop. He and his wife of 30 years are the parents of three children.

Adam S. Miller

Adam S. Miller is Honors Institute Director and a professor of philosophy at Collin College in McKinney, Texas. He is the author of seven books, including *Speculative Grace, Letters to a Young Mormon*, and *The Gospel According to David Foster Wallace*. He also directs the Mormon Theology Seminar.

Glen Nelson

Glen Nelson is a ghostwriter of twenty books, with three *New York Times* best sellers to his credit. He founded Mormon Artists Group in 1999 and remains its director. MAG has created 30 projects with 90 LDS artists. As a librettist, he has written three operas, five song cycles, two cantatas, and has published poetry and essays and

collaborated with artists on many projects. He and his wife have published a book on their art collection, *The Glen & Marcia Nelson Collection of Mormon Art*. His next book is *Joseph Paul Vorst*, to be published in the fall of 2017 in conjunction with a museum retrospective of Vorst's work co-curated by Laura Allred Hurtado, at the Church History Museum in Salt Lake City, Utah.

Steven L. Peck

Steven L. Peck, Department of Biology, BYU, researches evolutionary ecology and philosophy of science. He is an award winning novelist, poet, and short story writer. BCC Press has just published his *Science the Key to Theology* and his novel *Gilda Trillim* will be published in September by Roundfire Books.

John Durham Peters

Born in Salt Lake City in 1958, Peters taught at University of Iowa for three decades and is now María Rosa Menocal Professor of English & Film and Media Studies at Yale University. His last book is *The Marvelous Clouds: Toward a Philosophy of Elemental Media* (2015). He is glad that his new office is a block away from a bunch of glorious Turner paintings.

Jana Riess

Jana Riess is Senior Columnist for Religion News Service and the author or co-author of many books, including *Flunking Sainthood*, *The Prayer Wheel*, and the forthcoming book *The Next Mormons: The Rising Generation of Latter-day Saints* (Oxford, 2019).

Eric Samuelsen

Eric Samuelsen has premiered his plays *Miasma, Amerigo, Borderlands, Nothing Personal, Radio Hour Episode 8: Fairyana, Clearing Bombs, 3*, and *The Kreutzer Sonata* with Plan B Theatre Company. *Clearing Bombs* was nominated for the Pulitzer Prize. His other plays include *Gadianton, A Love Affair with Electrons, Family, The Way We're Wired*, and *Peculiarities*. Fluent in Norwegian, Mr. Samuelsen has also translated four Ibsen plays: *Hedda Gabbler, Little Eyolf, A Doll House*, and *Ghosts*, all of which have been produced.

Nathan Thatcher

Nathan Thatcher (b. 1989) is a composer, performer, arranger, and author. He has received commissions from numerous soloists and ensembles including the New York City-based sextet yMusic, the Calidore String Quartet, and Converge String Quartet. He has worked as a producer, arranger, orchestrator, copyist, transcriber, and conductor with a wide array of musicians including Nico Muh-

ly, Shara Nova, Sufjan Stevens, Daníel Bjarnason, Nadia Sirota, Son Lux, Sam Amidon, Joshua Winstead, Woodkid, David Byrne, and others. His arrangements have been performed by the Kronos quartet, the Brooklyn Youth Chorus, the Flanders Symphony Orchestra, and the Grant Park Orchestra and chorus, and appear prominently on the record *Away* by the band Okkervil River. He is also the author of *Paco*, a biography and memoir about the discovery of the music of the Spanish composer Francisco Estévez. He completed a bachelor's degree in music composition at Brigham Young University and a master's degree in the same at the University of Michigan.

MORMON ARTS CENTER

June 28-July 1 marked the first large event of the Mormon Arts Center. Scholars, artists, musicians, and the public gathered in New York City at The Riverside Church for the Mormon Arts Center Festival.

A day was dedicated to scholarly presentations. It was organized by Claudia Bushman and Richard Bushman who invited a keynote speaker (Terryl Givens) and scholars (Paul L. Anderson, Campbell Gray, Kristine Haglund, Jared Hickman, Michael Hicks, Adam S. Miller, Glen Nelson, Steven L. Peck, John Durham Peters, Jana Riess, and Eric Samuelsen). Additional presentations were made during the Festival, and two of those scholars (Kent S. Larsen and Nathan Thatcher) were invited to submit their work for this collection, as well. The essays in this volume represent all of those scholarly efforts.

Each of the speeches were filmed and are available for free viewing on the YouTube channel of Mormon Arts Center. After the Festival, some of the authors revised and expanded upon their Festival presentations for the purposes of this collection of essays.

The Mormon Arts Center has three goals: to display and perform works by Mormon Artists in New York City and elsewhere; to publish scholarship and criticism about Mormon Arts as a way to reach a wider public; and to establish a comprehensive archive of Mormon Arts (1830 to the present).

MORMON ARTS CENTER BOARD OF DIRECTORS

Richard Bushman, co-executive director
Glen Nelson, co-executive director
Allyson Chard, managing director
Jeff Holt, finance director
Jenna Holt, treasurer
Claudia Bushman, historian
David Checketts
Brad Pelo

MORMON ARTS CENTER ADVISORY BOARD

Daniel R. Chard
Deborah Checketts
Brian and Rachel Crofts
Jennifer Darger
Antje Evans

James E. Faulconer
Angela Glenn
Campbell Gray
Stanley Hainsworth
Emily and J.P. Hanson
Margaret Olsen Hemming
Katie Holmstead
Laura Allred Hurtado
Jackie and Eddie Ibanez
Craig Jessop
Brian Kershisnik
Lance Larsen
Lansing McLoskey
Linda Nearon
Reid Neilson
Steven Peck
J. Kirk Richards
Diane P. Stewart
Benjamin Taylor
Ruth Todd
Harriet Uchtdorf
Shauna Varvel
William Wilcox
Warren Winegar

MORMON ARTS CENTER FESTIVAL VOLUNTEERS

Jo Bird
Lauri Bishop
Braden Burgon
Alyssa Chard
Kenneth Clay
Adam Daveline
Andrea Daveline
Miriam Deaver
Emily Doxford
Rebecca Holt-Gilmore
Sharon Harris
Carolyn Hartvigsen

MORMON ARTS CENTER DONORS (as of 10/1/2017)

The Mormon Arts Center is an independently-funded organization. We gratefully acknowledge donors who have contributed to the Mormon Arts Center and have made this Festival possible.

$25,000+
Kem C. Gardner
Samuel S. and Diane P. Stewart

$10,000-$24,999
Anonymous (2)
Beesley Family Foundation
Dan and Allyson Chard
David W. and Deborah Checketts
Brian and Rachel Crofts
Emily and J.P. Hanson
Jackie and Eddie Ibanez
Brett and Marcie Keller
David and Linda Nearon
Eric and Shauna Varvel

$5,000-$9,999
Anonymous
James and Kathleen Crapo
John and Becky Edwards
David and Angela Glenn
jetBlue Airways
John R. Miller Family
Joel and Colleen Wiest

$2,500-$4,999
Mark and Patti Amacher
Todd and Nancy Herget
Jeffrey D. and Jenna Holt
Brad and Melody Pelo
Vincent M. and Diana Rosdahl
JB and Hillary Taylor
Dennis and Martsie Webb

$1,000-$2,499
Cris and Janae Baird

Daniel and Diane Bartholomew
William P. and Barbara L. Benac
Richard and Jo Bird
Jeff and Sara Brunken
Karl and Diane Bushman
Serge Bushman and
 Patricia Shelley Bushman
Richard and Claudia Bushman
Chad and Kristin Christensen
Thomas J. and Carolyn Crawford
Linda S. Daines
Chester and Heidi Elton
Jason and Kristy Glass
Scott and Melissa Higbee
Paul and Kim Howarth
Kevin and Nicole Jackson
New Vision Art
Bryan and Ruth Todd
David and Rachel Weidman

$500-999
Ariel Bybee and James Ford
Roger and Kathy Carter
Connie Chard
Leslie Hinchcliff Edwards
Michael Fairclough and Joan Ashton
Lillian Handlin
Don and Audrey Hill
Katie and Adam Lindsay
Hannah Miller
Jon Moe and Marilee Jacobson Moe
Jack and Kathy Newton
Scott and Chris Peterson
Mark and Thaylene Rogers
John and Nancy Van Slooten

Brent and Enid Smith
Joe and Jolene Swenson
Bridget Verhaaren
Lynda and Larry Y. Wilson

$100-499
Lisa and John Adams
Steve and Gena Alder
John Allred
Colorado Faith Forums
Kent and Allison Dayton
Jay and Ellen Eckersley
Carras and Kathryn Holmstead
Tom Hurtado and Laura Allred Hurtado
Alice and Bradley Jardine
Joseph and Annette Jarvis
James Johnston
Brooks and Jana Lindberg
Anthony Moustakas
Glen and Marcia Nelson
Charles Randall and Jann Paul
John Durham Peters
Walter and Linda Rane
Robert Shull
Sean Stevens
Doug and Cinda Taylor

$50-$99
Spencer Ellingson
Gaylen C. and Dana Garrett
Catherine Hall

$1-$49
Anonymous
Royden Card
Arthens Hughes
Annie Poon
Ryan Rees

Made in the USA
Middletown, DE
28 May 2018